MAYBE YOU NEVER CRY AGAIN

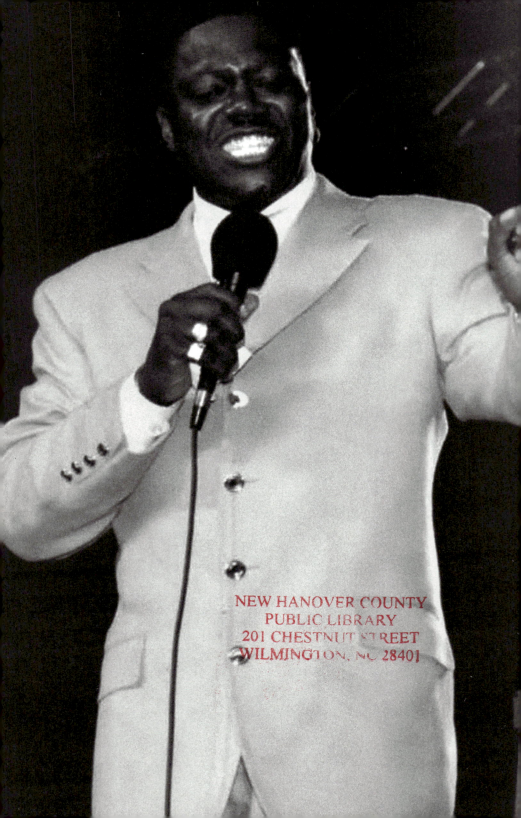

MAYBE YOU NEVER CRY AGAIN

Bernie Mac

with Pablo F. Fenjves

ReganBooks
An Imprint of HarperCollinsPublishers
www.reganbooks.com

HarperCollins books may be purchased for educational, business, or sales promotional use. For information please write: Special Markets Department, HarperCollins Publishers Inc., 10 East 53rd Street, New York, NY 10022.

FIRST EDITION

Designed by Platinum Design, Inc., NYC

Printed on acid-free paper

Library of Congress Cataloging-in-Publication Data has been applied for.

ISBN 0-06-052928-8

03 04 05 06 07 QN/RRD 10 9 8 7 6 5 4 3 2 1

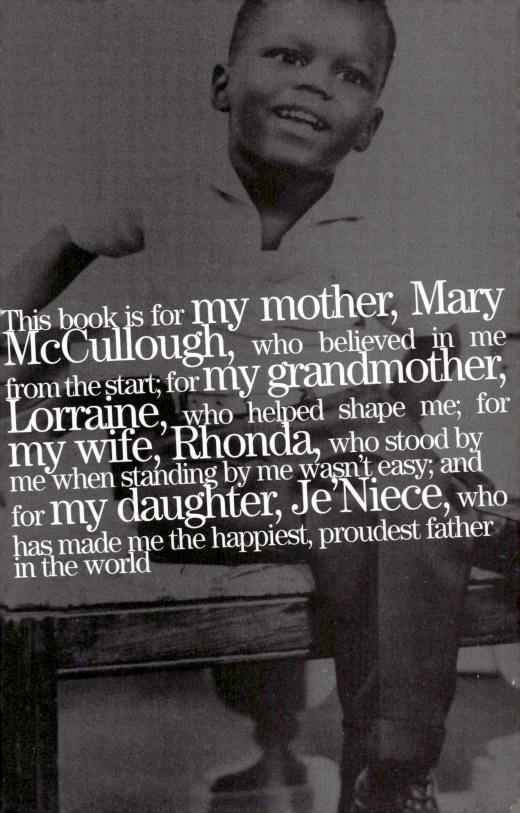

This book is for my mother, Mary McCullough, who believed in me from the start; for my grandmother, Lorraine, who helped shape me; for my wife, Rhonda, who stood by me when standing by me wasn't easy; and for my daughter, Je'Niece, who has made me the happiest, proudest father in the world

CONTENTS

"BLACK PEOPLE: THEY TELL IT LIKE IT IS."

TAR BABY, SPOOKY JUICE

01

My name is Bernard Jeffrey McCullough, but people know me as Bernie Mac.

My mama, God rest her soul—she used to call me *Beanie.*

Used to say, *Don't you worry about Beanie. Beanie gonna be just fine. Beanie gonna surprise everyone.*

Woman believed in me. She believed in me long before *I* believed.

I loved my mama with all my heart.

I was born October 5, 1957, on the South Side of Chicago, in the Woodlawn area, a neighborhood that hasn't changed much in forty-five years. Our house was on 66th and Blackstone, but the city tore it down when the rats took over. We moved to a new place on 69th and Morgan, in Englewood, right above the Burning Bush Baptist Church, a two-story, redbrick building. My grandfather was a deacon at the church, and I think he got a deal on the place. So we packed up: my mother, Mary McCullough; her sister, Evelyn; my older brother, Darryl; my grandparents, Lorraine and Thurman; and little me. Somewhere along the line, maybe during the move to our new digs, we lost Daddy.

We were poor. You know how to tell if a person's poor? You look in the fridge. If there's nothing in there but bologna, you're talkin' serious poor. Mmmm, but that bologna was good! We used to fry it up till a black circle formed at the edges, then roll it like a hot dog and eat it slow, make it last. You'd be chewing with your eyes closed, telling yourself, Never had *nothin'* taste so good!

Lot of beans in our house, too. Pinto beans. Lima beans. Red beans.

And cereal. Only you'd be eating it with a fork, leave the milk at the bottom for the next guy. I ain't lyin'. You think I'm lyin', you don't know what poor is.

Sundays was different, though. Sundays we had a real dinner. Roast and mashed potatoes and butter rolls and macaroni and cheese and gravy, boatloads of gravy. That was some serious eating. I couldn't wait for Sundays. I *lived* for Sundays. 'Course, next day we were back to potted meat and beans, with sometimes a neck bone floating around in there if you was lucky.

Here's the thing, though: I didn't think nothin' about it. I thought we were just like everybody else. I thought life was *good*. I thought, This is how life *is*.

I was a big-eyed kid. My eyes were about the size they are now, in that little head of mine—and my eyes are *way* big, so imagine it: like a pair of flashlights comin' at you through the darkness. Kids called me "tar baby," "spooky juice." I was scary.

"What you looking at?" they'd say.

"I'm looking at you, motherfucker."

Three, four years old, and that was one of the first words I knew: *motherfucker.*

Grandpa Thurman would slap me up the side of the head and tell me to talk classy. "I won't have none of that intrepidation here, boy! Understand?" He was about five-six, stocky, light-skinned, his hair thin in back and starting to go gray at the temples. "None at all. *None.* Gonna expedential your ass right the hell up! Hear me? Your ass gettin' expedentialed."

Motherfucker thought those were real words. And he was always repeating everything three, four times.

"Huh?" I'd say, and I'd look at him like he was an old fool.

He'd slap me up the side of the head again. "Don't talk back to me, boy! I'll abstract you. Man's gotta rederfrine himself to succeed in this here life."

I would go outside in the afternoon, see if anyone my size was around. Maybe kick an old can up and down the sidewalk till the neighbors told us to shut the hell up. That was the neighborhood. Nobody calling out, "Hey, Bern, get your cleats, time for football!" Or, "Wash your hands, boy—piano teacher on her way over!" We didn't have *play dates* in our neighborhood. We didn't worry about being *overscheduled*. We learned to entertain ourselves. I used to have long conversations with the living room wall.

"Who you talkin' to, boy?" my grandma asked, shuffling along on those swollen-ass ankles, eyes squintin' and flashin' in that pitch-black face.

"Nothin'."

"You always underfoot, Bern. Go outside and sit on the stoop."

"I already done that."

"You sassin' me, boy?"

"No, ma'am."

"Wait till your grandpa come home. I'm gonna tell him how sassy you're gettin'. He gonna whup your ass."

In my family, you learned respect. In my day, the adults were in control. There were rules, and by God, we had to follow them. Every time my mama set down the law, she'd say, "I know you don't like it, Bean, and I know you're mad at me. But life isn't a popularity contest." Good thing, too. Lots of days she would have finished last for damn sure.

Most times, though, she didn't say much; she could stop me with a look. She figured you didn't want to be talkin' to little kids. They're not hearing you. Little kids aren't much smarter than dogs.

When I was about five years old, though, she began to change her ways. She started trying to communicate with me. She'd still

give me the look, of course, only she'd add a little philosophy to go with it.

"Talk is cheap, Bern. When you tell me you're going to do something, I expect it to get done. Ain't nobody going to do it for you."

If I got angry, she'd tell me to get over it. "Only person you're hurting is yourself." And if I did something she considered too stupid for words, she'd shake her head and look seriously disappointed. "Act like you got some sense, boy," she'd say. "Maybe one day it'll come true."

It *did* come true, of course. But it was a long time coming.

////////////////////////////////

I remember the day I started school. Me and the kids in the neighborhood, walking along with our little lunch pails, looking like we was going off to tiny jobs. 'Course, we had our mothers with us. Two blocks was a long way to go.

I was a shy kid. Other kids, they settled right in and made themselves at home. But me, it took a while. I was the kid in the corner, wide-eyed, sayin' nothin', takin' it in. Didn't have much in the way of social skills, I guess.

I'd go home after school and eat potted meat and—weather permittin'—go out front and park my little ass on the stoop. I'd watch the neighbors on *their* stoops. Watch the cars cruise by. Watch the people in the cars watching me back. Do this till I'm yawnin', then I'd go back inside and pick up where me and the living room wall had left off.

One night, though, I come in and find my mama in front of the TV, cryin'. And you know how it is when you're a little kid: your mama cryin', you gonna be cryin' in a minute.

"What's wrong, Mama?" I ask her.

"Nothing, baby."

I climb onto her lap. She holds me. I look at them big-ass tears coming down her cheeks and I reach up and wipe 'em with my pudgy little hands. "Mama," I ask her again, "why you cryin'?"

"It's nothin', Bean. Sometimes I think sad thoughts."

"What thoughts?"

She didn't answer. She was lookin' at the TV. Black guy's talkin' to Ed Sullivan. I look at him, but I don't hear but a few words. And I can't make them out anyway, see, because suddenly my mama's laughin' to bust a gut. Her whole lap's shakin'. I got to hold on tight or get thrown clear across the room.

I turn to look at her—this is the same woman that was cryin' a second ago?—then turn back to the TV. "Who that man, Mama?"

She's still laughin'. Takes her a while to catch her breath. "Bill Cosby, son. He's a comedian."

A comedian?

"What's that?"

Now she's laughin' harder. Tears still comin' out of her eyes, but she's happy. She's slappin' the arm of the chair, she's so happy. She's lettin' it out.

I look over at this Bill Cosby again. I don't know what he's talkin' about—something's going on in his bathroom—but I know that whatever it is, it's got *power.*

"That's what I want to be, Mama. A comedian. Make you laugh like that, maybe you never cry again."

Oh man, now she gets into some serious sobbin'. She's hugging me so tight I can hardly breathe.

"Oh, Beanie!" she's saying, wailing. "My little baby. I love you so much. Do you know how much I love you, little Bean?"

Now I had some direction. I was going to be a comedian. I practiced on my pencils. I had a box of pencils at home, five hundred

pencils. They all had names. Jamie, Zeke, Hightop. I'd sit there and my pencils would be talking to each other, tellin' jokes: "Your mama so fat, even the tide won't take her out."

Grandpa Thurman walked by, shaking his head. "That boy crazy. Ought to be locked up."

I took my talent to school. Be the cutup, brother. Bernie comin' out of his shell. Bernie the class clown.

Teacher would ask the class, "Who was president of the United States when the Declaration of Independence was signed?" I'd say, "Bill Cosby." She'd ask, "What's seven times fourteen?" I'd say, "Why you askin' us? *You're* the teacher."

She didn't like that one bit. Called Mama. "Bernie knows the answers better'n most of the other kids, but he likes to say it wrong. He thinks it's funny."

Mama didn't like that much herself. "It's a shame when you're born stupid, Bern, but when you practice it—I got a problem with that."

I bowed my head like I was supposed to do. "Yes, Mama."

"When your granddaddy gets home, he gonna whup your ass."

Shit. I was gonna get my ass whupped.

During the week, my grandpa was a janitor at General Motors. Sundays he spoke for the Lord. But *every* day he kept us in line.

So now I'm worried. I'm thinking about this ass whupping. I'm thinking how my mama just done ruined my entire evening. Sent it all to hell. I can't eat. I can't hardly breathe. I'm in a got-damn trance. Only one thought goin' round in my head, and it's like a broken record: "Grandpa Thurman comin' home to whup my ass."

And there he is now. I can hear them talkin' in the other room. I'm shakin' already. My grandpa walks in, all stiff and bowlegged. Looks at me in that special way of his: Seems like *everybody* in my family has a special look.

"What is wrong with you, boy?" he says, snortin' like an old bull.

I don't say nothin'. I know he's not really askin'. It's what you call a *rhetorical* question: What he wants to hear is his own self.

"Somethin' wrong with you, boy? You wrong in the head? How did you come out all wrong like that—kin o' mine?" Repeatin' everything three, four times like he does, circlin' me. "You think it cool to be messed up?"

"I ain't messed up."

WHAM! Knock me up the side of the head good. "I'm just gettin' started, boy," he says, and he leaves me there, seein' stars. He walks into the kitchen. I can hear him ask Grandma what's on the menu for the evening. Like he don't know. *Potted meat*, old man. It's a long way from Sunday.

//////////////////////////

You grow up, world starts changing. Or maybe it's the way you see it, even if it's only on *Leave It to Beaver*. I'm watching TV with my buddy Almon Vanado, seven years old. He lived around the corner, on 68th.

"Why we poor, A.V.?" I ask him.

He shrugs. Don't know.

Later, at dinner, I ask my mama: "Why we poor?"

"Don't mean nothin'," she says. "You be proud, son. Hold your head high."

My grandma whacks my elbow off the table. Sneak attack. I almost fall clean off the chair. "What'd I say about elbows on the table?" she asks, but she's not wantin' an answer. "Use your manners, boy. We're poor, but manners don't cost nothin'. Good manners tell people who you are."

My grandma had other sayings, too. Sayings ran in the family. On bad days, she'd say, "Life is a heavyweight fight, Bernie. Protect yourself at all times."

On good days, it was, "Beautiful mornin', ain't it, son? I get another crack at it this mornin'; another chance to improve myself."

My grandma was the mayor of the neighborhood. Everybody knew my grandma. When somebody was sick, she was the first one there. Bringing soup, cleaning up. If somebody couldn't pay the rent, she organized a rent party. Other times, I got sent out to help the neighbors—even if they didn't need it.

"Grandma says for you to go help Mr. Willis wash his car," my grandpa would tell me.

"What for? He got a boy of his own."

WHAM! Right across the back of the head. No warning. "I'll knock your eyeball out, boy! Then *step* on it."

No idle hands in our house. Busy busy busy. We was church people, and we were there to set an example.

Sunday comes around. I wake up thinking of roast and potatoes, and that chocolate cake that comes after. Lyin' in bed, tastin' it already. Grandma walks in. "Time for church, Bern."

"I'm sick, Grandma," I say.

"I'm sick *every* day," she says.

I whine a little, but there's no getting out of it. Put on that starchy shirt and march downstairs to the got-damn church.

Man, it's crowded. Who knew the world was so full of sinners? Everybody hugging and kissing like long-lost relatives, when you saw them only last night, dancing in the middle of the street, drunk.

Then you go inside to your regular pew, first row, and suffer through all that singing and praying and hollering. And then Grandpa's up there, his voice rolling like thunder, shaking his fists. *Sinners!* And everybody's hollering back, "Oh yeh, Lordy! We sinners and we knows it!" Shaking their fists, too. Some of them got-damn faintin' in the aisles. And I'm thinking, Dear Lord, can I get some quiet here?

Finally, it's over—but it's still not over. I have Bible class to get through. And, you know, I like a good story as much as the next guy, but why they always tellin' us we're going to hell?

One day we had a little banquet after church, and one of the guest deacons said to me, "Bernie, I hear you think you're funny?"

"Pretty funny," I said.

Eight years old and I already had a reputation. This was 1966. Cosby was going strong. Richard Pryor was a rising star. And Bernie Mac was about to test the waters.

"Ladies and gentleman," the man said. "We have some entertainment for you this afternoon. I think you all know little Bernie. Little Bernie is a regular comedian."

He made me go stand up front, where everyone could see me, and I looked out at their stony faces. Tell you something I learned early on: Black people are tough; they want to be entertained. And I could see it in their eyes: *We don't think you're funny, boy. Nothin' funny about kids.* I waited for them to quiet down, then I got started: "My family—you don't want to mess with my family. My grandpa, he say everything four times—four times he says it—*four!*" They're laughing already, looking over at Grandpa, who's not laughing. They know what I'm talking about, though. I do his voice, make it go all deep, and I snort and breathe heavy and do all his gestures just right: "Pass me that gravy, woman. Don't be hoggin' that gravy. How many times I got to ask for that gravy? I'll bonk the top of your head you don't pass me that gravy *now.*"

Those two, Thurman and Lorraine, they were bickering all the time. She says black, he says white.

So then I do my grandma, giving it back: "Thurman, you ain't bonkin' nobody. And you calm down about that gravy. Boat'll get to you. You start on 'em potatoes." I squint my eyes the way she does, and it's clear from the laughter that they got grandmas that

squint, too. I tell 'em how she shuffles up behind you, scares you half to death. "And when she give you a bath, man—she rub you till you *bleed*." They're really laughin' now.

But my grandma's not laughin'. She grabs me by the ear and takes me out back and smacks my ass hard. "You making fun of your family, Bernie? In front of all these people!"

"No, ma'am."

"You think it's right to tell the family business?"

"No, ma'am. I'm sorry, ma'am. I was just jokin'."

"Ain't no joke! You go out there and apologize right now!"

She follows me out, and I can't help myself. I'm doing it again—in my grandpa's deep snort: "Who done ate up all the corn bread? How many times I got to tell you, woman—you never make enough corn bread!"

Yank! She's got me by the ear again. Drags me outside and up the stairs. It hurts like hell, but I don't care because everybody's laughin'. They're laughin' so hard I can hear them all the way up in my room. Pull on my ear all you want, Grandma—it's worth it.

"So," my grandpa asked me later that evening, circling me, "you think I say things four times? I don't say things four times. Have I ever said anything four times?"

"Never, sir," I said, bowing my head. "I was just makin' up stories."

He told me he was gonna whup my ass—*four* times he told me—but he didn't whup my ass. He thought it was funny, too. He didn't say so, of course, but I heard them talking about it later that night in the kitchen. My grandma's laughin' as she tells it again, saying, "That Bern, he too funny! Had 'em rolling in the aisles."

My mama sayin', "Boy told me he wanted to be a comedian. He gonna do it, too. Beanie gonna surprise everyone. Big things in store for my son."

Following Sunday, people still talking about it. Visitin' deacon takes me aside, says, "You got the power of speech, Bern. Ought to sign up for Young Deacon Night. Lord Almighty's callin' you to the pulpit, he be callin' you, and he be callin' *loud*."

Motherfucker. When I get old, if I say things four times, please shoot me.

I tell the deacon: "I don't think I got time, sir. Mama wants me to do better in school. I'm near the bottom of my class."

The deacon thinks on this for a moment. "Maybe she got a point, Bern. Maybe you ain't smart enough to serve the Lord."

Black people: They tell it like it is.

School, I was funny, too. I couldn't help myself. I liked making people laugh. Teachers call my mama to complain. Principal talks to me. Minister. Coach. School *janitor*, even. Everybody tryin' to talk sense into Bernard, but Bernard ain't listenin'.

Miss Ford says, "Why you accept failure, Bernie? Are you afraid to succeed? You're better than this. You got smarts to spare."

"I'm sorry," I say.

"You want to be funny?" she says.

"I guess," I say.

"Okay," she says. "Friday afternoon, you can be funny. You get up in front of the class and be funny."

I thought she was kidding, but she wasn't kidding. She wanted to see me fail. She wanted to embarrass me so I'd fly right. "Everybody, put up your books," she said. "Bernie gonna tell a story."

And that's what I did. I got up there and told a story, and everybody listened. It was about a man who had all the water in the world, and it was hotter than hell out, like maybe a thousand degrees, and he wouldn't give anyone even a little sip. Not all my stories were funny. Some of them were just stories.

When I was done, the teacher couldn't believe it. "Bernie," she asked me—and the class was listening, everybody nice and quiet, "where'd that story come from?"

"I don't know," I said. "Inside."

"You made that story up?"

"Yes, ma'am."

"By yourself?"

"Yes, ma'am."

"I want you to write it down for me."

I went home that night and tried to write it down, but I couldn't do it. It didn't work that way. Stories came out of me when I opened my mouth, not when I was sitting in front of my blue notebook.

I told my teacher how it was.

"Okay," she said. "Never mind about the writing. If you behave yourself, you can tell stories every Friday."

And that's what I did. Every Friday I'd get up in front of the class and tell stories. Kids lived for that. I ain't lyin'. I'd be up there tellin' crazy stories, anything that popped into my head. I'd tell them stories I made up, like the one about the man who lived right outside my window, only an inch tall, named Li'l Bit. Or I'd tell them things from real life: the way my grandpa made up words, say, or the way my grandma's feet spilled out of her shoes like big fat sausages. I told them about all the got-damn beans at our house—seventeen kinda beans—and I said our house was fulla gas.

Got to a point where the teacher's using me to keep order. "You kids keep making noise, Bernie won't be telling his Friday story." That made them toe the line. It was magic. I was just a kid, but I felt the power in stories.

In the schoolyard, big kids comin' at me now. "You think you funny, spooky juice? I don't think you funny."

I'd tell the big kids the story about the visiting deacon: "Lord be callin' you to the pulpit, Bern!" Voice rolling like thunder. "He be callin' you *loud!*"

Hear them laughin'. Feels good. Better than getting beat the hell up. Feels good to be popular. We all want to be loved. And some people, well—they need it more than others. Some people *hungry* for it. And I might as well admit it here and now: I used to be one of those people. At home, phone would ring, I'd jump to my feet: "That for me?" Mail come, I'd run over to see if anyone's writin' little Bern. Someone knockin' out front, I'd race my big brother to the door.

Grandma says, "Bern, there's gonna come a day when the phone rings and you won't want to answer it. The doorbell rings and you'll look through the peephole and creep off and hide. Mail comes and you'll let it pile up.

"By the time you die," she went on, "two million people will have passed through your life. And maybe three or four of them will still be by your side."

I didn't have a clue what she was talking about. But I do now.

"YOU'LL BE SCARED, SON. BUT THAT'S THE WAY IT IS. YOU HAVE TO MEET *ALL* THE CHALLENGES, BIG AND SMALL. BECAUSE HOW YOU START IS HOW YOU FINISH."

02

I MAY WEEP, NOT BUT I'M GOING TO SUFFER

I'm a born fighter. I ain't lyin'.

Take sports. I *loved* sports. Every chance I had, I'd be out in the park, tearing up the courts. Like every kid in the neighborhood, I thought sports was my ticket out of the ghetto. But I must've been the only one who thought so.

You remember how it is when you're in the schoolyard and they're picking sides? Well, I was always about the last to get picked. You'd be lining up, hearing the names. Bobby. Ray. Munson. Pookie.

You're waitin' to hear yours and it don't come. And when it finally *do* come, some of the guys whine: "Shit. Why we gotta get Bern? That nigger can't play ball."

I didn't whine, though. I never cranked or moaned. I gave it everything I had, even when everything wasn't enough—*especially* when it wasn't enough.

"You keep at it, Bean," my mama told me. "One day you'll be getting picked first. Teams'll be fighting over you."

So maybe I wasn't a *born* fighter. Maybe it helped to have a mama that pushed you along. Whatever, that's the way I am to this day: a fighter. *Never say die.*

My brother, Darryl, was the opposite. I never could figure it out. We had the same mother, and she brought us up exactly the same way, but you'd never know it.

Darryl settled for a lot less than he could've been. He was good-looking, solid, *strong*—a fifth-degree black belt in karate— but there was something wrong inside him. He was full of anger; came off him in waves. Any little thing—POW!—set that boy off.

Still, when you're a little kid, you love your big brother—and I loved Darryl something fierce. He was a *man;* ten years older than me; *powerful.* I wanted him to love me, too.

Now that I think back on it, though, it's like he hated me. Every chance he got, he'd beat me up. Beat me so hard I'd wet my pants. Beat me till he drew blood.

"If you tell Mama," he'd say, "I'm gonna have to kill you."

"Why you want to hurt me?" I'd say. "Why you so mean to me?"

"*Mean?* That ain't nothin', nigger. I'm just getting started."

Something evil inside that boy.

Darryl had a dog in those days, name of Bullet, big, handsome, full-blooded, gum-chewin' German shepherd, so fierce no one could go near him except Darryl. And he was a homosexual. Bullet, I mean. I ain't lyin'. A *gay* dog. Everybody in the neighborhood wanted to get that dog mated with their dog, get them a nice fierce litter. But Bullet, you put him near a bitch, he'd try to kill her. Fangs out and foamin' at the mouth.

He'd see a male dog, though, and nothing could stop him. Knock Darryl down to get to him. Mount that dog right quick, all stuck together, and Darryl would have to throw buckets of water over their sorry asses to cool them down.

Later, at home, Bullet would lie there, his paws all limp, happy, a look in his eye, *That was some fine dog. I liked that boy.*

Sometimes Darryl would give Bullet a stick of gum. And Bullet would chew on that thing, *smack smack smack*, openin' wide when the gum got stuck to his back teeth. I can still see that dog, lying back like a fallen woman, smackin' away.

Darryl went off to Vietnam when I was still in grade school, and I thought for sure I'd never see him again. Mama said it was wrong they'd even taken him: He had asthma so bad as a kid that it damn near killed him. We all prayed for him to survive, and our prayers were answered, but he came back from the war angrier and more evil than ever. He moved out and got a job at the post office.

I missed him more than ever. Can't explain it. Man did nothing but hurt me, physically and emotionally, and I still loved him. What did I know? I was a child. I wanted attention. I looked for

other ways to get it. I'd go into stores, steal candy bars. I'd ditch school. I'd go down to the projects and break windows. I wanted to get caught. I wanted to be *noticed*.

Then, one day, twelve years old, I got noticed good. Went into a store and stole some baseballs, and never made it out the door.

"You little sumbitch," the man said. "I'm going to call your father."

"Ain't got one," I said.

"What's your name, boy? Give me your home phone number."

"No," I said.

"You ain't gonna give me your number?"

"No, sir."

"You want I should call the cops instead?"

I didn't answer. And that's what he did; he called the cops. They came and took me down to the station and I gave them my name and number right quick. They didn't torture me or anything, but I'd watched a lot of TV in my young life—and I knew they would if they had to.

My grandmother said, "Keep him." And she hung up.

Officer told me what she'd done. "You're lying," I said. "I don't believe you."

But he wasn't lying. He put me in a cell and left me there to think on it, and it was hours before I saw him again.

"Let's go, boy."

He unlocked the cell and took me out front, where I found my mama waiting. And Lord, the *look* on her face. The pain. The disappointment. I don't know for sure if that was the moment that changed me, but it was a start. I *never* wanted to see that look again.

"Hey, Mama," I said, mumbling.

She didn't say anything. She looked at me and her eyes watered up and she didn't blink because she didn't want the tears to drop.

"I'm sorry, Mama," I said.

Still nothin'. She turned and made for the door and I hurried after her and followed her into the street. Went to the corner and waited for the bus in silence and rode all the way home in silence.

When we were a half block from home, she stopped and turned to face me. "I may weep," she said, "but I'm not going to suffer."

"Ma'am?"

"If you're bad, Bean, if you go bad on me, son, I won't be there for you. Understand? I'm not coming to get you again."

We never again spoke of that day in my house. There was nothing to say. Sometimes less is more. Worked for me.

//////////////////////////////

In 1972, when I was fourteen, we moved to Ogden Park, a nicer neighborhood. But it's all relative.

'Bout every day, some kids would sidle over and ask me, "You with a gang?"

"No," I'd say. I was cool about it. I wasn't going to mess with that element.

"You too ugly to be with a gang."

"And too black."

I'd laugh and slap my thigh and slur my words and mumble like I was stoned or something. They thought that was cool. They'd say, "Bernie fuuuuucked up, man!" And they laughed right along with me.

But one day they stopped laughing. Kid from school came up to me on the bus, said, "Watch your back, Bernie. They're comin'."

"Who?" I said.

"Who do you think?"

"Fuck them," I said. "I'm not joining."

When the bus came to my stop, everyone went running off in different directions. I didn't know what the hell was going on, until I turned and saw eight guys coming up the street behind me.

As they got closer, they did this crazy signing thing: fists clenched and crossed at the wrists, followed by a smack to the chest.

"What do you want?" I said. I was trying to sound a lot tougher than I felt.

"You," one of them said. "Try to run and I'm gonna shoot you in the back of the head."

Two guys grabbed me by the shirt and led me down the block and into the alley. I could see people scurrying into the shadows like scared rabbits, and I heard them saying, "They got Beanie! They got Beanie!"

There was an abandoned building in the next block, and they dragged me into the basement. They had a desk and everything inside, and I was thinking, What? These motherfuckers got an office?

They did that gang thing again, with the clenched fists and the chest beating. And then the one guy asked me, "You want to be a gangster?"

"No," I said.

"Well, you *gonna* be," he said.

"I don't want to be no gangster," I said.

"Too bad, motherfucker."

He turned and looked at the guys behind me, and they came at me, four of them. And I saw how one of them was this kid from school, Edward. He was looking at me like he felt bad, but the others were already drilling me. Fists coming at me hard. And Edward's saying, "Don't hit him in the face!"

But it was too late. They'd hit me in the face a half-dozen times already, and everywhere else for good measure. And I'm falling and getting up and getting hit again, so dizzy and disoriented I couldn't see to run.

Then the lead guy told them to stop, and I got back to my feet and tried to get my bearings. I didn't feel any pain, but I was furious. I was hot all over. Hot on my face, too. A fire in my chest like a storm was comin'.

"You wanna join now, nigger?"

I turned to look at him. It was the lead guy again, at the desk. "No," I said.

BANG! One of them sumbitches hit me in the back with a two-by-four. I fell to my knees and got up quick. I was hurting now. Too many of these guys. Didn't have a chance in hell.

"Represent, motherfucker!" the guy behind the desk said.

And I did it. I'm ashamed to tell you, but I did it. I clenched my fists and crossed my arms at the wrists and smacked my fists against my chest.

"You *in*, nigger. With us all the way," he said. And they're grinning like I'm supposed to be celebrating or something, and I walked toward the exit and they moved aside and let me go.

I went home. I walked through the door and I could hear my mother and grandmother in the kitchen, getting dinner ready. I didn't go in like I usually did. Instead, I hollered hello and went to the living room and looked out the window. I could see the bangers coming down the street now, crossing into the park, where the playground was. I could see them through the trees, sitting around, horsing around, looking for trouble. I didn't move for an hour. I just sat there and stared.

Then my mother came into the living room, surprised to find me there. "Beanie! You finished your homework already, son?"

I turned to look at her.

"Good God, boy," she said. "What happened to your face?"

I didn't say nothin'.

"I'm going to ask you one more time," she said.

"I got tackled and my football helmet fell off," I said. "Got dragged hard along the ground."

She knew I was lying. "Come to dinner," she said.

"I'm not hungry."

"That's no excuse. In this house, we eat dinner together."

I followed her into the kitchen, but I was still thinking about those guys. My grandmother looked at my face and jumped and went to say something, but my mother stopped her with a look. My grandfather wasn't there; must've been on the late shift. I didn't say much at dinner. They talked about regular things in their day, and about the price of groceries.

After dinner, I went upstairs to my room and tried to do my homework. But I couldn't think about anything except those guys. Then there was a knock at the door, and my mother came inside.

"Beanie," she said, "let me tell you something. In life, there's always going to be trials and tribulations. And one day, one of those trials is going to represent such a challenge that you'll think you can't possibly meet it. You'll be scared, son. But that's the way it is. You have to meet *all* the challenges, big and small. Because how you start is how you finish." Then she patted my hand and left the room and closed the door behind her.

I lay in bed that night, tossing and turning. Didn't get a wink of sleep. In the morning, I got up before everyone else and took a butter knife from the kitchen and went to look for my grandfather's tools. I took a file and filed it down till it was sharp as a needle, then I found some black electrician's tape and taped the knife to the inside of my right hand. I went and got my books and used them to cover up the knife in my hand and stepped into the kitchen. My grandmother and mother were there. They turned to look at me.

"I'm going to school," I said.

"Ain't you hungry?"

"No."

They could see that things were still very wrong. My grandma said, "Beanie, you be a man today, hear?"

"Yes, ma'am," I said, and left the house.

On my way down the street, I saw Edward—the kid from school, the one who'd told them not to hit me in the face—waiting for me near the bus stop. He looked worried.

"Bernie—"

"Don't say nothin'," I said, cutting him off. I didn't want anything from him. "I got no beef with you. But I'm telling you right now: I'm not running with no fucking gang. And I'm going to kill the next motherfucker that comes up on me." I showed him the shiv, taped to my hand.

"Don't worry," he said. "I'll take care of it." And he ran off to tell the others to leave me the hell alone. "Bernie is *out*," he said.

After school, I went to the park, to play ball, try to improve my game, and the guys who'd beat me up the day before walked right past me, didn't say nothin' directly. They sat and watched me play for a while, making fun. But then the ball went off to one side, and I went to get it, and the lead guy got right in my face. "I hear you think you too good for the gang?" he said.

POW! I hit him smack in the mouth, and again—POW, right quick—a left hook that knocked him down. But suddenly the rest of them were on me—too many to handle—so I threw a few more punches and turned and ran. I was flyin', movin' like lightning, and as I reached the sidewalk I almost collided with my big brother, Darryl.

"Hey," he said, grabbing me. "Why you runnin'?"

And he turned around and saw these five guys coming toward us, and he looked dead at 'em—and they froze the hell up. All five of them. Stopped on a dime. Looked *scared*. And Darryl said, "You guys fuckin' with my brother?"

And the one guy—he was like shakin'—the one guy said, "We—we didn't know he was your brother, man."

"He's my brother all right. And if you want to fight him, he'll take you. But he'll take you one at a time."

Man, these guys were *nervous*. Darryl was known in the neighborhood. Didn't take shit from no one. He was mean and crazy. Kids called him Karate. *Nobody* messed with Darryl.

Now the guys were trying to back down; telling Darryl that we didn't have to fight; that maybe we should forget the whole thing; and how sorry they was. But I looked at Darryl. I *wanted* to fight. And he walked us back into the park and I took the leader on, one-on-one. And I'll tell you: I tore his ass up good.

"Represent *this*, motherfucker," I said. The sumbitch was scared to get up.

And my brother said, "It's over, see? If any of you bother my brother again, you better shoot me in the back of the head, because I'm coming for you."

Darryl and I left the park and he walked me to the corner. He didn't say nothin'. Didn't tell me I fought good or anything. He must've figured I knew I'd fought good and that I must've felt that inside me. It wasn't for him to judge my fighting, anyway. It was for me. And then he said, "See ya." Like it was nothing. And off he went down the street.

"Where you goin'?" I said, hungerin' for him.

"Practice," he said, not even turning to face me. "I got me a new band."

"Band?" I hollered. I didn't know he had a band.

When I got home, I went into the kitchen to get a glass of water. My mama said, "How you doin', Bean?"

"Good," I said.

"You know," she said, "funny thing about life. Most people, they got a problem, they crank and moan. What they don't think about is fixin' it themselves."

I didn't say nothin'. I just listened.

"But if you fix it yourself, you're going to find that there's always going to be one person in the world you can turn to. *You.*"

"Yes, ma'am."

"One person you can depend on."

"Yes, ma'am."

"Thinking is something people don't do enough of, Bean. It's a strong man that knows how to sit in the dark and be alone with his thoughts."

"I'm trying, Mama."

She had it down. *Suffering is the best teacher of all. If you want people to respect you, you got to respect yourself first. Life don't change unless you make it change.*

Mac-isms, I call 'em. They're with me to this day. I *use* them to this day.

Later that same evening, before dinner, my grandma came into my room, clutching her worn Bible. "Read to me, son," she said. When I was a kid, she used to read to me all the time, but now her cataracts were so bad she could hardly see. Still, she knew that Bible inside out. Every last detail: who did what where and who was who's brother and that bit with the burning bush and so on and so forth. Someone had sure drummed that book into her head when she was a little girl.

"Men are weak, son," she said. "They like sheep. They followers. And usually they follow the wrong man down the wrong road."

"Yes, ma'am."

"You remember your seven deadlies?"

"Yes, ma'am."

"Tell them to me," she said, and she closed her cloudy eyes to listen.

"Pride, greed, lust, anger, envy, gluttony, and sloth."

"Gives me the shivers just to think on it, son. Lot of wickedness in this world. Takes a strong man to find the right path and follow it."

We went down to dinner, and my grandfather was already waiting at the table. He looked at me like he wanted to slap me up the side of the head.

"Messing with that bad element!" he said. "Pass them there bread rolls, boy! You never gonna learn."

He didn't mean anything by it. He just didn't know how to spin things the way my mother and grandmother did. There wasn't any lesson in it—which was odd, seeing how he was a deacon. But it was just the way he was. Wasn't warm or affectionate, either. Never once put his arms around me; never once told me he loved me. But that had power, too. His attitude shaped me, too. He was there for a reason.

I passed him the rolls.

"When you gonna start using your head, boy? You know what that even mean—*thinkin'*?" Didn't bother me. He could call me a damn fool if he wanted to. I'd been hearing shit like that my whole life. *You stupid skinny ugly and your hair nappy, too.* But so what? Take it in; only makes you stronger. And at the end of the day, you're gonna need your strength. At the end of the day, you in this fight by yourself.

A few days later, a Saturday, early evening, Darryl swung by and picked me up and took me to the Regal Theatre. It was Chicago's answer to the Apollo, and it was as fine a club as I'd ever seen. 'Course, it was the *only* club I'd ever seen.

"You gonna hear me croon," Darryl said, and it was all he said.

He had me help him carry some stuff inside, then found a place for me to sit, way in back. I had a pretty good view of the stage, and when Darryl came out with his band I grinned and clapped along with everyone else. He had a nice voice, my brother, and I enjoyed listening to him, but he was just the opening act. It's the main event that has stayed with me to this day—and the main

event was none other than Moms Mabley, the legendary comedi-enne, in what might have been one of her last performances ever. She hobbled onto the stage, popped out her teeth, slapped a hair net on her head—and *damn* if she didn't turn into another person. It was magic. She had the whole place roaring with laughter, and I was roaring louder than them all.

"Have a good time?" Darryl asked me on the way home.

"Great," I said.

He never told me why he'd come by the house to take me to the Regal. Never talked about the neighborhood gangs or the fight in the park. Never asked me whether anyone had bothered me since, which they hadn't. Maybe it was a family thing. We were taught not to crank and moan. We were taught to let things sit deep inside us and figure them out for ourselves. Fact is, nobody really cares about your little problems. And you know for damn sure that nobody wants to hear you whine.

After that, I started going to the Regal by myself. They got to know me there. I ran little jobs for them. Helped move stuff around. Went to the store for cigarettes if someone ran out, or coffee, or ice cream when it was hot. And in between I watched the shows.

The music and dancing were pretty good, but for me the main attraction was the comedians. Whenever they brought one out, I held my breath during the entire set. That's the way it felt, anyway. I'd watch the way they moved. The way they timed things. The lit-tle pauses here and there. The way this one cocked his head to the left just before he told the punch line.

One night, Pigmeat Markham was on. He was an old-timer, like Moms Mabley, and he'd come up through the Chitlin Circuit, same as her. But you could see the big, raucous man he used to be, the power he held when he did the bit that made him famous: *Here Come Da Judge.*

For me, a kid, to see that, not breathing the whole time he was on—it was something special. This was comedy, this was living history, and it was powerful.

////////////////////////

Sometimes Darryl would come for Sunday dinner with his best friend, Uncle Mitch, but mostly he wouldn't talk to me, and he hardly ever even looked at me. He and Mitch were inseparable, and they were two of a kind: men who quit their dreams. Darryl was gifted. Like I said, that boy could sing. For a time, after that first band broke up, he was hooked up with the Chi-Lites, but he couldn't get along. Then he tried to start another group, and the same thing happened all over again: Seemed like Darryl fought with *everyone.*

After dinner, when he and Uncle Mitch was gone, the adults would talk about them. *That Darryl—boy is headstrong. He don't know how to listen, don't know how to get along.*

Uncle Mitch had his own gifts, and his own troubles, too. He was maybe one of the best natural-born ballplayers in the whole South Side, but he let it slip away. *That boy don't focus,* they'd be saying in the kitchen. *He let the bad element deteriorate his goals. All that God-given talent, and he don't have the guts or the heart to make use of it.*

Thinking back on it now, I know they were saying this for my benefit. And it worked. *Eventually.*

"Darryl has a lot of his father in him," my aunt Evelyn told me. "You're more like your mama."

Maybe she was right, but I wouldn't have known—I never really knew my father. He only came to see me three, four times my whole life. His name was Bernard Jeffrey Harrison, but I took my mother's name, McCullough, since he was a stranger to me.

Early one Saturday, I heard my mother on the phone, talking like she's tense about something, keeping it under her breath. When she hangs up, she comes lookin' for me, tells me, "Put your little suit on. You father's comin' to see you."

"My father?"

"That was him on the phone. He's gonna take you for ice cream. Get dressed right quick."

I had this little suit I only wore Sundays, to church, with my starchy shirt, and I put it on and went and sat in the living room, my hands quiet in my lap, my eyes glued to the front door. I didn't move a muscle. *My daddy was coming! My daddy loved me! My daddy was gonna take me out for treats!*

Hours go by. Three o'clock, four, five, six. No Daddy. My mother comes in from time to time, looks at me, feelin' for me, getting angry and trying hard to hide it. Finally, she can't take it anymore. She tells me to change out of my little suit. "Your daddy's not comin', Beanie." I start crying. I tell her she's wrong, I tell her he's coming for sure. "I'm *not* changin'!" I want my daddy to see me in my Sunday best.

She just shakes her head, all brokenhearted for me, says we're out of milk. She's going to the store, she tells me. "Be right back."

I sit there, wipin' the tears, and when I look up I hear something at the door. I think it's my mama; that maybe she forgot something. But it's not. It's my daddy. I'm grinning so hard my jaw aches. I about float right off that couch. My daddy smiles down at me.

"Well, well, well. Can this really be Bernard Junior?"

Big man. Six-three, two hundred–some pounds. He didn't hug me or nothin', like maybe he didn't know how, so I jumped up and grabbed him around the waist till my arms were achin'. He was laughin', patting me on the head like I'm a little dog.

"I thought you wasn't coming!" I say.

"Me? Not comin'? You really think I'd let you down?"

"No, sir."

"I know I'm late, son," he says. "But there's a reason I'm late." He holds up a set of keys and jiggles them and takes me over to the window. I look outside. Car out there, right in front. "See that car? That your car."

"*My* car?"

"Sure is. I bought that car for you, son."

I'm ten years old. Maybe he jumped the gun a little. But I'm not thinking about that. I'm so excited. *My daddy bought me a car!*

"Only one thing, see," my father says, and he crouches low, gets right in my face, big smile. "I spent all my money on the car. So I don't have money for gas. And without gas money, I can't take you nowhere."

"I got some money, Daddy!"

"You do?"

"I've been saving and saving!"

I did chores around the neighborhood. I helped the old lady across the street with her garbage. I used to walk my neighbor's dog. I shoveled snow. Washed cars.

I'd been planning on getting a bike, but this was different. This was for my daddy. This was *important*. I went and got my piggy bank. There was forty-seven dollars inside. My daddy's beamin', and I feel so *proud* I'm like floating all over again. But just then my mama walks in with her carton of milk, and she can't believe her eyes.

"What's going on here?" she says.

I see my daddy take the money and shove it deep into the pocket of his pants. "Nothin'," he says. "The boy and I are talkin'."

"Are you taking Bernie's money?"

He doesn't answer. Instead, he moves toward the door. She goes to stop him and he shoves her and she falls backward to the floor. Milk goes flying. I run over and punch him in the legs. "You

hit my mama!" He pushes me away and moves toward the door again and my mama's back on her feet, moving fast. He whips around and slams her with his arm, right up near the throat, and she hits the wall.

"Mama!"

I don't know which way to turn, but now he's gone and my mama's on the floor and I run to her side. "Mama, Mama! Mama, you all right?"

She takes me in her arms. Holds me there, the two of us on the floor. "Beanie," she says, softlike, right in my ear. "I wish you hadn't seen such a thing, son. I wish you'd never seen such a thing." After that, she didn't say nothin' more. She just cried softly and held me for a long, long time. Rocked me. We held and rocked each other.

"THINK BEFORE YOU SPEAK, SON. DON'T JUST SAY EVERY LITTLE THING THAT POPS INTO YOUR HEAD. YOU GOT TO LEARN TO GO DOWN IN THE DARK AND BE ALONE WITH YOUR THOUGHTS."

03

SHE WAS GOING TO EDUCATE ME IF IT KILLED HER

When I was in the eighth grade, I got home one day and walked in and saw my mother dressing. She had a sliding door on her room, and it was open, and she hadn't heard me coming. When she looked up, she saw me there, my mouth hangin' open, my eyes big as spotlights. I was looking at her chest. One of her breasts was gone. There was a huge scar in its place, like a square.

She slid the door shut. I walked over and slid it open again.

"Mama, what's wrong? What happened to you?"

"Close the door, Beanie."

I couldn't move.

"Did you hear what I said, son? Close the door."

I backed out, dazed, and did as I was told. I went into the kitchen, looking for my grandma. She was sitting there, her glasses on her nose.

"Grandma," I said. "What's wrong with Mama? She . . . her breast . . . she *cut*."

I was crying by now. I was trying to hold it back, but I couldn't help it. My whole body was shaking.

"Wipe your tears, boy. Be strong."

"But what's wrong with her? She sick?"

"Go ask your mother, Bernard."

I went back. Knocked on her door.

"Come in," Mama said. She was finished dressing.

"Mama," I said. "I have to ask you something."

"What is it, Beanie?" She was acting like nothing happened.

"What's wrong with your chest?"

"None of your business," she said. She said it gentle, but I knew she meant it. She gave me that look of hers—the one that went right through you—and fetched her bag. She worked for the Evangelical Hospital. She was a supervisor, in charge of personnel, and she was working lots of overtime back then. "Now go do your homework. And clean up your room. And I'll see you when I get home." She kissed me on the forehead, gave me a little pat on

the backside, and moved toward the front door. "Mother!" she hollered toward the kitchen. "I'm gone." And off she went.

I went back to the kitchen and looked at my grandmother. She could see the hurt on my face, but she wouldn't tell me nothin'. People in my family keep things to themselves.

Sometimes, late in the day, after my mother left for work, I'd sneak off and hook up with my friends. I knew every inch of my neighborhood, all the way from 74th and State to 59th and Loomis. I knew every yard and every alley and every boarded-up house. I even knew all the dogs, and I knew which dogs could jump what fence. You *had* to know this shit, because there was always guys looking for trouble, guys who got their kicks crackin' heads.

There was this one old building at 67th and Morgan where my friends and I liked to hang. People lived upstairs, but the basement was abandoned. Landlord'd be puttin' locks on the door, and we just jimmied them till he gave up—me and my friend Morris Fraser. *Big Nigger*, we called him. He was on his way to six-four and 275 pounds, with not an ounce of fat on him. He and Almon Vanado and Billy Staples and Morris Allen were my best friends growin' up. Billy didn't make it—that's a whole 'nother story—but Big Nigger and A.V. are my best friends to this day. Two of a kind. Lions with hearts of gold. Self-made men.

We dragged a couple of couches into that there basement. Old, broken-down chairs. One time, we found a TV that still got a couple of channels. Used to bring girls down, too. We played spin the bottle, truth or dare—stuff like that. But we kept it clean. No drugs, neither. I only tried drugs once in my life. I ain't lyin'. Somebody gave me a hit of marijuana that must've been laced with angel dust. I thought my heart was going to pop the fuck out of my chest. Never touched that shit again.

Plus I'd seen what wrong living could do to people. Crack-addled losers nodding off in alleyways. Dead junkies getting

wheeled into waiting ambulances. Brothers knifing each other over nothing.

Man, all those wasted lives! Was a winehead on our street, Zachary. Couple of drinks, he'd get up and sing—voice so sweet it'd bring tears to your eyes. Couple more drinks, he couldn't even stand. He'd be sitting there, mumbling, drooling, talkin' to the ghost beside him: "Give it back, nigger! Let's see that bottle! Don't drink all of it, got-damn you!"

My mother would see things like that, she'd always find the lesson in it. "What a shame," she would say. "We know where that man's going to end up, don't we, Beanie?"

Spitting venom, I called it. These stories she told. It was her way of educating me. Any little thing, she'd run with it. The couple across the street, fightin': "That's no way to treat someone you love." The girl down the block, dressed like a whore: "We know she gonna make a big success of her life for sure!" Men going at each other with broken beer bottles: "Let your emotions get the best of you, Bean, and you might find yourself doing something you'll regret for the rest of your days."

Everything was fodder. She was going to educate me if it killed her.

"Don't want you going to the park after dark no more," she'd say. "Bad element takin' over the park."

"Everybody else goin'," I'd say.

POP! She'd whack me up the side of the head. There were no excuses in that house. No blame, neither. You took responsibility. Three people livin' there, busy shapin' me: Mary McCullough, Lorraine McCullough, Thurman McCullough.

"You think that makes it right? That everybody else goin'?"

"No, ma'am."

"It *don't* make it right. And if you took a moment to think about it, you'd see how it don't."

"Yes, ma'am," I mumbled.

"Think before you speak, son. Don't just say every little thing that pops into your head. You got to learn to go down in the dark and be alone with your thoughts."

"Uh-huh."

"What? You feeling sorry for yourself now?"

"No," I'd say, but I was.

"Well, stop it. Self-pity is self–brought on."

I didn't always like this *shapin' Beanie* business. I'd pout and look away and smack my lips like there was something sour in my mouth.

"Don't you smack at me, boy!" she'd say, and I'd hang my head. "And you *look* at me when I talk to you." I'd look up, takin' my sweet-ass time. And even when I was angry, I'd think, *My mother is a beautiful woman.*

"Are you listenin', son?"

"Yes, ma'am."

"What you been listenin' to?"

"You."

"Well, that's good," she said. "For *now.* But pretty soon I'm gonna want you to start listenin', to you."

"Huh?"

"You'll figure it out."

I did figure it out. But it was a long time comin'.

When I think back on it, I think about all the good things I had, not the hardships. I had the luxury of being a little boy, and that's really something. Lots of kids today don't have that luxury. Grow up too fast. Don't have time to have their kid thoughts and dream their kid dreams and use their imagination. Everything is *hurry hurry hurry.*

But in our house they knew what they was doing. There was rules and regulations, and you best followed them if you didn't want your ass whupped. You in charge of the garbage, well, you

better damn sure *be* in charge of it. You had homework to finish, get it finished, child.

At our house, dinners was important, too. We had dinner as a family whenever possible. Everyone together, heads bowed, saying grace. Adults served first.

After, maybe you could do a little visitin' nearby, but you had to be back by eight o'clock, when the streetlights came on, and in the bath by nine. And don't use up all the hot water, either!

Ten o'clock, lights out. With maybe an extra hour on weekends.

Sundays there was church, and no ball playing or music afterward. Sundays was a day of giving, a day to think of others. Sundays you went out and was a good Christian neighbor, whether you felt like it or not. You delivered food to those that needed it. Ran errands when errands needed running. Checked to see how the old lady down the street was getting along.

There was order in our house. Direction. Discipline. But a kid was still a kid, and they respected that. When a kid was around, you didn't discuss no adult business. A kid didn't have to know that the bills weren't getting paid, or that someone was having trouble at work. Life was going to creep up on that kid soon enough, with all its hardships, and there was no need to hurry it along.

That's what I remember when I think about my childhood. That I grew up at the right pace. That my family allowed me to be a little boy and then a teenager, and made sure I became a proper man.

///////////////////////

In 1973, when I was fifteen years old, my mama said we were going visiting. It was a Saturday. I didn't feel like going. "Who we visitin'?" I asked.

"Never you mind," she said. "Just hurry up and get dressed."

We left the house, and she was breathing hard by the time we got to the corner. She was real sickly by then, and thin as a rake.

"You all right?" I asked. She was leaning against me for support.

"Never better," she said.

She took me to 105th and Eberhardt, still not telling me what she was up to. When we got there, she walked me down the block, slowly, and stopped in front of a real nice house. "Now ain't that a lovely house?" she said.

It sure was. It had two stories, a front yard, a backyard, and a wooden fence, fresh-painted. It looked like something from *Leave It to Beaver*.

"Real nice," I said.

"Well," she said. "It's ours." She said it matter-of-fact, no emotion, nothing.

"Say what?"

"This is our new home, Bean. We move in next week."

I couldn't believe it. She hadn't said a word about this to any of us. It had been Mama's little secret. Even as she was fading away, Mama had been working overtime to take care of her family. And even now she didn't want to make a fuss.

We moved in a week later. We felt *rich*. We felt like landed gentry.

We got a real house here, motherfucker. We like regular people. We *somebody*.

'Course, it took a while to get used to the *quiet*. I missed the ruckus on the street, the loud voices and the fighting and the gunfire. This was like the suburbs. I could hear the got-damn *crickets*, and the stars were so bright they kept me up at night.

I was at CVS at the time, Chicago Vocational High School, over on 87th and Jeffrey. That's another thing my mother had arranged. She didn't want me going to Parker, and I couldn't get into CVS without taking a test. So I took the test and passed. That's what they told me, anyway. But to this day I know I couldn't have

passed. I didn't even finish the test. I gave up in the middle. So it's clear my mama pulled some strings to get me in.

After school and on weekends I usually hung with Billy Staples. He lived one block over, and he was so good looking that the girls were always following us around. We'd play sports, mostly, with the girls watching Billy from the sidelines, and maybe go to the lake for a soda after. From time to time Billy would pull out a joint, but he knew I didn't like it. We used to fight about that shit, but we fought with love. Billy was like a brother to me, a *real* brother.

We had another friend back then, James Spann, couple of years older, liked living on the edge. He was slick and smooth, kind of pimpy, and he kept me around because I was solid: six feet and almost 180. You didn't want to be messing with Bernie Mac, believe me.

Spann knew people. He'd take us to parties and stuff. We'd swing by Billy's place and pick him up and off we'd go. And the minute we walked in the door, the women were all over Billy. It's like Spann planned it that way. I'd be standing there with my drink and Spann would come over and tell me that he had to run an errand, and we'd leave Billy to his women and go off for a short ride. I was pretty naïve back then, a gullible kid, but I knew Spann was dealing drugs; I knew he was only dragging me along because I was big and scary looking, and because I could look mean if I had to.

Still, I started getting uncomfortable with these little side trips.

"I ain't getting out of the car," I'd say. "This is bullshit."

"That's cool," he said. "I know you'll come if I holler."

"Don't be so sure," I said.

He was slick, that Spann. It was always "a little stop on the way to Billy's"—only the little stop was three miles in the wrong direction.

One night we pulled up outside this badass building. I told Spann he shouldn't go in. "I have a bad feeling about this place," I said.

"You one of those people can see into the future now?" he said. He was grinning his big grin.

"No," I said. "I just don't like it."

Spann ignored me. He reached under the seat and handed me a gun.

"What the fuck you givin' me that for?" I asked.

"Just hold it," he said. "And if there's any trouble, use it."

"I ain't using that got-damn gun, Spann," I said. But he was already out of the car and heading for the building. I picked up the gun. Felt its weight in my hand.

A moment later, WHOOSH! Spann's coming out of the building, running for his got-damn life. He jumps behind the wheel and starts the car and pulls out, and two guys burst onto the sidewalk, shooting. *POP POP, POP POP POP.*

Spann's yelling at me to shoot back, and I didn't want to. But I turned in my seat and fired twice into the air. I didn't hit no one, of course. I wasn't aiming. If I'd hit anyone, I probably wouldn't be here today.

"Motherfuckers!" Spann was saying. "Can't trust nobody nowadays!"

I looked over at Spann and didn't say nothing. But at that moment I knew something for damn sure: It was over between us.

Takes a strong man to find the right path and follow it.

I was going down the wrong path. I didn't need friends like Spann. No hard feelings, brother. But it was time to move on.

///////////////////////////////

My mama was always tired in those days, but she never cranked or whined. We'd have dinner and sit in front of the TV after. Sometimes she'd nod off, and we'd cover her up and let her lie there, and we'd watch shows well into the night. I couldn't get enough TV. I watched everything. *Lost in Space. Gunsmoke.*

Voyage to the Bottom of the Sea. The Fugitive. Marcus Welby. Perry Mason. The Twilight Zone.

I saw television as a form of higher education. I learned all about structure from those shows. Structure and pacing and plot. I learned the difference between suspense and surprise. I learned how to make stories *unfold*. I tried to beat Perry Mason at his own game, and a lot of times I did pretty well.

But comedy and comedians had a special place in my heart. I used to study Bill Cosby, check out his moves, practice them in front of the mirror. Man was smooth. Even white people liked him. He had what they called "crossover appeal." Of course, back then, I had no idea what that meant. My world was black. Hell, I didn't even *know* any white people.

Flip Wilson had a show, too, starting back in 1970. And Redd Foxx got his show in '72, after thirty years of standup. Redd had a real edge to him. I liked him more than either Cosby or Flip. Redd was raw. Redd told it like it was, took chances.

Many years later, I actually met Redd Foxx, and he gave me a piece of advice that helped put my career on the right track. But I'm getting ahead of myself; let's get back to my mother.

Like I said, she was sick. Within a year of moving into the new house, she got too sick to work. One day I happened to be coming down the street just as she was getting home with my aunt Evelyn, and I saw from afar the way Aunt Evelyn had to help her out of the car. She was so weak she couldn't lift her own legs. I ran over to see if I could help, but she was on her feet by now, leaning on Aunt Evelyn for support, and she acted like it was nothing and disappeared into the house. Aunt Evelyn gave me a sorrowful look, then followed after her, and that's when it finally hit me. I walked off, thinking terrible thoughts, and by the time I reached the park I was in tears.

Billy Staples saw me and hurried over. "Bernie," he said, "what the hell's wrong with you, man?"

"I think my mother's dying," I said.

In a matter of weeks, my mother had turned into a skeleton. I don't think she weighed more than ninety pounds. But still she didn't crank or moan. Weak as she was, she tried to make herself useful. She'd putter around the kitchen, getting dinner together. Or tidy up. Or catch up on the bills.

When the weather was good, she'd sit in the backyard and try to get a little sun.

One day, as she was crossing toward the deck chair, the bathrobe slipped from her shoulders. She had a huge bandage on her back, and the robe caught an edge and pulled it down. I just about died on the spot. Her skin was like paper. It was so thin I could see clear through it, to her beating heart.

She readjusted the tape with one thin arm and lifted the robe back onto her bony shoulders. That's when she saw me standing there, watching her. She looked at me with terrible sorrow. "Go back in the house, son," she said. "Fetch me some water."

I did as I was told. I went and got her a glass of water and took it outside and set it next to her. She had a terrible smell about her in those days. The cancer was eating her up. To this day, I can see her lyin' there, the sun on her thin little shoulders, and I can smell that haunting smell.

"Don't stand there lookin' at me like that, boy," she said. She was weak, but she said it hard and hurt my feelings.

I went inside. My grandpa was just getting off the phone. "That was your father," he said.

"My father? What does he want?"

"He heard how sick your mama is. He wants to see her."

"Why? He think he gonna get something out of her?"

My grandpa didn't answer. I was still hurt, and now I was getting angry.

"That man weren't no father to me," I said.

"Well, that's true," my grandpa said.

"What do you mean?"

"He and your mother, they was never married."

Jesus. I can't even begin to tell you how bad that felt. My parents had never married. I was crushed.

"I don't believe you," I said.

"Go ask your mother," he said.

I was angry-hot inside, but I didn't want to show it. I couldn't ask my mother, the condition she was in. And if it *was* true, you'd think the old bastard would have found a nicer way to tell me.

My father came over later that day, and he spent a few minutes outside, talking to my mama. I watched them from the kitchen window. When he came inside, he smiled at me like he was happy to see me or something.

"How you doin', son?" he said.

I felt like punching him. "How you think?" I said. I didn't even try to hide my anger.

"Why don't you walk me to the bus stop?" he said. "We'll talk."

I nodded. *Sure. Fine.* Suddenly I wanted to go. Suddenly we had something to talk about.

We left the house and made our way down to 103rd Street, and before we'd gone a hundred yards I cut in front of him and made him stop. "I got to ask you something," I said, "and I want you to give it to me straight. Are you married to my mother or not?"

He tilted his head to the side, like he was carrying some terrible burden. "Did she say that?" he asked.

"Never mind what she said," I snapped. "I'm asking you."

"Ask your mother," he said.

"What the fuck you tellin' me to ask my mother for? She's so weak she can hardly talk. I'm asking *you*."

He saw the bus in the distance, approaching, and kept walking. I fell into step beside him, shaking with anger. "You gonna tell me or what?"

"Son, that's not important."

"The fuck it isn't! It's important to *me*."

He turned and grabbed my arm and I pulled away from him. I had to stop myself from hitting him, and it wasn't easy.

"Listen to me," he said, "no matter what you hear tell, I'm still your father, and my blood runs through your veins."

"Get the hell out of here," I said.

He looked at me hard, like I'd hurt his feelings, then turned and hurried off to meet the bus. I watched him go. I saw my father for the punk he was—a no-good coward. But it didn't make me feel any better.

I went back home and my grandfather looked up as I came in.

"What'd he say, son?" he asked.

"Nothing," I said.

"Nothing?"

"I just walked him to his bus."

I went outside to see how my mama was doing. She looked up at me and smiled a sad smile.

"How you doin', Mama?"

She lay there on her chair, studying me for a while. She must have seen something on my face.

"You know, Beanie, as you go through life, you're going to meet all sorts of people. And many of those people, *most* of those people, sometimes your own *blood* even, they don't have your best interests at heart."

"I know that, Mama."

"If you learn to listen, if you really *hear* what's being said, good and bad, you'll see that most times it's got nothing to do with you. At the end of the day, son, the loudest, clearest voice

needs to be the one inside your own self."

That's what my mama had been trying to teach me my whole life. To listen to that voice above all others.

"I love you, Mama," I said.

"I love you too, Beanie."

She closed her eyes and I sat there until she was asleep, then I went inside and called Billy Staples and we met up for a little basketball.

Man, you couldn't stop me that day! I was shooting like it was nothing. The ball felt smooth against my fingertips, and it held solid there—as if my hand was magnetized. It was amazing. I could do no wrong. I could see seven moves ahead of everyone else, and I could see them in slow motion. It was magic. I was in a place I'd never been before. Every time I let that ball go, pure net.

My mother died a few weeks later, in August 1974. It was a school day. I remember going into her room that morning, to say good-bye. She was propped up in her rented hospital bed, her face turned toward the window, and I could hear her talkin' to someone. But there was no one in the room. No one I could see, anyway.

"Who you talkin' to, Mama?"

She looked at me and smiled. It looked like it hurt her to smile. Her face was tight, like a skull. Her lips were dry and cracked. I bent low and kissed her on the lips.

"You have a good day at school, hear?"

"You look so tired, Mama."

She smiled again and turned away, closing her eyes, and I left for school. I wouldn't let myself believe that she was dying. This was my mother, after all, and I was just a little kid. She *had* to be there for me when I got back.

I had choir practice after school that day. By the time I got home, she was gone.

"FUNNY THING ABOUT LIFE EVERYTHING'S A LESSON. GOOD THINGS SHAPE YOU, BUT THE THINGS THAT CAUSE YOU PAIN SHAPE YOU HARDER AND BETTER."

04

MOTHERFUCKIN' CLOWN *SMART* ALL OF A SUDDEN

With my mama gone, things changed at the McCulloughs. She was the quiet center of that household, and suddenly everything felt off balance.

For days and weeks afterward, people were coming by to pay their respects. People from the old neighborhood. People from her place of work. People I'd never seen before. Seemed like everybody in the whole world was missing her, and the world was a colder place without her.

At the funeral, my brother, Darryl, stood by the casket and stared down at her face. He didn't move a muscle the whole time. Just stared. Kinda spooked people.

I was in the front row, with my family, but I didn't feel like crying. Don't ask me why; I just didn't. Everyone was looking at me like there was something wrong with me, so I forced up a few tears and they was all relieved.

I cried later. But it was a long time comin'.

My mother had left a letter making Aunt Evelyn my guardian, but Evelyn wasn't up to the challenge. She was a good woman—don't get me wrong—but she wasn't as strong as she pretended. My mother knew this. In her letter, she tried to give Evelyn confidence. She reminded her that she was a Christian, and that Christians can deal with anything. And she asked her to take good care of me, her little boy.

She wrote the letter on February 3, 1973, two days before she went back to the hospital to see if there was any hope for her at all. "My dearest Evelyn," it began, "words could not express my sincere evaluation of you. That is why I saved this message until the very last days. With meditation and prayer, it was most wise to handle it this way.

"Sometimes you appear to be under such emotional stress, I often wished it could be someone else, just pray for strength and guidance and everything will be ok. . . . You have to be strong and

handle whatever comes, because life plays many tricks and fate intervenes, therefore we have to adjust our life accordingly."

She asked Aunt Evelyn not to try to impress anyone with a fancy funeral, but to keep it "quiet, quick and cheap," and she urged her to "try to understand Bernard, so you too will develop a fine relationship."

That fine relationship never happened, of course, but I was okay with that. My mama had taught me to be strong, and I was gonna be strong. I didn't need nobody. I could take care of myself. Even at the funeral, these people, looking at me all-sorrowful, talking about my terrible loss—I wasn't going to let them get to me. And at school the following week, the kids, looking at me all misty and miserable—I wasn't going to let them get to me, neither.

No, sir. I was *strong*. I was gonna push on. Not look back.

I filled the time with sports—things had changed, like my mama'd predicted: they was picking me *first* now—and doing odd jobs around the neighborhood. I worked at Hillman's Grocery on King Drive, baggin' and stockin' shelves, and helping people get their groceries to their cars. Sometimes, at night, one of the neighbors would come over and ask me to baby-sit, and I was glad to do it. I'd make the kids laugh and put them to bed and watch TV.

At school, I was back to my clowning self in no time. I never cracked a book and I never paid attention to my teachers—except for Miss Ford, of course, who let me tell my Friday stories.

That first Friday after my mother passed, though, she took me aside before class. "I'm sure you don't much feel like entertaining us today," she said.

I took a moment before answering. On some level, she was probably right. I didn't much feel like entertaining anyone. But on another level, she couldn't be more wrong. I had to entertain people. I had to keep myself busy. I didn't want to think about my mother, her cracked lips, her thin shoulders, the way I could see

clear through her skin to her beating heart. I didn't want to think about the empty chair at the kitchen table, or her spot on the couch, and how I couldn't look at them without missing her. I had to keep *active*. I wasn't going to feel sorry for myself. *Self-pity is self-brought on.*

"No, ma'am," I told Miss Ford. "I feel fine." And when the time came, I told a story about a kid who loved basketball so much he taught himself to practice in his dreams.

That kid was me. I loved basketball. I could lose myself in basketball. You find The Zone and nothing can touch you. In The Zone, there's no pain.

I remembered how it was earlier, when I'd be the last to get picked. And how it was now, being the go-to guy. I wondered what would've happened if I'd listened to all them whiny voices: *Oh, man! Not Bernie! That nigger can't play.* That was what my mama meant when she told me to listen to my own self. I was glad I'd listened to my own self. Was the only reason I got good.

You be patient, it comes. And when it comes, you ready.

"Your brother was here earlier," the coach told me one day.

"What do you mean?" I asked. I hadn't seen Darryl since the funeral.

"What do you mean, what do I mean? Your brother was here, checking up on you, see how you gettin' along."

"I didn't see him," I said.

I went home and asked Aunt Evelyn and my grandparents if they'd heard from Darryl, but they never heard from him now. They hadn't seen him since the funeral, either. He never even called. I didn't tell them he'd been by the school, but knowing that he'd been there made me feel good. I thought maybe Darryl really cared about me, and he was just too twisted up inside to say anything. So I went over to his place one day. It was a condo building, real sweet. He rented it. Had two bedrooms and thick carpet on the floor, real clean.

"What the hell you doin' here?" he said. I thought he wasn't going to let me in, but he moved aside and I stepped through and he closed the door.

"I never see you no more," I said.

He didn't say anything. He was ironing a pair of pants. My mama taught us both to iron, and to this day I can iron better than any dry cleaner. I saw Darryl's shirt laid out on the bed, every crease perfect, just waitin' for him to slip into it. A pair of cuff links was sitting next to one sleeve, and his clean socks were by the edge of the bed, next to his shiny shoes.

"You going out?" I asked him.

He didn't say anything. Kept ironing his pants. I looked over at the dresser; there must've been ninety bottles of cologne there, all of them lined up nice and orderly. Darryl was particular about smellin' nice, and I learned from him to be particular about it, too.

"What do you want?" he said finally, but he wouldn't even look at me.

I knew what I wanted. I wanted him to look at me. I wanted him to tell me that he missed Mama, too. I wanted him to say he loved me. I wanted him to be my brother. I wanted him to love me the way I loved him.

"Nothing," I said. "I just came to say hi."

"Well," he said. "You done said it."

I said good-bye and left, and all the way home I kept trying to figure out why I didn't matter to him. My own blood—surely that was worth something? But no. If there was one thing Darryl taught me, it's that you can't depend on anyone—least of all the people you think are close to you.

It reminded me of another of my mother's Mac-isms: "If you want a helping hand, look at the end of your arm."

Funny thing about life. Everything's a lesson. Good things shape you, but the things that cause you pain shape you harder and better.

That summer, I worked for the National Youth Program, picking garbage off the expressways or painting lines down the middle of roads. I got another job building houses. I learned how to lay foundations, how to put up walls, how to lay pipe and wire.

At night I'd go back home in time for dinner, but things had changed there, too. My grandmother wasn't a very good cook. She cooked bland food, and I liked food you could taste—food with garlic and seasoning and spice. Plus Grandma's eyes were failing. Half the time she didn't know what she had in front of her.

"How'd you like your dinner, Bean?"

"It was wonderful, Grandma."

I could have turned and dumped the whole sorry mess in the trash, and she'd be looking right at me and smiling, not seeing it. She was *that* blind.

"Pass the butter," my grandpa said. And I'd pass the butter.

One of the strangest jobs I ever had was at this building not far from school. Guy there, Mr. Walker, he was the super, and the basement was infested with rats. Nobody would go down there, not even Mr. Walker. But I didn't mind. I had this stick, thick as a broom handle, with the end taped up so I could get a good grip on it. And I'd grab me one of those aluminum garbage can lids, big old battered round thing, and make my way into the basement, banging on that damn lid.

Those rats would freak the hell out. I'd go down into the darkness, my eyes adjustin' to the light, and I could see the whole place in motion. Rats everywhere. Rats trying to climb the walls. Rats pouring out of the garbage cans. An *ocean* of rats. You looked at it too long, you got seasick.

Finally I'd stop all my bangin' and just listen. Be a confused rat here and there, lost, still trying to find its way out. But most of them was gone, and I knew I had about three minutes to get that

garbage the hell out of there before they came back. So I *moved,*
brother. Bernie Mac was lightnin'.

Early evening, in good weather, you'd find me in the park,
playing ball with Billy and Big Nigger. James Spann would come
around and watch and tell his pimp stories, but we were wiser
now, and we'd stopped hanging with him. He always talked in the
lowest, crudest way. He'd see a girl and say, "I did her. She a ho."
Man was toxic, and I didn't want to be around him.

One time it rained and I let Spann give me a ride home. He said
we should hang; he was missing me; said there was a party Saturday
and there'd be lots of booty and would I come. We pulled up at my
corner and I told him I'd think about it, but I knew I wasn't going.
I thanked him for the ride and got out and saw Darryl coming out
of the grocery store, a cold soda in his hand.

"How you doing, Dar?" I said to him. It'd been months since I'd
seen him.

Darryl looked down the street. He was watching Spann drive
away. He didn't much like him.

"Why you hangin' out with that guy?" he said.

"I'm not," I said. "He gave me a ride home."

Darryl gave me that crazy look of his, like he used to when we
were younger and he was getting ready to beat me up. Only he
knew he probably couldn't take me now—his little brother was all
grown up—so he turned and walked away.

By the time I got home, my grandma had already heard from
Darryl. The boy had meanness in him, but he still cared about me.

"Your brother just phoned," my grandma said.

"Oh?"

"Said he saw you with some bad element." She meant Spann,
of course. My grandma knew everything about everyone.

"I don't mix with no bad element," I said.

"Son," she said, "I'm going to ask you one time." Blind as she was, she fixed me with that squinty look of hers. "Are you smoking reefer?"

And I looked right back at her, and I said, "No, ma'am. You know I don't do that."

And she came over and hugged me because she knew I wasn't lying.

///////////////////////

One morning, not long after, I was eating my breakfast cereal when Grandpa Thurman walked into the kitchen. "You know what today is, boy?"

"No," I said. But I did.

"A year ago today, son, the Good Lord took your mother."

I didn't say anything. I hadn't dealt with my mother's death, and I wasn't about to start. I kept eating my cereal. My grandpa shook his head like I was a lost cause, and walked on out.

I got to class and started clownin', being my regular self. Miss Walters came in. "Bernie Mac," she said, "pipe down and get in your seat."

"You don't have to worry about me, Miss Walters," I told her. "Someone's coming for me any minute now."

It was a crazy thing to say, and to this day I don't know why I said it or where it came from. But a few minutes later there was a knock at the classroom door and a kid poked his head inside and said I was wanted in the principal's office. All the kids were hooting and whistling and hollering. "You set that up, Bernie Mac!" "How'd you do that, boy?" "Hey, Bean, can you get *me* out of class, too?"

Miss Walters had a look on her face, but she didn't say nothin'; she just watched me go. I made my way down the corridor to the principal's office and found Mitch there. "Uncle Mitch?" I said. "What you doin' here?"

"I need you to come go with me," he said.

"What's up?" I could see something wasn't right.

He looked at me for a long time before answering. "Bern," he said finally. "I need you to get strong all over again."

My heart jumped clear into my throat. "Somethin' happen to my grandma?"

"No," he said, and he took a deep breath. "It's Darryl."

I went weak at the knees. "Darryl," I said. "Is he okay?"

"No, Bern," Mitch said. "Darryl's dead."

The story went like this: Darryl'd been over at a girlfriend's house the night before. I didn't know this girlfriend—Darryl was very secretive, he didn't share much with the family or anyone else. Anyway, the way the girlfriend told it to the police, he woke up after a night of lovemaking and said he had a pain in his chest. She said for Darryl to lie back down, and that she was gonna call for help. But Darryl didn't want help; he said he'd had a pain just like it once before, and that it passed then and it would pass now.

But when he stood up, he felt dizzy, so he sat back on the edge of the bed and put his head between his legs.

"You sure you're okay?" the girlfriend asked him.

Darryl nodded. Took another minute. Then stood up again. And that's when it happened: He gulped air, roared like a lion, then tipped over backward and died.

Two days later I was standing over his casket, just like Darryl had stood over Mama's casket a year earlier. My brother was twenty-seven years old. He hadn't even lived half a life, and even that had been a mystery to me.

I looked over at the mourners. The only ones I knew were Uncle Mitch and a couple of other guys and my own family. The pews were filled with strangers. Maybe his girlfriend was among

them, but I didn't know her, and she didn't come over to introduce herself. I didn't understand. All I could think was, *Who are all these people? Friends of Darryl's? Another family?* How little I knew my brother. How little any of us knew him.

At home, we didn't say much about him. And at school, I acted like it had never happened. Same thing all over again—kids lookin' at me, sorrowful. *Bernie's brother died. Too bad about your brother, Bern.* But I'm shrugging it off and clowning like everything's fine.

But it wasn't fine. I felt more lonesome than I'd felt my whole life. Darryl had never been there for me, true, but he was still my brother. And until the end I guess I hoped we'd find some way to connect.

A few days later, I was leaving work at Hillman's Grocery and found my father outside, waiting for me. He smiled that smile of his, a little off to one side.

"Hey, son." Smooth son of a bitch. "I want to talk to you."

I learned long ago, people like him—just let them talk. They usually hang themselves.

He fell into step beside me. Said he lived not far from there. Wanted to show me his place.

I don't know why I went—I wasn't interested, I was my own man now, I didn't want anything from him—but I guess curiosity got the better of me.

It was a shabby little dump, overlooking an alley. We got inside and he said he'd offer me something to drink, only he didn't have nothin'. Then he got to talkin' about Darryl, shaking his head and pretending he was about to cry.

"It's just the two of us now, son," he said, and he put his hand on my shoulder. I knocked it away.

"What do you want from me?" I said.

"I don't want nothin' from you, boy."

"Sure."

"I want to be here for you, son. That's all. I'm trying to be a father to you."

I didn't know what to say. Stuff like that—even when you know it isn't true—goes through you hard; you feel it strong.

The phone rang. He jumped up like he'd been expecting a call and crossed into the other room and caught it on the second ring. I heard him whispering to some woman—sweet stuff: "Yeah, baby . . . You know it, girl"—and by the time he came back into the room my strong feelings had passed.

"Friend of mine," he said. "Calling about a prayer meetin'."

"Sure," I said.

"Why you so mad at me, son?" he asked, whining.

"Don't call me 'son,'" I said. "I ain't no son of yours. I never want to see you again."

And I let myself out.

A few days later, I was on my way home from school with a bunch of kids when they began to pick on this skinny girl, Margaret. They were poking at her. Pulling her hair. Calling her names. She was a tall, lanky thing, built like a twig, and the only reason they were picking on her is because she was smart.

Margaret broke into a run and the kids chased her down the street, hooting and hollering. I found myself running right along with them, caught up in the craziness, part of the gang. Couple of the guys cut her off in an empty lot and knocked her to the ground, and one of them grabbed her by the shirt and ripped it clean off her body.

Margaret tried to cover herself with her bony little arms. She was sobbing something awful, clawing at the dirt, trying to escape—but we had her surrounded. We were like a pack of wild

animals, torturing the poor thing, and one of the boys found a stick and was jabbing her between the legs. But suddenly someone shouted at the top of his voice: "STOP IT!"

Everyone froze; turned to look. They were looking at *me*. It was *me* that had shouted. I grabbed the stick out of the guy's hand and slung it across the lot, and Margaret jumped to her feet and reached for her shirt and ran away.

The guys were lookin' at me like I'd ruined their fun, and they came at me now—came at me hard. Yeah. I got beat the hell up, I ain't gonna lie to you. But I got in a few good licks of my own.

"Lord Almighty, Bern!" my grandma said when I got home. "What in God's name happened to your face?"

"Nothing," I said, and I was smiling. I was smiling because I felt good inside: I had stood up for something that was right.

After that, things started changing for me at school. I became one of the good kids. I remembered what my mother said—how nobody could do it for me but me—and I realized she was right.

I began paying attention to the teachers. Took notes. Started crackin' the books.

One time a friend saw me reading, said, "Put that book down, nigger! Come on over here and smoke this joint."

I looked at him and said, "You read this book, I'll smoke that joint."

Guy shook his head, went off mumblin' to himself. "That Bernie Mac—he crazy. Brother reading a *book*!" Left me to my book.

I was buckling down. I was going to all my classes. I found out I really liked English and history and that I was a pretty good writer, too. If I didn't know a word, I'd go up to the front of the class and look it up in the dictionary. That's what it was there for. Learning wasn't such a bad thing after all.

Before long, I knew the answers. I'd put up my hand and tell it right; tell it like it was. Teacher lookin' all surprised. "That's good, Bernie. Real good." Everybody else lookin' at me like, *S'goin' on with Bernie? Motherfuckin' clown smart all of a sudden?*

Fools: They think it ain't cool to be smart. But I'm beginning to figure it out. You're not smart, you're going nowhere fast. So got-damn *get* smart, brother.

And that's when it hit me: *They were right all along.* Principal. Coach. Minister. Got-damn janitor, even. I go look for these people. Tell them thanks. Tell them I'm sorry I didn't listen earlier. Tell them things is turning around.

Wish my mother was still around so I could tell her thanks, too; tell her I was sorry for all the pain I'd caused her.

In no time flat, things really did turn around. Got an A in English class one day. Only three kids in the whole class got an A, and the teacher was reading out the names. She was about to read my name when she looked up and saw me shaking my head, shimmying low in my chair, ashamed. So she didn't read my name.

But afterward, she called me aside and waited for the class to empty out.

"Why didn't you want me to read your name, Bernie?" she asked. "You earned it."

"Don't know," I said. I was mumbling. Couldn't look her in the eye.

"You think everybody liked you better when you were a clown?"

"I'm not sure. I guess maybe." I was confused. I'd been wearing my ignorance like a badge of honor.

"Think it's cool to be a fool?" she was asking me now.

"No, ma'am."

"You are so talented, Bernie Mac. But you're scared of success. You'd rather belong. You'd rather be one of the gang."

I didn't say anything. I hung my head.

"Life ain't about cool, son. Cool changes every day, but smart is forever."

Woman was right. Woman knew what she was talkin' about.

There were seven hundred kids in my class, and I was always right near the bottom of the heap. But by the end of the year I'd made it almost halfway to the top. I still had a long way to go, sure, but I'd come a long way—and it felt *good*, brother. I ain't lyin'.

Had good friends, too.

Senior year, I hooked up with Geri Duncan. She was a fine-looking girl, and I really liked her, but I got to make a confession here: Sports came first, followed by comedy. Girls were a distant third.

Every day after school, if I didn't have to work, I'd be on the courts. First-draft pick, motherfucker. *Never say die.* Havlicek, Clemente, Reggie Jackson, Pete Rose. Stand up and be counted, brother. That's one thing I learned from those men: You don't give up. You *never* give up.

After that, it was TV. And sure, I probably watched too much TV. But I wasn't neglecting my schoolwork anymore. And that was a good thing. Because doing well was changing me. I had more self-respect. I was feeling more confident.

Weekends, I'd hook up with Geri and the gang and party. And you know those stories I used to tell in Friday class? Well, I was telling them now. Only I was telling them at parties, at friends' houses; I was telling them waiting in line at White Castle. I was the got-damn entertainment.

"You the funniest guy I know," Billy Staples told me.

Getting up in front of people, it was nothing to me. I liked it. I liked the attention. I liked the spotlight. I liked it going all the way back to the day I got my ear pulled at the Burning Bush Baptist Church. I liked making myself heard at choir. I liked

people watching me on the basketball court. I liked standing up in front of the class, every eye on me.

Most of all, though, I liked making people laugh.

"You think you a clown or something?" Geri said to me one weekend. We were at a friend's house, eating pizza, and I'd just done one of my crazy riffs.

"Not a clown," I said. "A comedian."

"That don't pay the bills, Bernie."

"Tell it to Richard Pryor," I said.

"Ha!" She laughed at me. "Ha!" Just like that. Then turned her back to show just what she thought of that.

Geri was a serious girl. Where I come from, the serious girls try to find serious men fast. They want to build something and get the hell out of the ghetto. I felt like Geri was always watching me, maybe trying to figure out if I was the type of serious man she wanted for herself. She had a habit of seeing things that weren't there.

"What you lookin' at Rhonda for, then?" she asked me one day.

"Rhonda?"

"Don't act all innocent with me, Bernie Mac! I saw you looking at her!"

She meant Rhonda Gore. Rhonda was a year younger than us, a junior, and—now that Geri had pointed her out—pretty damn cute. But until that moment I hadn't really noticed her. Honest. I wasn't like that. Never have been.

"I ain't lookin' at Rhonda."

"You think she's pretty?"

Man, that's like a woman asking if you think her ass looks big. "Pretty? Rhonda? What you talkin' about?"

"Bernie Mac, don't give me that shit. You *know* what I'm talkin' about."

But she was wrong. I kept telling her she was imagining the whole thing; I'd never said more than a few words to Rhonda.

She gave me a look. "Don't try to be funny with me, Bernie Mac."

"Funny? That's what I am, woman. Funny."

This was back in the fall of 1975. And the reason I remember, see, is because that's the year *Saturday Night Live* came on TV. I remember sitting in front of that TV at Geri's house, glued to it, and promising myself I'd never miss a show. Chevy Chase, Dan Aykroyd, Garrett Morris, Gilda Radner, Jane Curtin, Laraine Newman, Bill Murray. These were some seriously funny people.

And I remember thinking, This is what I want to do with my life. What they're doing. This is who I *am*.

And it *was*, brother. But it was a long time comin'.

"BUT BROTHER, I COULDN'T GET THE LAUGHTER OUT OF MY HEAD. I KNEW IT WAS A SOUND I WANTED TO HEAR FOR THE REST OF MY LIFE. COMEDY WASN'T A CAREER. IT WASN'T EVEN A CHOICE. COMEDY WAS A CALLING."

COME BACK WHEN YOU'RE FUNNY, KID

I never did understand the senior prom. Seems like a lot of fuss about nothing. But Geri took it very seriously. And she wanted me to take it just as seriously; wanted to talk about the limo, and the kind of dress she was wearing, and would I buy her this and that, and when the hell was I going to get fitted for a tux?

I got tired of hearing about it. What'd she want from me? I was working at Hillman's Grocery, making two bucks an hour. I could only do so much.

"You don't take nothin' seriously, Bernard!" Geri snapped. "The prom is important to me."

"I know, baby."

"Then *act* like you know."

"I'm tryin'. Can't we just relax about it? You gotta learn to relax, woman. You too nervous. Let's go have a beer."

Man, she just lost it. Said all I ever wanted to do was hang out and make people laugh and be the life of the party. I didn't think there was anything wrong with that, but she saw it different. And—just like that—she broke things off with me.

I didn't see it comin'. I ain't lying. And I wasn't happy about it. And when I thought about it later I figured maybe she never meant to be with me from the start. I wasn't *serious* enough for her. She kept raggin' me all the time about the future. Like, what did I think I was going to amount to, anyway?

Richard Pryor? Ha!

Not long afterward, it's Saturday night, and I don't have a date. And I see how they're doing open mike at the Regal. So I went up by myself and waited in line with everyone else. Some of those people ahead of me were funny, but most were painful to watch.

My turn was coming up. Emcee looked at me—sees a big-eyed kid with an edge on him, cocky—and he wasn't impressed.

"Who think you funny?" he said. "Your mama?"

"Yeah," I said. "She used to."

I got up onstage and did my Michael Jackson impression. "I'm leaving this got-damn family! I'm the only one with any talent. Sick of you hangers-on."

Didn't exactly knock them dead.

"Come back when you're funny, kid," the emcee said.

"Okay," I said. "Maybe I will. Surprise the hell out of you."

I felt bad inside, but I didn't let it show. On the bus on my way home, I remembered another of my mother's Mac-isms: *Sometimes when you lose, you win, son. Failure is just life's way of preparing you for success.*

A few weeks later, I got another chance to fail. It was a Tuesday. I heard they were doing Amateur Night at this place called the High Chaparral, on Stony Island Avenue. I went on my own.

Guys were getting up there, most of them a lot older than me, and giving it a shot. Nothin' but tired-ass jokes. Nobody in the audience even cracked a smile. They were just sitting there, slouched in their seats, arms crossed, angry-ass looks on their faces—challenging you to entertain them.

Emcee said, "Anyone makes a person laugh gets fifty bucks."

So I went up; told the emcee I'd like a shot.

"Nah," the man said. "You're just a kid. You can't go up there."

But an old fella was sitting nearby, nursing a beer, and he started hasslin' the man. "Let the boy up!" he's hollering. "Ain't nobody making anybody laugh anyway."

Other people picked it up. "Give the kid a got-damn chance already!"

So the emcee shrugged, gestured. *Go ahead, boy. Hang yourself.*

I got up there and did James Brown as a mailman. "YOU GOT MAIL! Whoa-oa-oa! *Lots* of mail. You got mail like I knew you would."

Some guy in the back row laughed. I kept going. I did Michael Jackson again—"See if you can get a got-damn record deal without me!"—and the crowd ate it up.

I did *The Dick Van Dyke Show*, only Rob and Laura was black. "What you say, bitch?"

Then I talked about old people. "When you see white folks retire, they truly retire. They go someplace warm and get them a nice house and fish and play golf just about every day. And they smile a lot. But us black people, we get old, we don't go nowhere. When black folks retire, they hang out at the barbershop. Some of them even get another job. I knew this sumbitch had a job at the plant. Got old. Got sent home. A week later he's working as a janitor at the bus depot."

By the time I got off the stage, the place was rocking. It was a rush, brother. Like high-octane fuel. But I kept real cool. I was *smoof*.

Emcee was waiting for me in the wings. He didn't even crack a smile. He pulled out a wad of bills and peeled off two twenties and a ten. "Not bad, kid," he said. "Not bad at all."

"Thanks," I said. I took the money and walked out the back door, into the alley—I could still hear them laughing—and made my way down the street, toward the El. I was feeling good inside, but I was calm. I was sitting inside my own self, like my mama had taught me, sitting in the dark with my thoughts.

But brother, I couldn't get the laughter out of my head. I knew it was a sound I wanted to hear for the rest of my life. Comedy wasn't a career. It wasn't even a choice. Comedy was a *calling*.

When I got home, I found my grandma at the kitchen table, with her magnifying glass, figuring out which bills needed payin' first. "Where you been, son?" she asked.

"Nowhere," I said. I wanted to go upstairs and sit quietly with my thoughts.

"Nowhere?" my grandma repeated.

In our house, you couldn't get away with that type of answer.

"Sit down, Bernard."

I did as I was told. She put the magnifying glass down and looked at me with those cloudy eyes.

"I hear tell you ain't got a date for the senior prom," she said.

My grandma, she knew everything. Couldn't keep a secret from her. "Yes, ma'am," I said. "Looks like I'm going to miss the prom."

"I don't think so," she said. "What about that nice girl used to take a class with Geri?"

"What nice girl?"

"The one that got her jealous that one time."

"*Rhonda?*" I said.

"Yes. That's her. Rhonda."

"I don't hardly know her, Grandma."

"Well, that don't matter. I think you should call her."

"Why would she go with me, Grandma? She don't know me, neither."

"Boy, you're graduatin' high school," my grandma said. "This is important. You're going to the prom."

I didn't want to call Rhonda. Made me nervous. I thought for sure she'd find the whole thing as strange as I did. So I called Geri instead; gave her another chance. She turned me down flat. Said she'd already asked her cousin. Then she hung up. Girl was *mad*.

I got Rhonda's number and phoned over. "Rhonda," I said, "this is Bernie. Bernard Mac. Can I come by and talk?"

"Sure," she said. She said it like it was the most natural thing in the world.

I went over to her place.

"You know Geri broke up with me, right?" I said.

"I know."

"Well," I said, "prom's next week, and I got no one to go with, and I thought maybe you'd like to go with me."

Rhonda didn't say anything for a minute, then she shook her head. "I can't go, Bernard," she said. "I don't have a dress."

Well, I guess her mother, Mary, was in the other room listenin', because right quick she came out and said, "Honey, the dress is no problem. Don't you worry about the dress. I'll take care of the dress."

Rhonda looked at her mother, then she looked at me. What's she gonna say now? *No?*

And Mary said, "As long as you're going to the prom, Rhonda, you ought to go to Bernard's graduation, too. It's this Saturday."

Rhonda looked at me and smiled. Her mama was in total control.

So Rhonda came to my graduation. Sat there with my grandparents, Lorraine and Thurman, and my aunt Evelyn. Everyone beamin'. *Little spooky juice up there; boy made it.*

I wished my mother had been sitting there with them, and for a moment, I felt I might cry. But I held strong and the moment passed.

When they called my name, I got up and strutted across the stage like a tough guy, big smile on my face, always the clown. But the truth is, I felt mighty good inside.

Principal looked me in the eye, handed me my diploma, said, "You ought to be proud of yourself, Bernard."

And I said, "I am, sir." I was, too. *Real* proud.

Rhonda wore a real pretty yellow gown to the prom, and I wore a tux with a yellow shirt to match the gown.

When we walked through the door, guess who's the first person we saw? That's right: Geri. And boy, was she pissed. "Bernie Mac," she said. "I knew all along you had your eye on Rhonda!"

"You're wrong," I said.

But she wouldn't hear it. She was furious. And that guy she was with didn't look like no cousin I ever met!

Then I'm thinking, *Wait a minute. Why do I feel bad? I haven't done anything wrong here.* So I began to relax with Rhonda. And I had the best time ever. And she looked so pretty. She had her hair pulled back, tapered, sitting high on her head.

I took that girl by the arm and led her out onto the dance floor, and brother—we *danced.* I was the best dancer out there. I ain't lyin'. You should have seen me. The Bump. The Funky Chicken. The Four Corners. Me and Rhonda, we tore the place up. We tore it up so bad they're still rebuilding.

Later, during a break, I said to her, "Maybe I didn't pay attention to you before, Rhonda, but I should've paid attention." She was so sweet and pretty, but I hadn't seen it because I was with someone else and I hadn't allowed myself to see it.

After the prom, I took Rhonda to White Castle for burgers. And after that, we went and parked by the lake and watched the sun come up. I had never felt so comfortable with anyone in my life. It seemed like we'd been close forever.

But when I got back to her house, there was hell to pay. Her father, Freddie, cussed me out somethin' fierce: "You better not let daylight catch you with my daughter again, Bernard Mac, or you'll be catching a bullet!"

Even Aunt Evelyn was waitin' up for me at home. "Where have you been all night, Bernie? You in trouble. You got that poor Rhonda in trouble, too."

I thought it was a little late for her to be playing guardian, but I didn't say so. I just said I was sorry, told her nothing had happened, then went to bed and thought about Rhonda and what a fine time I'd had.

Next few times I took Rhonda out, I acted all silly and goofy. I think I was nervous. I liked her too much and I was trying too hard. But Rhonda set me at ease; made me relax. She was a year younger than me, but she was already thinking seriously about the future. She was going to Dawson's Nursing School after she graduated. I felt like a big kid next to her. I couldn't see beyond the next day, when I'd be stocking shelves at Hillman's.

Rhonda didn't seem to mind, though. We went everywhere together: to parties and movies; for walks along the lake; shopping at the mall; for burgers or chicken. Sometimes we'd double-date with Big Nigger and his girl, Deborah. It worked out good. I was beginning to think that maybe girls were on the same level as sports.

I was also thinking that it would sure be nice to have a car when one day, clear out of the blue, I got a call from some insurance company. They told me I was the beneficiary on my brother's policy. I couldn't believe it. I went out and bought a 1975 Malibu Classic. It cost me $4,795, plus another thousand in liability insurance, but what can I tell you? I was still a kid. I *wanted* that car.

Before the summer ended, I landed a job with General Iron, a scrap yard on Magnolia and Division. Helluva job, too. It was assembly-line work. The crane would dump huge piles of scrap on a big-ass conveyor belt, and me and the guys would level it with rakes and pick out the steel before it went into the cruncher. Cruncher only handled iron; steel messed up the works. So you had to move fast.

Some mornings Rhonda and I would drive over to the scrap yard together, and she'd drop me there and take my car to school. (Man's got to be crazy about a woman to let her drive his car!) Then she'd come back for lunch, with sandwiches and cold sodas, and we'd sit in my car, listening to the radio and grinning at each other. You know how it is when you're in love: Every song is a love song; every song was written for just the two of you.

On cold days, at work, the sweat would freeze on my body, and when my shift ended I'd hurry home and take a hot shower and watch the red dust swirl along the porcelain and down the drain. I'd see that and think, Stuff *can't* be good for me; imagine what's in my lungs. It stained the tub; left a red film there. My grandma made me scour it down.

When I was done showering, I'd splash myself with cologne and get dressed and leave the house, smellin' sweet for my girl.

Fridays we'd go to parties. I was always the funny man. Saturdays we'd have dinner with Rhonda's family, and play cards or something. And we never missed *Saturday Night Live.* I was practically living at Rhonda's place. I spent all my free time with her. I'd only go home to sleep.

"You sure are serenading that girl," my grandma said.

"You're the one who set me up with her," I said.

My grandma laughed. It was sweet, hearing her laughter. She was getting old. Her eyes were worse than ever and her legs were starting to get awful weak.

"You turned out pretty good, Bean," she said, and shuffled off, still chortling, mumbling to herself.

Fact is, I *was* serenading Rhonda. Bernie Mac was in love.

I'd leap out of bed in the morning, thinking of her. I'd call her first thing. I'd call her from work if she wasn't coming by at lunch. I'd call her the moment I got home to tell her I was gonna hop in the shower and get dressed and be on my way real soon.

No, sir. I couldn't get enough of Rhonda.

///////////////////////////////

By this time, Big Nigger had joined the navy and A.V. was off in college, and Billy Staples had become my main man. I loved Billy, and sometimes it hurt me to see the mess he was making of his life. He had a child with this girl from high school, and he said he wanted to be a good father. But he didn't want to marry the girl,

and he started going over less and less. He said he was too busy—he was studying to be a carpenter—and I didn't know what to say about that. I had pretty strong opinions on the subject of fatherhood, but he wasn't asking for them.

In the fall, I signed up for a couple of classes at Kennedy King Community College, over on Olive and Harvey. My mother had urged me to try to get into social services. She felt I had the personality for it. But I wasn't so sure. It seemed so glum. Just talking about it weighed me down. I thought a comedian would for sure bring a lot more joy into people's lives than any damn social worker, but I felt I owed it to her—and to myself—to give this college thing a try.

One evening, though, heading back from class on the El, I looked around and saw all these tired, miserable faces, and I decided to lighten things up. I picked out the most tired-looking guy and I said, "My friend, women are going to be the death of you." He looked up at me, confused. Other people were listening. "You look like you're gettin' *too much.*"

He laughed—what man's not gonna laugh when you're tellin' the world he's gettin' more than his share of booty?—and other people laughed right along with him. I told a few more jokes but kept it clean on account of the children on the train, and pretty soon I had them roaring.

As we came up on my stop, an old lady shuffled over, slow as my grandma, and handed me a five-dollar bill. I just took it. Not even thinking, really. "Thank you, ma'am," I said, and I waved and left the train.

"Five dollars?" Rhonda said later, cuddling on the couch. "For telling jokes?"

"Go figure," I said.

Next time I got on the El, I did it again. I brightened up all those sorrowful faces. And the time after that, I gave them more. Pretty soon, it was like they were waiting for me on the train. "There he is! That's the funny guy I told you about!"

And suddenly I'm thinking, "Man, this comedy stuff is *sweet.*" But other times someone'd be handing me a crumpled dollar bill—"Here, boy"—and I felt like a panhandler.

It wasn't a good feeling. I wanted to be legitimized.

I began to think, *This nigger needs a stage.*

"I don't know about this community college stuff anymore," I told Rhonda one night.

"Give it time, Bern."

"I think I'm more of a funny person," I said. "Billy Staples says I'm a born comedian."

"You *are* funny, Bern. But you're also smart. Real smart. Working and school and everything. I got myself a smart smart man here."

"Why you repeatin' everything four times?" I said. "Sound like Grandpa Thurman."

She laughed. She knew I was just messing with her. We'd cuddle up harder. Life was good. I had a fine woman, and she had a man with a job, a car, and academic aspirations. Didn't get any better than that, right?

We were watching TV one night when Cosby came on. I told her about the time I walked into my house, five years old, and saw my mother sitting in front of the tube, crying. Told her how Cosby had made my mama laugh to bust a gut. Told her what I'd said: "That's what I want to be, Mama. A comedian. Make you laugh like that, maybe you never cry again."

Rhonda thought it was a nice story, and she smiled at me. But it was one of those worried smiles. Maybe she was hoping I wouldn't do anything crazy, like quitting college or something. I didn't say anything, but the only part of college I enjoyed was the trip there and back, when I got to do my standup on the El.

When Rhonda graduated from high school, she was up near the top of her class. I went to the graduation with her family. I was grinning so hard my jaw ached.

There was a party after, but Rhonda didn't want to go. She said she'd rather be alone with me. So I took her to a nice place for dinner, just the two of us. We had a good table in the corner, and I felt very romantic. I was thinking I might be the luckiest sumbitch in the world.

I felt so lucky that the next week I quit school.

"You did what?" Rhonda asked me.

"It's not my thing, girl. After a full day at the scrap yard, that classroom is the last place I want to be."

She didn't crank. But I could see she was a little worried. And I got a feeling something had changed.

One Friday, not long after, I walked into her house, feeling good. I was fresh-showered and smellin' fine. "Let's party," I said. "Billy knows a guy who's having this thing at his house."

Rhonda looked at me. "All you want to do is be the funny guy at the party," she said. "Think you a comedian or something?"

"What's wrong with that?" I said. "I *am* a comedian."

"There's more to life than parties and laughter," she said.

"You don't have to tell me that, woman. I work hard every got-damn day."

"Gotta think about the future, Bern," she said.

But I wasn't thinking about the future. Not often, anyway. And not right then for sure. What I was thinking was that Rhonda was beginning to sound a lot like Geri: *Bernie not ambitious enough. Bernie not doing anything with his life. Bernie going to end up working a bullshit job till he dead.*

I guess I must have had some of those fears myself, because it just set me off. And while I'm not a man who loses his temper easy, when I do—watch the hell out.

"You are a pain in my ass," I told her.

She got up off the couch, her hands on her hips, steamed, and looked dead at me. "Don't you dare talk to me like that, Bernard Mac," she said.

"I'll talk to you any damn way I please," I said. And I stood up and pushed her down on the couch—pushed her *hard*—and stormed the fuck out of the house.

I went to Billy's friend's party. Had a few beers. Made everyone laugh. Billy put his arm around me, hugged me. "You are a funny sumbitch, Bernie Mac. You the funniest sumbitch I know. You ought to be out in Hollywood, brother."

Felt good. I needed that.

The next day, when I got out of bed, I felt lousy about Rhonda. I'd never raised my hand to a woman in my life. That's not the way I'd been taught. And I loved Rhonda. Then I got to thinking about what she'd said, and I realized that maybe I *was* worried about the future. But not in the same way. Rhonda wanted me to stay focused; to concentrate on my job; to get promoted and build something and take it seriously. It's not as if she spelled it out for me, but I got the sense that she was *thinking* it. And me? To me, working a regular job was just temporary. She was right about there being more to life than parties, but she was wrong about the other thing: There wasn't more to life than making people laugh. That's what I wanted to do with my life. I wanted to be a comedian. I wanted to make people laugh.

Like I said, it was a *calling*.

I decided I needed to explain to Rhonda just how serious I was about my comedy, so I called her house. Her mother, Mary, answered. I said, "How you doin', ma'am. It's Bernard. Can I speak to Rhonda?"

"Rhonda's not here."

"Where is she?"

"Went away this morning."

"*Went away?* What do you mean, went away?"

"Went away, Bernard. I can't talk right now." And she hung up.

So I went over to Rhonda's house, to find out what the hell was going on. "Where Rhonda at?" I said.

Mary didn't answer right away. Instead, she picked up the phone and dialed, and I could see her dialing long distance.

"Hello?" It was Rhonda's voice, small and far away.

"Bernard's here," Mary said. "He wants to talk to you." And she handed me the phone.

"Rhonda, where you at, girl?"

"Cleveland."

"Cleveland! What you doin' in Cleveland?"

"I got a job here."

"What do you mean, you got a job there?" I was getting pretty worked up.

"Good job, too."

"Where you stayin', then?"

"With my aunt Sweet."

Her aunt *Sweet*? What the hell kind of name was that? "What about us?" I said.

"It's over, Bernard."

"*Over!* Don't say that, girl. I'm calling to apologize."

"I'm sorry, Bernard."

"No, Rhonda, listen to me. What I did was wrong. I had a couple of beers in me—I know that's no excuse. But you know me: two beers and I'm flying . . ." It was true. More than two beers, I'm giving you a lap dance. "Rhonda? You there?"

"I don't want to talk anymore, Bernard. It's over."

"Rhonda, please listen to me. I'm really sorry, girl. I never should have pushed you. I never should have lost my temper."

But she hung up on me. Just like that. Hung the hell up.

<center>***</center>

After that, I called her every day, sometimes three or four times a day, racking up the bills. She was working at a grocery store with Aunt Sweet, doing the cash register, and I even called her there.

"Don't call me here no more, Bernard. I'm going to lose my job."

I was scared inside. I didn't want to lose Rhonda.

"Your job? I'm callin' because I don't want to lose *you*, woman!"

"I can't talk now. I got customers."

I got off the phone and saw how my aunt Evelyn's giving me one of those looks that run in the McCullough family. "What'd you do to make that girl so mad?" she asked me.

"Nothing," I said. "I don't know."

But I did know. I'd been abusive toward her. And Rhonda had her self-respect: She wasn't going to take that from anyone, least of all a man who said he loved her.

I called again. Apologized again. But Rhonda held firm. For *six weeks* she held firm. Finally I told Aunt Evelyn I was going to drive to Cleveland. "Be cheaper than these phone bills, anyway—and probably more effective."

"You stop moping around, boy," she said. "You leave that girl alone. Let her live her life. If it's going to be, it's going to be. If not, not."

I didn't think that was very good advice. "It's meant to be if I make it happen," I said.

"Boy," she said. "You bullheaded."

I kept calling. Nothing. Rhonda was bullheaded, too. I got a bad feeling that there was more to this than Rhonda was letting on.

One night I got a call from her mother. "Bernard," she said, "I need you to come over here."

I went. "What's up?" I said.

"Rhonda's pregnant," she said.

"What?"

"You heard me."

"Who's the father?"

"Who do you think, fool? Askin' that—it's an insult to Rhonda."

I couldn't believe it.

"Wow," I said. "I don't know what to say." And I really *didn't* know what to say. I was nineteen years old, a kid. I wish I could tell you my head was full of intelligent thoughts, but it wasn't. It was empty. I was a kid with a kid on the way.

"Don't you know nothin', boy? Why do you think Rhonda left?"

"I thought it was on account of the fight."

"Well, of course it was. That was part of it. But that's not why she left. She left because she didn't know if you was ready to have a child. Rhonda didn't want to trap you into nothin'. She's not like that."

My head was spinnin'. "I gotta talk to her," I said. "Let me call her from here."

"No," her mama said. "She's coming home tomorrow."

I drove down to the Greyhound terminal the next day, waited for Rhonda's bus. She got off the bus and I looked at her belly. Sure enough, she was already showing a little. She had seen me looking, and she started crying.

I went over and hugged her. "Why you cryin', girl?" I asked.

"Because I want something out of life, and you don't."

"Why you sayin' that? I want *lots* out of life."

"Well, it's not free," she said. "Life don't come to you."

"I know that. My mama used to tell me the same thing. Life don't change unless you make it change."

"Then why the only thing you care about is sports and partyin' and your damn car?"

"I care about comedy," I said. "I'm going to be a comedian."

"How?"

"You *know* how. I make people laugh. I go to a party, everybody says, 'Here comes Bernie! Life of the party.' I get on the El, people throw money at me."

"That doesn't mean anything, Bernard," she said. "I'm talking about real life."

By the time we got to her place, she was crying again. She wouldn't even let me go inside.

I drove home, thinking about what Rhonda had said. She had a point, but then again, she didn't. I wasn't sure what she was complaining about. I had a job and got to work on time—mostly. And I worked *hard*. I figured she was still upset about the community college thing. Maybe she wanted me to be more than a scrap yard worker. Maybe she wanted me to have some real goals, and maybe the goals I had in mind didn't seem real enough to her.

My mama used to say, "Talk is cheap, Bean." And she was right. Maybe I was talking too much about becoming a comedian. Maybe I needed to shut up about it and *act*. Of course, at the moment there were more pressing things on my mind—namely, the life growing inside Rhonda.

I got back to the house and found my grandma in the kitchen. "Grandma," I said. "We have to talk."

"What kind of trouble you in now, boy? Didn't you learn *nothin'*?"

"Rhonda's pregnant."

She looked at me. Didn't say anything. Just looked at me hard, waiting to hear what *I* had to say. I knew what I was going to say. I knew I wasn't going to be like my sumbitch father.

"Grandma," I said. "I'm going to ask Rhonda to marry me."

She got tears in her eyes. Took her a moment to catch her breath. "Bernie," she said, "I feel we did a good job with you, boy."

Then we hugged each other.

Next day I went to Rhonda's house. We were sitting in the living room, and I was working my way around to saying what I had

to say. "You know, Rhonda," I said, "you and the baby, I don't think it's right for you to be somewhere across town."

She was looking at me, trying to read between the lines. "I don't want you and the baby in one place, me in another. I don't want to just *visit* from time to time. This is my son or daughter we're talking about."

I really believed that, too. Coming up in the streets of Chicago, I had seen a lot of ugliness. I had seen a lot of fathers disappear. I had seen women alone with five kids, each one from a different father—and none of the five fathers hardly ever there to look in on their kids. I didn't understand that, how a father could turn his back on his own blood.

She was about like frozen there, staring at me hard. "Bernard Mac," she said. "What are you trying to tell me?"

"I'm telling you I want to marry you, woman."

Rhonda jumped in the air, screaming. "Oh my God! Oh my God! Oh my God!" She threw herself into my arms and was bouncing so hard we both about fell off the couch.

Her mother came running out to see about the ruckus. "Lordy, Lordy! What's happenin' out here? What's all the hollerin' about?"

And Rhonda said, "Bernard proposed to me! Bernard just proposed to me!"

And her mother said, "I hope you said yes, girl!"

And Rhonda said, "I sure did!"

Got so loud in that house! We were all of us jumping up and down now, screaming and hugging.

"When you gonna do it?" her mother asked.

And I said, "Now. Soon. Before the baby's born. I want us together. I want us to be a family."

And her mother said, "Why don't you do it on my birthday?" And Rhonda and I looked at each other. And that's what we did.

That mother of hers! Still in total control.

"BUT HEY, WE HAD EACH OTHER. WHY CRANK AND MOAN?"

MAC DADDY

Marriage! A child on the way! Life was about to change in a big way, and I had to make some changes myself. I went over to see my grandfather. "Grandpa," I said, "I'm getting married. I'm not going to work in no scrap yard fourteen hours a day."

My grandfather was still working for General Motors, but he was gettin' on and was almost ready to retire. He knew what I was saying.

Next day, he went over to the personnel office and talked to them, and he must have said the right thing because they asked me to come in for a physical.

I went. They didn't say much during the physical, but when they got done they told me, "You start tonight."

Shit. My grandfather was *connected*. Old man had power.

I went over to Rhonda's and didn't say a word. Acted regular. I remember I was on the night shift at the time, at the yard, because at around three o'clock she notices it's getting on and she jumps up and says, "Bernard, look at the time! You're going to be late for work."

I just looked at her and smiled. "We gettin' married, girl. I'm not working at no scrap yard."

"What? You quit?"

"Uh-huh."

"Lord, Bernard. What you gonna do?"

"I got me a job at GM, and I start tonight. But I don't start till four-thirty."

Well, that girl just melted! "Blue Cross/Blue Shield!" Those were the things that mattered. She threw her arms around me and hugged me tight. "This is the kind of man I want to marry!"

We were married on Saturday, September 17, 1977: Rhonda's mother's birthday. Had a church wedding, with a big reception at a motel on 63rd and King Drive. There were more than two hundred people there, and I was walking around in a daze. I kept thinking, *Wow, I'm married. I'm a month shy of twenty*

*years old and I'm married and I got a kid on the way. I can't
believe it.*

Rhonda looked beautiful. She was wearing that smile of
hers—the one that sends my temperature shooting up—and I was
a happy man.

I had found us a little place on 80th and Champlain, and we got
back there and walked through that door as man and wife. It was
a magical time. The future looked bright. Rhonda was going to
nursing school. We had our baby coming. And I had a good job.

The GM factory was at 103rd, off Cottage Grove, and they
made locomotives. But I didn't have anything to do with that part
of it. I worked with my grandfather, cleaning the personnel build-
ing. He was in charge of the whole building, and he took his work
very seriously. He was good at it, too. He taught me how to mop
and buff a floor and how to keep the water off the baseboards. He
taught me how to wipe down glass so there wasn't even the *ghost*
of a streak. And he taught me how to dust corners right.

I was making sixteen dollars an hour. That was a fortune to me.

Nights I'd go home to Rhonda and we'd make love and fall asleep
listening to the got-damn mice. I was killing half a dozen of the little
critters every night. Get up to fetch a glass of water and it was
WHAM, BAM—got two of them. Rhonda hated the mice. Kept her up
half the night. I wanted her to get her rest. The baby was coming, and
between the kickin' and squeakin' she wasn't getting any sleep at all.

One weekend I got to talking to the other tenants about the
mice problem, and we decided to go on a rent strike. Everybody
was all for it, but none of them held out. One by one, they caved
and paid their rent, until the only ones still owing were the Macs.
So sure enough the landlord kicked us out; said he knew all along
I was behind the insurrection.

We moved in with one of Rhonda's aunts—she had a little
room in her basement—but a week later I found a place on

116th and Harvard. We tried to make it nice. We found a couch with no legs and put books under it to hold up the ends. When you sat down, the springs would pop up and attack you. It was like something out of *Alien*. The building wasn't much, either: Seems like we'd picked the most popular crack house in the neighborhood.

But hey, we had each other. Why crank and moan?

Christmas we went over to Rhonda's house. Her family is very close. It was wall-to-wall people, most of them new to me. But I had A.V. there, home from college, and Billy Staples. Big Nigger was off in the navy.

We played pool and had a few beers and listened to music and ate a big dinner. That family of Rhonda's, they've always been big cookers. And you know me: I appreciate a good meal.

People kept comin' by to pat Rhonda's belly. She was getting bigger every day; fit to explode.

One January morning some weeks later, she woke up looking scared. "Bernard," she said. "It's time."

I drove her to the hospital. She was in some bad pain, only the nurses said it wasn't time, so we went home. Then late in the afternoon, Rhonda got that look again.

"Bernard, it's time."

"You sure?" I asked her.

"Bernard, I'm sure. Don't be interrogating me!"

Hokay! Step away! Lot of hormones happenin' here.

So we waddled down to the car and I drove her back to the hospital, but—wouldn't you know it—it still wasn't time. I didn't say a word. I didn't even look at her funny. I just drove us back home like a good husband.

Shortly before midnight, though, Rhonda got into some serious hollering. I told her to lie down and began to rub her belly, and before long she fell asleep. I fell asleep right next to her.

In the middle of the night, I heard a scream. I jumped out of bed and went into the bathroom and found Rhonda there, looking at the floor.

"My water broke," she said.

I got her dressed and drove her to the hospital, third time now, and she was hollering all the way there, clawin' at my shirt and lashing out and punching my leg.

We got to the emergency entrance and they wheeled her away, still hollerin'. But they didn't seem worried; they saw women in that condition every day, maybe forty times a day. They told me to have a seat, that it would be a while.

I went down to the cafeteria and got a sandwich and brought it back, and just as I was finishing my sandwich the doctor came out. "Mr. Mac," he said. "It's showtime!"

I got dressed in that blue gown and put those booties over my shoes and they took me into the delivery room. Rhonda's laid out there, legs up, sweatin'. She's not even remotely happy to see me; she's in too much pain. They had nurses there, preppin' her and whatnot, and the doctor took me over and pointed me in the right direction.

"Something hairy down there!" he said.

I looked. I wasn't sure I *wanted* to look, but I looked. And sure enough, some little hairy head was kinda pokin' out of there.

Rhonda was really screaming now. But not for long. Next thing I knew, doctor was sayin', "Rhonda, Mr. Mac—you got yourself a baby girl!"

I was like, wow—a baby girl! But I was keeping the emotions inside, like I'd been taught my whole life. Rhonda was different, though. She was crying a river and laughing all at the same time. I was holding her hand and watching as they cleaned up that little mess and weighed her.

"Seven and a half pounds!" the nurse said. "This is a solid, healthy girl. Congratulations."

The nurse brought her over and put her in my hands—she looked *tiny* to me—but Rhonda was already hollering for her

baby. "Let me hold her! Give me my little girl!" So I handed her over and Rhonda started crying and wailing louder than ever.

I took a closer look at that little baby girl. She had my eyes—I felt like I was looking into my own eyes—but she had a lot of Rhonda in her, too.

"Ain't she beautiful?" Rhonda said.

"I never seen a baby more beautiful," I said.

"Mr. Mac," the doctor said, "we'll take it from here. Your wife needs her rest. You go home and get some rest, too, and come back first thing in the morning."

So I went home and picked up the phone and called my buddies.

"Guess what today is? January twenty-first, 1978. It's my daughter's birthday. My little girl, Je'Niece. Come on over. There's a party at the Macs', and it starts as soon as you get here."

Then I called the family. I called my grandma and told her I had a baby girl. I called Rhonda's mother, Mary, and told her she was a grandmother all over again.

And then the boys came over and we drank a lot of beer. Billy Staples, my main man; Morris Allen, on his way to being a stockbroker; and a friend who'd been working at Dock's Fish Fry since high school—I'll call him Kevin Carter, though that's not the brother's name.

"Mac Daddy!" they got to calling me. And it seemed like every time someone called me that, I had to pop a fresh beer.

Next morning, I realized they must have called me Mac Daddy a lot of times, because my head was really throbbing. I went downstairs and found Billy on the couch and Morris passed out on the floor. The place was a mess. I didn't even know where to begin.

I stepped over Morris's body and went into the kitchen and called Rhonda at the hospital to see how she was doing. "I'll be over soon," I said. "I don't have to be at GM till late."

And she said, "Make sure you clean up!" That woman! You couldn't put nothin' past her.

So I woke the boys and they helped me clean up and went on their way, and before I left I put the little crib together and made sure I'd done it right.

I got to the hospital to find Rhonda glowing, our little girl in her arms. I'd never seen such a beautiful woman and such a beautiful baby. You think I'm being sentimental, but it's the truth. I took them home and got them situated and kissed them both good-bye and went to work.

I was proud. My grandfather shook my hand and went around telling everyone, "My boy had himself a daughter!"

Later that night, he even let me use the phone at work to call Rhonda. He was a by-the-book guy, and we weren't allowed to use the phones, but he made an exception this once.

I asked Rhonda how she was, and how the baby was doing. "Fine," she said. "We're both fine." She had this businesslike tone of voice. "I want you to stop by Leon's Barbecue on your way home," she said. "Get some fish." Hey, this was my wife and the mother of my child: If she wanted to eat barbecued fish at two in the morning, I wasn't going to argue.

So I stopped at Leon's after work and picked up some fish. Got home and found Rhonda and my little girl in our bed. I brought the fish to bed, and Rhonda dove in and ate like a cavewoman. I watched her eat and smiled and patted my little girl's booty, and I had a piece of fish myself.

This was all right. It was *better* than all right. I had a decent crib and a good job, and I had a wife and child and my whole life ahead of me. Was going to be a good life, too. I'd see to that.

In the days and weeks that followed—well, I can't even begin to describe it. Having a child—nothing touches it. I was like high all the time; *gone.* I floated around the house, trying to make myself useful. I even changed diapers. I'm not going to say I liked it, but I did it. On the other hand, I did like doing that thing with the blanket where you make a triangle and fold it

over your kid and she looks like some kind of papoose.

You can't stop staring at your kid. I ain't lyin'. I'd wake up two or three times a night and look at her and get close to make sure she was still breathing. Then I'd look over at Rhonda. And I'd think: *This is what it means to be a family. I have a family of my own.*

My thoughts turned in other directions, too. I realized I had to get serious now. This tiny little girl depended on me. And my wife depended on me. And they were going to depend on me for a long time to come. But that made me feel good inside. It was a challenge, and I accepted the challenge. This was what life was *about*. This was the cycle of life, beginning all over again, right here in my own home.

/////////////////////////

Things at work were going pretty well, too. I had just made the union, plus my grandpa was getting ready to retire. I was going to be cleaning the building solo.

From time to time, this other old fella, Charlie, would come over and keep us company. He was a friend of my grandpa's and was getting ready to retire himself. He was in charge of the coolants for the big machines. I thought that might pay better than mopping floors, plus it seemed to take some real skill, so after my grandpa retired I asked Charlie about it and he said he'd be happy to show me.

It was quite a job. Charlie had about six buckets of coolants, which he mixed himself. Had to keep the balance just right. And when you fed the coolant into the machines, you had to watch the levels. Too much would smother the motor and conk it the hell out. But I paid attention and got the hang of it pretty quick.

"You a smart boy, Bernard," Charlie told me. "I don't know why Thurman kept saying you was a fool."

"That's just the way my grandpa is," I said, smiling. "He can't help himself. He's always been that way."

Charlie thought about this for a moment, cocked his head, looked at me. "Old people don't change," he said. "We sewn into our

skins for life. Maybe it's Thurman's way of telling you he loves you."

Maybe.

Got home that night and—speak of the devil—phone rang as I came through the door. Grandpa Thurman was on the line. "Beanie," he said. "Got bad news."

"What's that?"

"Your father passed."

"Huh?"

"Your father passed. He gone. Passed away. Lord took him."

Still sayin' everything four times, snorting and wheezing. "Service Saturday. Two P.M."

My father's kidneys killed him. Gave out. He was a big man—damn near about two-fifty by then—and they had to take him to the hospital and put him on dialysis. He kept complaining, "I ain't sick! I feel fine!" But nobody would listen, and he got tired of telling them, so he just up and walked out.

Hospital called his family to say he'd run off. But it was too late. They found him on the floor of his apartment, stone-cold dead.

Saturday came along. Grandma called to ask if I was going to my father's funeral. Said I should pay my respects. Rhonda agreed. "Bury him and the past with him."

So we went, Rhonda and I. To the A. R. Leaks Funeral Home, the hot place in our neighborhood. Black people take death seriously. It was like a *designer* funeral.

I met his daughter from another woman, Gayla Harrison, nice-looking woman, a little older than me. She tells me she's the one who found him. Went for the landlord to open the door for her and there he was on the floor, *Daddy*. Wiping away a tear now. And I'm thinking, *He weren't no daddy to me, woman*. But I didn't say anything. Bit my tongue.

I tell you! Service hadn't even started and already I'm hearing

a *lot* of cryin', with Gayla leading the chorus. "Oh, Daddy, Daddy! If there's anyone for sure going to heaven, it's you!"

To listen to her, you'd think Bernard J. Harrison had been the best father in the world.

I looked at Rhonda and shook my head. *That woman's crazy.* I looked around at the mourners, waiting for things to get started. Strange bunch of people. Suddenly I see a man eyeballing me, coming toward me. He looked just like my father. Big fella, heavy-set, strong.

He reached my side and held out his hand and introduced himself as my father's brother, Pierce. He had a deep, sorrowful voice, just like my father. "I can't manage my brother's weight, son," Pierce said. "Would you be good enough to help me?"

Lazy bastard. I ended up under one end of the casket. Me, who didn't want to be there in the first place. Now I'm really wondering why the hell I'd shown up.

Midway through the service, the man who ran the funeral parlor came out and stopped things. Asked if he could talk to members of the direct family. He took us out back and said my father had no insurance, and that if we didn't come up with five hundred dollars he'd nail the coffin shut right quick and tell County to come get the body.

Suddenly, everyone was poor. *Dirt* poor. They were all looking at me like I was their best friend. My newfound uncle Pierce said to me in his deep voice, "Bernie, this is your father speaking." Sounded like got-damn Darth Vader. Then I saw Rhonda looking at me, and she nodded yes, and I signed a waiver saying I'd make good on the five hundred dollars.

We went back out and got on with the service, listening to all sorts of people go on about what a great man my father was. And all I'm thinking is, Who was that man? Where was that man? I didn't know that man. He was no father to me. I didn't have a father.

"'I WANT YOU TO HOLD YOUR HEAD UP,' SHE SAID. 'CAN'T HOLD MY HEAD UP,' I SAID, NEAR TO CRYING. SHE REACHED ACROSS THE TABLE AND TOOK MY LEFT HAND IN BOTH OF HER HANDS AND SHE SQUOZE IT. AND SHE SAID, 'BERNARD MCCULLOUGH, YOU JUST HANG ON, BO I KNOW YOU'RE GOING TO MAKE IT.'"

07

YOU BLUE AGAIN, BERNARD

One night, back in 1983, I'm sitting on the couch with Je'Niece and Rhonda, watching Eddie Murphy on *Saturday Night Live.* The brother started hot, and he was getting better every season.

"He funny," Je'Niece said.

"He sure is," Rhonda said.

"He's a comedian," I said.

Rhonda looked over at me but didn't say anything. I was thinking about that long-ago day on my mother's lap, age five, when I decided I wanted to be a comedian, save my mother from further sorrow. Only I still wasn't a comedian. I was a janitor at General Motors. My part-time job had become my full-time life.

Some nights, hell—it seemed like my head had just touched the pillow when the alarm clock was blaring in my ear. I'd get up in a daze, eat something, try to help Rhonda get Je'Niece ready for kindergarten, and hustle off to the El. I seldom joked with the passengers in those days; I was too tired to be funny.

End of the day I'd come home and pick up my little girl at school. Bring her back to the house. *Boops*, we called her. Girl loved Betty Boop. Couldn't get enough of Betty Boop.

"Come here, Boops," I'd say. "How'd you get to be five years old so fast?"

"I don't know, Daddy."

There were times I looked at her and felt it didn't get much better than that. That little hand seeking out my big hand. Her tiny little fingers. That little gap-toothed smile. The way she cuddled up against me on the couch, rested her head against me to watch TV. I could never leave this girl. I could never abandon her. And to this day I can't understand any man who won't be a father to his child.

I got to the factory on one of those perfect mornings and got called into the office before I'd even started work. They told me they were doing some *reshuffling*. My ass got reshuffled the hell out of there. Five years of work, and they gave me a check and showed me the door.

"What in God's name did you do, Bernard?" my grandfather asked me.

"Nothing," I said. "They was general cutbacks. Went by seniority. Lot of old-timers there from your day, so—guess what?—I'm *out.*"

He shook his old head and snorted. "What you gonna do now?"

"I'm going to be a comedian," I said.

My grandfather laughed so hard he choked. It took him a while to catch his breath. "I got news for you, boy," he said. "You're no Eddie Murphy."

Rhonda was working at a North Side hospital at the time, and trying to rack up the hours she needed to finish nursing school. I tried to ease her load by making myself useful around the house. I spent more time with Boops. I got her out of bed in the morning and fed her and combed her hair and got her dressed and off to school. While she was gone, I'd go back home and look through the classifieds, hoping for a break, and at lunch I'd go head over to school again and pick her up. We'd walk home, hand in hand, my little girl and me. I'd make her a sandwich, or maybe a little pizza, with a cup of hot vegetable soup on the side. And she always got a little cupcake for dessert.

Then we'd sit down and do her homework. Or read about Cinderella for the hundredth time. Or watch a little TV. And it had to be what *she* wanted to watch. The girl was tough. Headstrong.

"I don't want you watching that show," I'd say.

"You're mean," she'd say. "You're not my friend."

"Damn right I'm not your friend," I'd snap back. "I don't want to be your friend! You don't need no tall friend!"

Man, listen to me! I was beginning to sound like Grandpa Thurman, sayin' everything four times. But hell, that's the way it was. It didn't matter if she didn't like it. I was there to be a daddy,

and part of being a daddy is being tough—even when it makes your kid unhappy. Hell, *especially* when it makes your kid unhappy.

Parents today don't get it. They don't want to be parents. They want to be cool. They want to be hip. They don't want to be the bad guy.

But guess what? Being the bad guy is your *job*. Like my mama used to say, "This ain't a popularity contest." My mama knew better. She wasn't there to make me like her; she was there to shape me; she was there to make me a good person.

"You're the meanest daddy in the whole wide world," Boops would say.

Raising kids—it's like going to war, brother.

"That's right, little girl. I'm mean as a junkyard dog. Get used to it."

Nothing came up, workwise. So I went on unemployment. It was not a good feeling, but I didn't crank and moan. Cranking and moaning ain't my style. And when I got with friends, I knew they didn't want to hear it, either.

Speaking of friends, A.V. was still gone, off in college, and it'd be a couple of years before Big Nigger got back from the navy. But Kevin Carter was around, and sometimes I'd go visit him down at Dock's Fish Fry, where he'd been made a manager. He was always good for a laugh and a plate of fish.

Other nights I might hook up with my man Billy. He was beginning to get small jobs as a carpenter, but he hated working. And every time he met a new woman with a little money, he'd let the jobs slip away.

"You got too much pimp in you," I told him, but I'd say it with a smile. "You a lazy nigger."

"You're right," he said. It didn't bother him.

"God bless the child that's got his own," I said. "That's my motto." And it was. I was taught to do things for myself. But not Billy. Billy must have been missing the hard-work gene. He was more interested in handouts or crazy get-rich-quick schemes that never went anywhere.

Then I heard about a job—for me—from a guy who knew a guy who knew a guy. It was a moving company thing: heavy lifting. And the way it worked, see, is you'd set your alarm clock for five in the morning, and you'd call to see if they had anything. If they did, you had to get there on your own—and usually it was way the hell out in the suburbs. But I didn't care. I was grateful for the work. I'd go and meet the crew and we'd move people in and out of their homes and break for lunch and collect our cash and go home. Wasn't much to it.

Sometimes there was no work, though, and tired as I was, I'd get up and go down to the lumberyard a few miles from our place. Guys would get there at the crack of dawn, congregate on the corner, wait for pickups to come by and load up with able-bodied men. You never knew what kind of job you'd get on any given day. Could be demolition, could be raking leaves. Or could be nothing at all. Lots of days, I'd be out there all morning—rain, shine, sleet, snow—then come home with nothing to show for it and begin combing through those classifieds all over again.

A man not working, that's tough. If you're not careful, the misery can poison the people closest to you. I was careful. I kept my feelings and frustrations to myself. As best I could, anyway.

"You blue again, Bernard," Rhonda would say. "Why don't you tell me about it?"

"Nothing to tell. I got no work. Can't find any. End of story."

"It helps to talk."

"Not me," I said. "Never helped me." I wasn't lying. I've never been one to lay it out there. I think people talk too much. People

talk to hear themselves or maybe to try to figure things out, out loud. I like to figure things out before I open my mouth.

But the stuff I was feeling inside, it was not a good feeling. Felt like comedy was over for me. I had a family. I had to figure out how to make ends meet. This was about *survival*.

This went on for several months. Then one day, sitting in a coffee shop, circling the classifieds with my gnawed-off pencil, I ran into this guy I knew, Stan. We used to play ball at the South Central Community Center, over on 83rd and Ellis. Stan was working there now, and thought they might be looking for an athletic director.

"Would you be interested?" he asked.

"I sure would," I said. "I really need a job."

I went over the next day and met with Stan and a few of his colleagues at the center, and in the afternoon I took a physical and had my references sent over. Stan called me a few days later. "You got the job," he said.

I was elated. They put me in charge of the athletic program. I did everything. Football, basketball, boxing, dance. I was in charge of them all. And I was enjoying the hell out of it.

For a while there, we had a normal life. Rhonda was working and finishing school and I was working and Je'Niece was learning her alphabet and we felt we were on our way. We'd visit with friends or with Rhonda's family, and we'd double-date with Billy or Morris or Kevin Carter or Big Nigger and his new wife.

Sometimes we'd drop Je'Niece off with Rhonda's mother and go out to one of the local clubs to watch a little standup. I'd drink my beer slow, because we didn't have much money, and I could always feel the waitresses eyeballin' me. *Cheap bastard at Table 17. Lucky if I get a nickel tip.*

I could feel Rhonda eyeballin' me, too. She knew why we were there. She knew I wanted with all my heart to be a comedian, and I think it worried her. Maybe she didn't want me to take it too

seriously. Didn't want to see me fail and get my heart broken. Better I should have a regular job like regular people.

But the job at the community center didn't last. For some crazy reason, Stan began to cool on me. People liked me there. I made work fun. And maybe Stan thought I was after his job, because suddenly he was doing his best to make me as miserable as possible.

From the moment I showed up at work till the moment I packed my gym bag and left for home, he was all over my ragged ass. *Do this. Do that. How come the balls ain't put away right? Why'd class go long again? You think we runnin' a charity here?*

Motherfucker. I thought we were friends.

"What're you gonna do?" Rhonda asked me one night.

"I don't know," I said. "Not much I can do. I can't tell him I'm *not* after his job, because for sure he won't believe that."

Couple days later, sumbitch called me into his office. "Bad news, Bern," he said.

"What's that?" I asked.

"City's cutting back. They're cutting back on lots of programs. I can't afford to have you here no more."

"Maybe we can make this work," I said. "I like it here."

"I'd love to help you out, Bern. But you know how it is. It's not my decision."

Smarmy bastard. Trying to look like he was all broke up inside.

"Okay," I said, keeping my cool. "If anything changes, I'm around."

At the end of the day, I packed my bag, said good-bye to all my friends, shook hands with Stan, and headed home. I was steaming inside, but I didn't want to give him the satisfaction. Plus my mama always told me, "When you get mad, Bern—only person you're hurting is yourself."

Got rough now. I was frustrated and unhappy, and some of that poison was seeping out. I knew it was my fault, but I was weak. And that made it hard on Rhonda. She'd just started a new job, at the state mental hospital, and she liked it better. But she wasn't making anywhere near enough to support our little family.

The landlord kept coming by. He wasn't a bad guy, but he needed the rent money. We'd caught up some, but we were still two months overdue.

"What're we gonna do, Bernard?" Rhonda asked me.

"I don't know," I said.

I called my old friend Big Nigger and we went partying. I had a couple of beers and lit the place up with my comedy. "You the life of the party, Bern," Big Nigger told me.

"You got that right," I said. "I'm a regular comedian. I *should* be at the Regal. Or the Cotton Club."

"You should be, brother," Big Nigger said, "and you *will* be."

Rhonda was mad at me the next morning. I was just about to put her in her place, I was just about to say, "Who do you think pays the bills around here, woman?" But I caught myself. I wasn't paying the bills. Rhonda was paying the got-damn bills—those she could manage, anyway. The rest was going unpaid.

This went on for almost four months and led to the day that was the most degrading day of my life. No money, no prospects, no unemployment coming. And the rent going into its third month overdue.

I called Big Nigger, said, "It's me. I need you to take me to Seventy-ninth and Halsted."

Big Nigger swung by and drove me to Human Resources. "I can't believe I'm applying for aid," I said. Hell, if I wasn't near tears.

"One day you'll be laughing about this," he said.

But I didn't feel much like laughing. I didn't feel much like talking, either. And Big Nigger didn't push. We was just two close

friends, driving along, alone with their thoughts, each with his own problems—like everyone else on the planet.

Big Nigger pulled up in front of the building. I looked at the big brass letters by the entrance. "Department of Human Resources. What the hell does that mean? I'm a *resource*?"

He looked over at me, asked, "You gonna be okay?"

"I don't know," I said, and I slunk out of the car and went inside.

The guard up front pointed me in the right direction, and the sign said to take a number. I took a got-damn number: number 142. The place was packed. Couldn't even find a seat. People propped up against the walls, sitting on the floor, millin' in the aisles.

I looked around. Humanity. Jesus. All these crushed souls. I got to thinking about my wife and child, and how I was failing them. Big Nigger said I'd be laughing about this someday, but right then I was wondering if I'd ever laugh again.

Times like that—you feel yourself slipping into the abyss, and you know you can't go there. So I took a deep breath and made myself strong. And I did the only thing I knew was worth doing: making people laugh. That's right, I decided I'd entertain the 141 other people in line ahead of me.

"The joys of being broke, motherfucker," I began.

Heads whipped around. *What's that?* I started talking about jobs, and life in the inner city, and how you know your little girl ain't gonna have much in the way of Christmas that year. But I made it *funny*. And people were laughing. Letting it out.

Couple of security guards came over to see what all the fuss was about, and pretty soon they were laughing, too.

"I was gonna sing a little song I know, *Brother, Can You Spare a Dime?* But somethin' tell me this is the wrong place to sing it."

Even the clerks were paying attention. Mood in that whole place changed fast, like magic. That's comedy for you.

I kept going: "My landlord comes by. Tries to be nice. He tells me, 'Bernard, I like you. I've always liked you. But the rent's way overdue, and I've got people lining up around the block for this apartment.' 'Lining up around the block, motherfucker!' I tell the sumbitch, 'Who wants to live in this crack house?' And he says, '*You* livin' here, ain't you?' "

I stopped to catch my breath, enjoying the laughter, when one of the guards came by to say a clerk was sending for me. There was still about a hundred people ahead of me, but I went over to the window to see what was up. The elderly woman on the far side of the glass nodded hello.

"That was fast," I said.

She smiled at me. "Gonna let the funny man jump the line."

She took me out back and I sat across from her at a desk and she filled out the paperwork right quick. She had glasses like my grandma, little half-moon things on a chain, perched at the end of her nose.

"I'm going to give you four hundred cash and three hundred in food stamps," she said. "That ought to get you started."

Sweet Jesus. My head went down. I was so ashamed.

"Young man?"

I couldn't look up at her.

"I want you to hold your head up," she said.

"Can't hold my head up," I said, near to crying.

She reached across the table and took my left hand in both of her hands and she squoze it. And she said, "Bernard McCullough, you just hang on, boy. I know you're going to make it."

Man, I about lost it there and then.

I went home and the landlord was waiting for me. He said he was sorry, but I couldn't stay another day. He had to rent the apartment. New tenant was coming by first thing the next morning. And would I kindly try to leave the place clean.

I called Rhonda at work and told her, and then I called my grandfather, over at 105th and Eberhardt, and asked if we could please move in for a few days. And, you know, he was a good man, but he was getting on, and my grandmother wasn't doing so well on account of her diabetes, and he wasn't exactly thrilled about having us underfoot. But what could he do? We were family.

So Big Nigger and A.V. and Billy came over and helped us pack and got us moved in. Grandpa Thurman watched us bring the stuff in, frowning to beat the band. And I'll be honest with you, I wasn't exactly dancing, neither. My little family squeezed into one room, boxes and shit piled high against the walls. I was ashamed, brother. I didn't even want to show my face. Plus this was the house my mother had died in. I could smell that cancer smell, and it seemed to be following me around.

Got to bed that night, saw that Boops was fast asleep, and I turned to my wife. "I'm sorry, Rhonda," I said.

"What are you sorry about, Bernard? It's fine. We'll be fine."

It's like we'd changed places. It was usually me that told her to take it easy; that things would come out all right; that she worried too much. But now she could see how humiliated I was. I was failing my family. I knew I would overcome it, but at the time I was full of terrible feelings.

Next morning, while it was still dark outside, I got up and went to the newsstand and fetched the newspaper. I brought it back and sat in the kitchen, hunched over the classifieds, looking for work.

Then Rhonda was up and off to the hospital, and I got Boops fed and took her to school. When I let go of her little hand and watched her walk through the front door, I felt lost and alone.

Then I had to go back to Human Resources to get my state ID card. My picture on there: It made me feel like a criminal. Every time I went for my check and my food stamps, standing in those long lines, I'd reach the window and slide that little laminated card at the clerk. Lord, the way the clerk would look at my card!

Close at my picture, then up at me, then at the card again. That sour look; disapproving. It made me feel like a criminal. Made the degradation worse than ever.

Back at the house, I tried to make myself useful. Aunt Evelyn was out all day, at work, and my grandpa was usually off visiting with friends from church. But my grandma never left the house. The diabetes had really laid her low. Her eyes were worse than ever, and her legs had begun to fail. Everybody tried to limit her, but she wouldn't hear it. If I tried to help her off the couch, she'd shoo me away. "I can still do it! Get off me! Don't help me up!"

One time she almost blew up the damn house. She was in the kitchen, by the stove, and she couldn't see that the flame hadn't come on. Woman was cooking with gas; couldn't understand why the potted meat wasn't getting hot. They took away her cookin' privileges right quick.

It was hard on her. She was a proud woman, and she was getting old and feeling useless. All her life her greatest pleasure had come from helping others. Now that was being taken from her. Now she was the one who needed help.

One afternoon she was home alone, clipping her toenails, and her eyes were so weak she cut clean into her toe. It was bleeding like a motherfucker, but she wrapped that foot up and kept wrapping it till it stopped, and she didn't tell anyone about it. She was ashamed, I guess. Humiliation can take many forms.

Of course, she was in terrible pain, and my grandpa caught her limping and knew right off something was wrong. So he and Aunt Evelyn got the story out of her, and they took one look at that foot and rushed her to the hospital.

But it was too late. Gangrene had set in. They had to cut her leg off above the knee.

I went to the hospital and stayed by her side, tried to give her strength. But when the orderlies picked her up and put her in a

wheelchair, I could see in her eyes that she was giving up. She looked right at me, as if to say, *Son, it's over. It's all over for me. I've had lots of chances to improve myself, and this is it. This is as improved as I'm gonna get.*

On the heels of this tragedy, I got some good news. I was sitting in the kitchen going through the classifieds when I saw that Sears was looking for drivers. I called at nine sharp and made an appointment, and the next Monday I went down to the Holiday Inn, over on the West Side, for my interview. I guess it went pretty well, because they scheduled me for a physical. And I took the physical and they thanked me and sent me on my way. I went home and waited. And nothing. Not a word from Sears. Now I was getting worried. Not only didn't I get the job, but they'd found something wrong with me. I was dying, and they weren't going to tell me. With me gone, who was going to take care of Rhonda and Boops? Your mind—it'll drive you crazy if you let it!

Mornings, still dark, I kept going out to get the paper, circling those classifieds. But a few days into it, the phone rang. Woman on the other end said, "Bernard McCullough, this is Sears calling. You start Monday, seven A.M."

Don't take much to make an unemployed man happy. Rhonda got home, I was grinning. "I got a job, honey! I'm going to be working for Sears!" And she lit up like this was maybe the best news in the world. And it *was*. It's all relative. It was like the McCulloughs had just won the lottery.

I went down and got fitted for my uniform and went for training. They taught me how to break down refrigerators and dryers, and how to reassemble them, and how the doors fit and stuff, and then they sent me off to get a special license to drive the truck.

I was working again. Man, it felt good! Only they paired me up with this guy who smoked weed all day, *every* day. Useless sumbitch. He was always so stoned I had to do everything myself.

Now that I had a regular paycheck, Rhonda and I started looking for a new place. I don't think we were in a hurry; we didn't have enough for a down payment yet, but we were on our way.

That first paycheck, I bought groceries for the whole house. Aunt Evelyn and Grandpa Thurman had a way of separating their stuff—"Don't touch my chicken! That's my chicken on the second shelf!"—but I didn't care. In fact, it made me sad, the way everyone was fending for theirselves, thinking only of theirselves. Things had really gone down since my mother died. There were no family dinners. There was no family, come to think of it. My mother had really held things together, even when she had nothing left. She was a saint, that woman. That's the got-damn truth. She was a saint and I missed her something awful.

I loved my mama with all my heart.

"'GRANDPA,' I SAID. 'I WANT TO THANK YOU. I WANT TO THANK YOU FOR EVERYTHING YOU'VE DONE FOR ME. I ESPECIALLY WANT TO THANK YOU FOR BEING HARD ON ME.' I MEANT IT, TOO. HE TAUGHT ME THINGS I PROBABLY WOULDN'T HAVE LEARNED FROM A MORE LOVING MAN."

I'D HAD MY FILL OF DEATH AND SORROW

One night—this was in 1986—I came home around ten o'clock so tired I could hardly stand. Those 400-pound refrigerators take it out of you, and I had to be back at work at seven in the morning!

I looked in on Boops and took a quick shower and got into bed next to Rhonda, and I was asleep as soon as my head hit the pillow.

But then I heard someone call my name, "Beanie! Beanie!"

It was my grandma, home from the hospital and getting worse every day. I looked over at the alarm clock. It was two in the morning and I was bone tired. I couldn't even move, and Rhonda was dead to the world.

Again my grandma called, "Beanie! Beanie!" Her voice was weak, but I could still hear it. She must've said my name about umpteen times. So I threw the covers off me and got my feet on the cold floor, and just as I was about to get up I listened closer. She wasn't just calling my name; she was calling the names of all her kids and grandkids, in the order they'd been born. And she kept going around in circles. She'd had about nine kids, and five of them died early. But she was saying their names. All of them. Including the ones that died before she got to know them.

I lay back down and fell asleep again. Usually I went in when she called for me, but I didn't go in that night. I was exhausted.

Early the next morning, I got up and showered and put on my work clothes and went downstairs and my grandma was already up. She was sitting in her wheelchair by the door.

"Hey, young lady," I said. "How come you up so early?"

"Medicare's coming," she said. They had to take her in for her regular checkup.

"I heard you last night," I told her.

She smiled a little smile and waved her hand like it was nothing, and for me not to even think about it. And just then the two guys from Medicare showed up at the front door. Aunt Evelyn came down. We wheeled Grandma out and I kissed her and she patted my hand and looked into my eyes. Didn't say nothin'. Just

looked at me deep. Then the two men from Medicare took over and hustled her off.

I followed Aunt Evelyn into the kitchen. "She ain't comin' back," I said.

"Why you sayin' that?" she snapped. "Stop talkin' like that."

And I just repeated it: "She ain't comin' back."

I got home late that night and no one was around and I went upstairs and found Rhonda there, with Boops on our bed, asleep. She had a look on her face.

"What?" I said.

"You heard what happened to your grandma?"

"No," I said.

And she told me how they got her to the hospital. And how she was sitting there. And that when it was time for her checkup, the orderlies came by with that rolling stretcher and lifted her on the count of three. And as they laid her flat, my grandma looked away, turning her head to the side, like she was done looking at them, and at the world. And by the time they got her into the examining room, the doctor knew right off.

"This woman's gone," he said.

I didn't know what to say. I felt emptied out all over again. And I felt bad that I'd been too tired to visit with my grandmother the night before, when she'd called my name. But then I remembered the way she'd looked at me that morning, waiting on Medicare, and the way she patted my hand. And what I'd told Aunt Evelyn about Grandma not coming back. "She was ready," I told Rhonda. "She was tired and she was ready."

I went downstairs and had a little dinner and thought about how much I was going to miss her. Sometimes, people—it's strange. You look at an old lady, any old lady, and all you see is an old lady. What you don't see is the life that's been lived. With all the joys and sorrows. All those years. A lifetime. Gone.

///////////////////

Back at work a few days later, we're delivering a fridge to an apartment on 82nd and Peoria, my last stop of the day. And my sidekick—true to form—was too high to help. It was a two-flat building: nice, clean. I knocked at the door and a lady came out and I told her I had a fridge for her. And she watched me unload it and slide it onto the dolly and cut it out of its box and rock it up the stairs, one stair at a time.

"I can't believe you manage that thing on your own," she said.

"It's easy once you get the hang of it," I said. "Plus my partner's stoned out of his head."

She laughed and her brother came out from the back and we got to talking. I was making them both laugh, mimicking my partner, high as a kite. "I am stoned. I am seriously stoned, motherfucker. This is some fine weed. I got to get me some more of this weed. Get enough of this weed, I'll retire."

Then I did my Edward G. Robinson impression: "You think I'm soft. I'll show you how soft I am."

"You *funny*," she said. She about bust a gut.

"I'm working on becoming a comedian," I said, and I realized it had been a long time since I'd worked at it. It made me sad for a minute. But I was too busy to be sad.

I got the fridge into the kitchen and began screwing on the doors, and they asked me about me—was I married and stuff. I told them about Rhonda and Boops, and how we were looking to get us a new place—how we were living with my grandpa temporarily. And the lady and her brother told me that the family owned the building, and that they lived in that there apartment, but the other place had just opened up. I asked if I could see it, and they took me to see it. And it was exactly my dream apartment. Three bedrooms and two bathrooms, immaculate.

"Lord," I said. "This is the place. You think I have any chance of getting this place?"

She said their mother would be home that evening, and that she had the final say. And I asked if it'd be all right to come by later with my family.

I raced home after work. Told Rhonda about the place. "It's beautiful," I said. "We can't jinx this!"

I cleaned up, and we dressed Boops nice and hurried over and got there just as it was getting dark. For the next two hours, we talked and talked. Me and Rhonda and the brother and sister and their mother. I made everybody laugh. "I have a good feeling about you," the mother said. "You can have the place."

Well, Rhonda started crying. And Boops hugged her. And I was practically crying myself. The thing is, when you're looking for a home and you find something that holds as much promise as that place, well—it's hard to beat.

We moved in the next weekend. It was heaven. We'd never had such a nice place. That first night, Rhonda and I were walking around like we were in a dream. "Can you believe it?" I kept saying. "Can you believe this place is *ours*?"

A week later, Sears fired the stoner and paired me up with a guy I'll call Paulie. He didn't say much, but I could see that he was thinking all the time. They were the kind of thoughts, well—you got the feeling you really didn't want to know what was going on in that man's mind.

One day, soon after, we were on a job and Paulie "fell" down three stairs, real smooth.

"You okay?" I said.

It didn't look like much to me, but Paulie was moaning like a stuck pig. He said he was hurt bad, and for me to call an ambulance. So I called an ambulance and they came and took him to the hospital, and I finished my deliveries and went back and filed a report and went home.

The next morning, I got to work to see who they'd paired me up with, when I got called into the office.

"Where's the delivery money from yesterday?" they asked me.

"I don't know," I said. "Paulie handled the money. Ask Paulie. I'm sure he's still got it."

"We already done asked Paulie," the man told me. "He said he gave it to you."

I was stunned. "No," I said. "He didn't give me nothin'."

"Well, we need to get to the bottom of this, Bernard."

"We sure do."

"Why don't you take the day off?"

"I don't want to take the day off."

"Mr. McCullough," he said, his voice getting firm. "Take the day off."

I went over to the hospital and walked into Paulie's room and his eyes got big as saucers. Talk about *spooky juice.* "Hey, partner!" he said, acting real friendly.

I wasn't smiling, though. "Where's the got-damn money?" I said. "You stole the got-damn money."

"No, no, no, no, no," he said. "There's been some misunderstanding."

"You're got-damn right there has."

He was pretty nervous and said not to worry, that he was going to straighten this whole mess out as soon as he was on his feet.

"No," I said. "You're going to straighten this mess out right the fuck now. Or somebody's going to get fucked up for real. Right here in this hospital bed."

So he called the supervisor and told him that he had the money, and that he'd made a mistake—he'd just forgotten. Bernie'd never even gone *near* the money. Honest. Then he hung up and smiled at me like I'm supposed to thank him or something.

I went home, told Rhonda about it. People—they fucked up.

The next morning, I went back to work. And of course I'm thinking everything's been taken care of. But I was wrong.

"We're sorry, Mr. McCullough. We have to let you go."

"Why?" I said.

"I'm afraid I don't know. These are orders from upstairs."

Motherfucker. *Upstairs?* What upstairs?

"Sir, with all due respect—I didn't do anything."

"I'm sorry, Bernie"—Oh! So it's *Bernie* now!—"it's out of my hands."

Got-damn coward. Don't nobody take responsibility for nothin' nowadays.

I took the El home, thinking what was I gonna do. I had a nice place. Nice neighbors. I wasn't going to lose my home. I wasn't going to let my family find itself on the street again.

I went back to the damn classifieds. I called everyone I knew—and people I didn't know. Cold callin'. "Hello, my name is Bernard McCullough, and I'm looking for a job."

Click! Ain't no job here, motherfucker.

Suddenly I'm back to being a househusband. I'm getting Je'Niece to school and shopping for a little food and cleaning the way my grandfather taught me to clean. Buffing and mopping and keeping the water off the baseboards, and wiping that glass till it squeaked.

Whenever I'd see my nice neighbors, I'd smile like I didn't have a care in the world. I knew they were wondering what had happened to my job, and what was I doin' home all the time, dusting the corners with my little dust mop, but I wasn't going to look worried because I didn't want *them* to worry.

I knew something was going to turn around. I just didn't know when.

Long days, brother. Long, empty days.

I couldn't wait until it was time for me to get Boops from school. I couldn't wait for Rhonda to get home. I couldn't wait for us to be sitting around the dinner table together, a family.

And there was one other thing I couldn't wait for: late-night TV.

I was hooked on Johnny Carson and David Letterman. I ain't lyin'. It got to a point where I was looking in the paper to see who was going to be on, and I'd be flipping between the two shows to catch the best acts.

Johnny Carson—that's as good as it got. Man knew how to move. Had timing. Knew how to laugh at himself, too. If he told a joke that bombed, nobody found it funnier than Carson. He was very comfortable with himself. That's not something you see often. Man was gifted.

Letterman had launched in 1982, and he came at you from a whole different place. He was a little arrogant, and he liked to think he was smarter than everyone else, but he didn't lay it on thick or mean, so it worked. He was okay.

And of course there was that lineup of guests. There were the actors and assorted celebrities and whatnot, and they were fun to watch. But my real interest was in standup, and between Carson and Letterman you got a regular Who's Who of hot comedy.

Sid Caesar might show up. Richard Pryor. Jack Benny. George Carlin. Rodney Dangerfield was hot; I could watch that man put himself down for hours. Jackie Gleason. What can I say about Jackie Gleason? He was one of my heroes. You had Jerry Lewis, Don Rickles, Redd Foxx. And you had a slew of younger guys: Andy Kaufman. Billy Crystal. Steve Martin. Robin Williams. Steven Wright. And don't forget the women; God bless our funny women: Carol Burnett and Goldie Hawn and Madeline Kahn and Gilda Radner.

Too many people to name, and every last one of them contributing to my education. And it *was* an education. Hard work, I

tell ya. Hell, in those days, we didn't have a remote: You had to walk clear across the room to change the channel.

But seriously, I learned more about comedy in the space of a few months than I'd learned in ten years prior.

I began to see that there were basically four types of standup comics. The first type were the joke tellers. They'd just get up there and do bad jokes. You knew you weren't going to be seeing much of them in the future, and that worried me a little. I thought maybe I had a little of the joke teller in me.

Next were the political comedians. Guys like Mort Sahl, who were on top of all the current events. You'd read something in the paper only that morning, and there it was that very night, a routine on national TV.

Then you had what I call the "anthropologists." George Carlin was a good example. He was an observer. Watching people, studying them, dissecting them. Anthropologists can be very funny, but they're usually shut-down types. They never talk about themselves; never reveal anything personal.

Finally, there was the type of comedian I responded to: the ones who used their own lives to create comedy. I didn't know it then, but this was the kind of comedy that really reached me. It was comedy that came from pain. The comedy of Richard Pryor—when he got good again. Or Carol Burnett. She might be up there, stumbling like a drunk across the stage, but there was a depth to it that told you booze had made trouble in her life. What set these people apart for me was that they were true to themselves. Their comedy was honest comedy.

There was one other thing I noticed, and that was that each comic had his own style. There were similarities, sure, but comedy wasn't about copying the other guy. Comedy was about finding out who you were, and figuring out what you wanted to say—and then doing it in your own special way.

Middle of watching TV one night, the phone rang—and it rang *loud*. Unusually loud. I looked at it and knew in my heart it was bad news. "Hello?"

"Bean, it's Aunt Evelyn. I think your grandpa had a stroke. We're running him over to Roseland."

I got in my car and drove myself to the hospital. Aunt Evelyn was already there, along with some cousins, and I was just arriving when they called the McCullough family on the loudspeakers. We went over to the front desk and the nurse came out with a look on her face and already we knew; she didn't have to say anything. Aunt Evelyn and some of the others started crying. I asked the nurse if I could see him.

Grandpa Thurman was laid out flat. They hadn't even covered his face yet. Cheeks looked all hollow. I took my hand and set it on his forehead, which was still warm.

"Grandpa," I said. "I want to thank you. I want to thank you for everything you've done for me. I especially want to thank you for being hard on me." I meant it, too. He taught me things I probably wouldn't have learned from a more loving man.

"Grandpa," I said, because I wasn't done talking, "I'm going to be a comedian. That's right. You heard right. I'm going to be a comedian."

I don't know why that came out of me right then. Maybe because I'd had my fill of death and sorrow. But I knew I meant it.

My aunt and the others had worked their way into the room by now, and I guess they heard me, too.

"What you tellin' your grandpa?"

"I told him I'm going to be a comedian," I said.

"Here we go again," one of my cousins said.

"You watch me," I said. "I mean it this time."

And I walked out.

"YOU KNOW WHAT SHE USED TO SAY TO ME, MY GRANDMA? SHE USED TO SAY, 'BEAUTIFUL MORNIN', AIN'T IT SON? I GET ANOTHER CRACK AT THIS MORNIN', ANOTHER CHANCE TO IMPROVE MYSELF.'"

A couple of days later, I found out from the insurance company that my grandpa wasn't really my grandpa after all. So I'm thinking, *How many more unpleasant surprises has life got in store for me?*

I asked my aunt Evelyn to give it to me straight. Turns out that my grandfather fell in love with my grandmother the moment he first laid eyes on her. Only she was seeing someone else at the time. And she got pregnant with the child that would become my mother. And this someone else wasn't all that interested in marrying my grandmother. Which is when my grandpa stepped in. He was so crazy about her that he married her and was by her side when she gave birth to that baby—and the eight more that came after.

So, like I said, my grandfather wasn't a bad man. He was hard on me, and he didn't know how to love me. But he had a deep, abiding love for my grandma—and I respected him for what he'd done.

We had the funeral that weekend. It was real somber. All these people up there, remembering him, giving serious speeches. I looked at Rhonda, rolled my eyes. Went up front and started talking about my grandfather. But then he's taking over. I became my grandpa. Had the man down: the snortin' and shufflin', the deep voice.

"I'll knock your eyeball out, boy! *Step* on it. You think I'm lyin'? I ain't lyin'! Man's got to rederfrine hisself to succeed in this crazy world."

It wasn't a question of disrespect. I was honoring his memory. I was bringing him to life again, even if only for a few minutes. And everyone got it. They were laughin'. I did him and my grandma at the table. I did the bit about the corn bread and about ass whuppings, and I did his voice rolling like thunder over the congregation.

"Lord have mercy on you sinners!"

To hear that laughter. Man, it's like medicine. No, I'm lyin'—was like a drug.

Week later, I got home, woman called; she'd been at my grandpa's funeral, caught my act. "My cousin Joe passed," she said. "Could you come by and make us laugh?"

Say what?

I went. Got a few stories from her about her cousin Joe; kind of person he'd been in real life. Went out after the service and made them laugh.

When I was done, the woman came over and gave me $150. I ain't lyin'.

Then it's another funeral. And pretty soon the phone's ringing off the hook and I'm doing private parties and birthdays and more funerals.

One day, I turned to Rhonda and said, "I'm ready."

"What you ready for, Bernard?"

"You know what I'm talkin' about, woman."

"Spell it out for me."

"Well, it's like this. Comes a point where you have to stop waiting for life to change. You gotta change your own damn life. Life ain't waiting on you. You change it or it just don't get changed."

"Now *you* sounding like Grandpa Thurman."

I laughed. She was right.

"Rhonda," I said, getting serious. "Listen to me. I've wanted to be a comedian all my life. I have to stop making excuses. No one's stopping me except my own self. And if I fail, I fail, but at least I'll know I tried."

"It's not going to pay the bills, Bernard."

"I know that. I'm looking for a job. I haven't *stopped* looking for a job."

"I know," she said. "But I'm worried. That worries me, too."

"You're *always* worried, baby. What I want to know is, are you okay with it?"

She nodded.

"Might be some late nights," I said.

"I figured," Rhonda said, and she looked at me hard. But she was smiling.

So I started hitting the comedy circuit. Taste of Chicago. Chez Coco. The Dayton Gang. Every one of those places had started their own Amateur Night, and they'd give you a few minutes onstage—one short set.

"I knew this girl, her mama told her, 'If Jesus comes while you're having sex, you're going to hell.' I said, 'He ain't coming, woman. I put a little sign on the door: DO NOT DISTURB. Nailed it there with a cross.' Man, I got me some serious lovin' that night! Bust a nut three times. And that last time—I thought I saw Jesus."

When you nailed it, you knew you'd nailed it. When you didn't, the audience let you know—and they let you know *loud*.

"Get off the fucking stage, nigger!"

I'd get home at all hours of the morning and crawl into bed next to my sleeping wife. She'd moan and cuddle up to me. "How'd it go, Bernard?" she'd ask me. And I'd tell her:

"I killed."

"I bombed."

"I learned something new today."

Then I'd pretend I was back onstage and make Rhonda sit up in bed and listen to the whole routine: "Some guys, they marry their mamas. Yeah, you know who I'm talking about, girl—that guy there, sitting right next to you. They marry a woman tells them exactly what to do, how to do it, and when to do it. She tells him what to wear, where to go, how to park, what to eat, how to

hold the damn fork, and how much to tip the waiter. And he'll crank and moan about it, sure, but the truth is—he could never do nothing for himself in the first place."

Rhonda'd begin nodding off on me, and I'd say, "No, no, woman! Wait! I got this here other one." And I'd plunge in: "My granddaddy is a tough, hardworking man, and he isn't scared of much. But one thing he is for sure scared of is my grandma, Big Mama. She runs things over at our place. And when Big Mama's mad at him, brother—stand back. She gets tight-lipped and closes her eyes real slow, and then she takes a deep breath and always says the same thing: 'I'ma cut yo' ass in two.' "

Rhonda'd shake her head. "If your grandma could hear you now, Bernard McCullough!"

"You know what she used to say to me, my grandma? She used to say, 'Beautiful mornin', ain't it, son? I get another crack at it this mornin'; another chance to improve myself.' And that's what I'm getting, Rhonda. Every time I'm up onstage is another chance to improve myself."

The next day, we lost our nice apartment. We liked these people, and they liked us, but they came by to say that they needed the place—the daughter was pregnant—and how soon could we move out?

The next crib was a big step down, but we managed.

I told Rhonda not to lose hope.

I told her my comedy was getting strong. "I'm going to own this town someday."

She said she was happy for me, and went off to work. I watched her through the window. I saw she had that worried look on her face.

One night, at the Dayton Gang, I killed—I mean *really* killed.

I told about these old ladies from the Burning Bush Baptist

Church, all the time talking about how got-damn *blessed* they was, and I told it in a sweet, pitiful, old-lady voice: "I'm blessed, sister. I might be blind in one eye. The arthritis might be killing me. I take heart pills and my blood pressure is sky-high, but I'm *blessed*. Oh yes, sister. My diabetes is acting up somethin' fierce, and I got so much pain in my legs that I can't walk no more, and I ain't had a decent movement in years, but I'm *blessed*."

It was a freezing-ass night, like thirty below. I remember this because I'm walking the few blocks home from the bus stop at three in the morning, whistling like I'm on a Caribbean cruise. I get home, still whistling. Check on my baby girl. Kids so sweet when they sleeping!

Walk into the bedroom and Rhonda wakes up. Says in her sleepy voice, "What you so happy about?"

"I'm a happy man, Rhonda. You're a lucky girl. You married a naturally happy man."

"It's cold," she said, pulling the covers close. "Can't you put something up against that window?"

"Life is good," I said, fussing with the window like she'd asked.

"Good?" she said.

"Yeah," I said. "Not all that long ago, we was on food stamps. Now we got heat and electricity and the bills are getting paid."

"Turn that heat up," she said. "I'm freezin'."

"Well, here I am, baby. All the heat you need."

"Bernard Mac," she said. "I'm tired and I need my sleep and I got enough to worry about without worrying about you."

What can you do? Sometimes they're not in the mood.

"You worry too much, Rhonda," I said. "You should try to be more like me."

I meant it, too. I'm not a worrier. Worrying doesn't change anything.

But every person's different, and you can't try to change them. Rhonda was a worrier, like I said. Nothing wrong with that. Not for

me to judge, anyway. Plus I understood it: Rhonda wanted security. She wanted a nice house with tight windows and a backyard and maybe a fridge that didn't roar and shudder all night long.

Those are good things to want, sure. But let's be honest here: My wife was spoiled. She came from a family of girls that got everything handed to them. I ain't lying. Ask her. Their mama served those girls hand and foot, and their father—he was about as hardworking as they come.

My house was different. You need a pair of pants, too bad. Grandma needs glasses, and she comes first.

"What you doing there, Bernard?" Rhonda said, copping attitude. She buried deeper under the blankets, trying to get away from me. "Your legs like *ice!*"

"You got to have faith, woman," I said, snuggling closer. "I'll provide . . . Meanwhile, here's a little something to warm you up."

I was determined to make a good life for my family.

And in my heart I really believed I would.

˙///////////////////////////

One morning, early, the phone rang. It was a friend tipping me off about part-time work at Soldier Field, the stadium. I got the job.

I was there every Sunday before the game, and they had me moving beer kegs till the game ended. I was in charge of replacing the empty kegs with fresh ones, and I'd be running back and forth all day long, hoisting empty kegs and switching hoses and keeping the beer flowing. It was hard work, and I put a few inches on my upper body. People kept mistaking me for Arnold Schwarzenegger.

Meanwhile, I was begging this friend at United Parcel to get me a job. I'd already put in my application, and I was calling him every day, sometimes twice a day. Finally, one morning, the phone rang. It was my friend at UPS. "Bernie," he said. "Get your ass down here."

I hustled over to their offices at Roosevelt and Jefferson and got suited up and spent a week training. Orientation, invoicing,

rules of the road. At the end of the week, they said I'd done good, and that I started Monday. It was temporary. I was what they called part-time full-time. But things looked good.

I got home and Rhonda told me that the University of Chicago had just called about this other job, and I went to see them bright and early the next morning. It was a janitorial position, and it was on a trial basis, but they said I'd be hired permanent if I worked hard, and once I was permanent I'd get full benefits. This was the same deal they had at UPS, so I didn't get benefits at either place. But I had nothing to moan about. A week earlier I'd been unemployed. Now I had two jobs.

I worked the university job on alternate nights, from 10:30 to 7:00 A.M., then I'd hurry over to UPS and start my day behind the wheel. It got to a point where I could finish the janitorial stuff within four hours, which gave me time to grab a bite in Greek Town and catch forty winks before heading off to UPS.

And I still found time for comedy.

I was hitting all the usual clubs and plenty of new ones. Dingbats, Crystal Palace, High Chaparral (where I'd made my unofficial debut years earlier). They'd all jumped on the Amateur Night bandwagon, and it was pretty much the same at every club: You had five minutes to make an impression. If you did well, they let you keep going, and at the end of the night they might pat you on the back and give you ten or twenty dollars. But for me it wasn't about the money. Or the pat on the back. For me, it was about the laughter. It was about the lady in front busting a gut as she fell out of her seat. Laughter like that—it told me I had a future.

I'm not sure Rhonda felt the same way, and I can't say I blame her. Comedy—who made a living at comedy? *Stars*, that's who. And we were just regular people, trying to pay the rent.

She never said anything to dissuade me, though. Never put me down. Never questioned me. Still, I could sense her worry. I knew

she would've been happier if I'd been made permanent either at UPS or on my janitorial gig. Sometimes I got the feeling she hoped I'd go back to college. You know what I'm saying: She wanted me *serious* serious. But she didn't nag. If I wanted to pursue comedy, she wasn't going to stand in my way.

The thing is, it was my dream, not hers. She'd been brought up like most people: *Get a job, get a house, get a dog, buy insurance.* And there was nothing wrong with that. It's just I wanted something else. And I realized: If you have a dream, well, it's *your* business. You don't have to make other people understand it, and you probably shouldn't even try. All you have to do is make it happen.

My friends were pursuing dreams of their own.

Big Nigger was working at Presbyterian Hospital, running an X-ray machine, but he'd applied for work at the post office. A.V. was selling real estate. Morris Allen had been hired as a broker at Merrill Lynch. Kevin Carter was still over at Dock's Fish Fry. And Billy Staples—my main man Billy—he was still pimping women and scheming his get-rich-quick schemes.

They used to come to the clubs and watch me. If I was good, no one laughed louder than them. But if I was bad, they let me know.

"Nigger, you was off tonight."

"No, nigger—you stank."

But they said it nice. They were my friends.

And I didn't listen anyway. If I stank, I knew I stank. A thousand people could tell me I killed, but in that place deep inside me I knew otherwise. I've never been much good at lying to myself, and if I were, I still wouldn't do it. Can't see the point.

I started doing more private parties. Someone would see me at one of the clubs and ask for my number, and a few weeks later they'd call and offer me a little work. Two hours of joking would net me forty, fifty bucks. And I was happy to do it. I was getting paid to do something I loved, getting money to hone my craft.

I did children's parties, too. I went as a clown called Smoothie. Rolled my eyes and made the kids laugh. *Most* of them, anyway. Sometimes they'd take one look at me and run away cryin'. Some of the adults ran away, too.

Also did discos from time to time. Met a guy who knew a guy who knew a guy who owned a disco. Had me come by one Saturday to work the crowd; said to get out on the floor when the DJ took a break, do my thing.

I'll tell you, those were tough crowds. They were there to dance, not to hear some clown tell jokes. They were determined not to crack a smile.

I was back to doing my thing on the El train, too. And weekends, summertime, I'd try my luck downtown. At the parks. The museums. Competing with street musicians and mimes. My hat on the sidewalk in front of me. Not because it was about money—it was never about money—but because that's how it was. If you didn't put your hat down, people didn't understand why you were there.

But the stage was where I belonged. It's where I wanted to be. Don't get me wrong, the rest of it was fine. Parties, kids, discos, the El, whatever. Comedy was comedy. Funny was funny.

But the stage was a different league.

When that curtain goes up, you're in a special place. The spotlight's on you. When you're riding the El or out in the parks or at the discos, you have to win them over, draw them in. But at the clubs, people are there to be entertained—and you're the entertainment. It's as simple as that. They're expecting something from you—*Make me laugh, motherfucker*—and the pressure is on.

It's a challenge, and a challenge generally brings out the best in me.

For example, if I saw a guy in the front row slouched in his seat, not laughing—I'd work twice as hard. I needed to see that man laugh. Not to make him happy, but to make *me* happy.

Every time I was on a stage, I evolved. I learned something new. And my comedy was getting stronger. But the truth is, it was far from good. I was still a joke teller. A clown. I was looking for the easy laugh. My comedy came from the outside, from the world around me. I wasn't looking within. I wasn't going down inside me, to where it counted.

But I kept at it.

Some nights I'd be out till all hours, and come morning I couldn't get my sorry ass out of bed.

"Bernard, it's seven-fifteen," Rhonda would say, ridin' me.

I had to be at UPS by eight. "Tell them I'm sick," I said.

"You been sick three times this month already."

She was right. I'd sit up. My bare feet would touch the floor. Cold motherfuckin' floor. I'd get back under the covers.

"Bernard McCullough! Are you going to work or not?"

Je'Niece would start hollerin' in the other room. "Bring me my baby," I'd say. "Bring her here to cuddle with her daddy."

"Her daddy's going to lose his job pretty soon."

Shit. It's when you least feel like doing something that you most got to do it. I tried to remember that, but I didn't always succeed.

It was a day like that, with me putting my best foot forward, that I got to UPS and was told to turn in my uniform. Me and about a dozen other guys. It was all over. They weren't going to put us on the permanent payroll. Seems like, with all the benefits and everything, it was more profitable to just keep hiring new guys, training them all over again.

I went home and told Rhonda the bad news, but I wasn't worried. I'd been hearing a rumor that the university was going to put me on the janitorial staff full-time. On my way to work that night, I told myself I was gonna shine those floors till they

hurt my got-damn eyes. But when I got to work, everyone was standing around in a daze.

"What's going on?" I asked.

Lady named Henrietta spoke up. "Mac," she said. "This is our last night."

"*Last night?* That's crazy. Can't be. I don't believe you."

Lose both jobs on the *same damn day*? That was impossible. I really honestly didn't believe her. I went up to the fourth floor, my floor, and I worked that buffer like never before.

Break time, supervisor showed up. "I guess you've heard the bad news," he said. "But I don't want you to worry." He was full of mess. "I'm gonna get to the bottom of this." He was waving his fist like a preacher. "You're good workers, all of you. I'm not gonna let them do this to you!"

I packed up and left, and for several days I still hoped they might call. But I never heard from them again.

" **TIMES LIKE THAT,** I KNOW SOMEONE'S WATCHING OVER ME. THAT'S RIGHT, BROTHER. I BELIEVE. I BELIEVE IN GOD WITH ALL MY HEART, BUT I STOPPED GOING TO CHURCH A LONG TIME AGO. I DON'T NEED A CHURCH. I CARRY MY CHURCH WITH ME AT ALL TIMES, INSIDE MY OWN SELF. "

THAT 10

DARK PLACE IS WHERE MY PRAYERS GET ANSWERED

Every day I'd get Boops ready for school, and walk over with her. And when I dropped her I'd feel lonely inside. Lonely and useless. I'd go by the coffee shop and get me a coffee and look through the newspaper. You could see other guys had been into the newspaper already; classifieds all greasy. Maybe they were getting to the jobs before me. I figured I might have to start earlier.

But near the bottom I saw that Loomis Armored Car was hiring. The money wasn't much, but they had benefits—and with a wife and child those benefits meant the world to me.

So I went down to see them. I sat through an interview and aced the written test. They seemed to like me. They liked the fact that I'd already driven a truck for Sears and had my operator's license. They said it looked good. All they needed now was the background check, and then I could come back for the polygraph. "We're going to be training you in the use of firearms," they explained.

I went home happy. Went back two days later. Background had checked out fine; now it was time to hook me up.

The man that ran the polygraph got all the wires in place and began asking questions. "What's your favorite color?" "Is your name Bernard McCullough?" "You like cheeseburgers?"

Then we got into it deeper—drugs and liquor and whatnot.

And right quick, it was over. He told me to go wait in the other room. Someone would be with me shortly. I went off and waited. Ten minutes later, they took me back to the office. There was a look on the man's face.

"What's up?" I asked. I could see something was wrong.

"Why don't you tell me?" the man said.

"I don't know what you're talking about," I said.

"You didn't do so hot on the polygraph, Mr. McCullough."

"Oh?"

"In fact, you failed."

"Failed? How's that possible?"

Man showed me where the needle jumped. "See that. That's the part where they asked you about drugs. You lied about your drug use."

"No, sir," I said. "I don't do drugs. Must be a mistake. I'm known for *not* doing drugs. You can ask anyone. Call any of my references. A beer-and-a-half and I'm light-headed."

"I'm sorry."

"Maybe I can take the test again," I said. "I really need this job. I know I'd be good at it."

Man looked at me. "I'm sorry, Mr. McCullough," he said. "The position's been filled."

"Okay," I said. I got to my feet and stayed cool. "Thanks for the opportunity."

Two days later I was driving a school bus for the handicapped, and I did that for a couple of months. But it only paid a hundred bucks a week and I needed more than that to make ends meet.

I called my buddy Kevin Carter, at Dock's Fish Fry, and asked if he had anything. He'd been working there since high school, when Dock's only had one store. Now they had about twenty of them, and he was managing one of them.

Kevin said the Fourth of July was coming up, and they always got crazy busy on the Fourth. He said he might be able to put me downtown as a cook, and I told him I would take anything he had.

"I'm not going to lie to you, Kevin. I'm pretty desperate."

"I'll see what I can do," he said.

Within the hour, he called back and gave me the particulars, and the next morning I made my way downtown.

Guy there taught me how to cook. It was just fish, fish and shrimp and fries, but fish mostly, and there was an art to it. You had to pat the fish dry, throw it in the flour, flip it over, do it again, and lay it into the deep fryer real smooth. The fish had to come out nice and flat, not all curled in on itself.

Man, it was *hot* in that place. I was making three twenty-five an hour and I was on my feet fourteen hours straight and I was sweating like a stuck pig. I was there all weekend. It was so bad I almost wept from the heat. I must have lost ten pounds. My feet were killing me.

By the time my last shift finally ended, at the close of the holiday weekend, I could barely walk. But I didn't know anybody there to ask for a ride, so I said good-bye and made my way over to the El. The streets were still crowded with people, must've been a million of them, and it seemed like all of them were on their way home at the same time. It was a good thing the train was crowded, though: Only thing propping me up was the bodies around me.

The following week, Kevin called. "They like you," he said. "They want to hire you full-time."

It was humiliating. I'd gone from making seventeen dollars an hour at General Motors to eight dollars as a janitor to a lousy three twenty-five as a fry cook, maybe the hardest work I'd ever done. And all I could think to say was, "Thanks a lot, Kevin. I really appreciate it." And I *did* appreciate it. Honest to God.

The next day, I reported for work at the Dock's on 35th and Wabash. All day long, people screaming: *Large shrimp! Gimme another bucket! Twenty piece! Fish and chip—three times!* Sliding the filet into the oil real smooth, come out flat.

It was regular work. Things were going along at home. They was tight, but we were managing. I was in charge of the groceries and the phone and the electric bills. Rhonda took care of the rent—she was making more than me. She also made sure there was always a cold beer waiting for me when I got home.

Some nights I'd stumble through that door, dog-tired, and reach for my ice-cold beer and drop onto that *Alien* couch of ours. Beer went down good. I'd drink it and go look in on Boops after. Baby's sleeping. Left a little note for me. "Daddy, they having the

hot lunch tomorrow at school. I need two dollars." I would reach into my pocket and lay the money on the dresser, even if it was all the money I had left.

Sure enough, there'd be days I got to work with twenty-three cents in my pocket—not even enough to get home. But I wouldn't worry. I would do my job. I had fourteen hours of work ahead of me. I'd worry later.

One night, near about closing time, I was beginning to worry. I hated to borrow money, but I needed a dollar for the train. Just then, I heard a woman calling: "Sir! Sir!" I looked over. It was this lady I'd seen in there lots of times before, a regular.

"Yes, ma'am?" I said.

"This is for you," she said, and she slid a five-dollar bill toward me.

"For me, ma'am?"

"Yes," she said. "You always so nice to me. You always smile so pleasant. I wanted to show my appreciation in some small way."

Little things like that happened to me all the time.

Another time, one Saturday, I was home going through the bills, and I realized I needed $150 by Monday. The phone rang. Man said he saw me at Dingbats a few weeks back and wanted to know would I do a party for him.

"Would a hundred and fifty dollars cover it?" he asked.

Times like that, I know someone's watching over me.

That's right, brother. I believe. I believe in God with all my heart, but I stopped going to church a long time ago. I don't need a church. I carry my church with me at all times, inside my own self.

When I think of prayer, you know what I think of? I think of my mother telling me to go down into the darkness to be alone with my thoughts. That dark place is where my prayers get answered.

God helps those who help themselves.

If God had told me to put up my microphone and follow Him down a different road, I'd have done it, brother. That's how deeply I believe. I wouldn't even have *thought* about it. But God wasn't telling me any such thing. God was telling me to make people laugh.

And that's what I was going to do.

I was a cook at Dock's Fish Fry, and I was working sixty-hour weeks. But I was also a comedian. I believed that with all my heart. And I kept at it. I was going to keep my promise to Rhonda. One day, I was going to own the town.

Everything was clicking. *Ding ding ding.*

Meanwhile, I had some fish to fry.

"HEY, WHAT CAN I SAY? I WASN'T ALWAYS A SAINT"

YOU
SUCK!
GET OFF
THE MOTHERFUCKIN'
STAGE,
MOTHERFUCKER.
ET YOUR UGLY ASS
UT OF HERE.

11

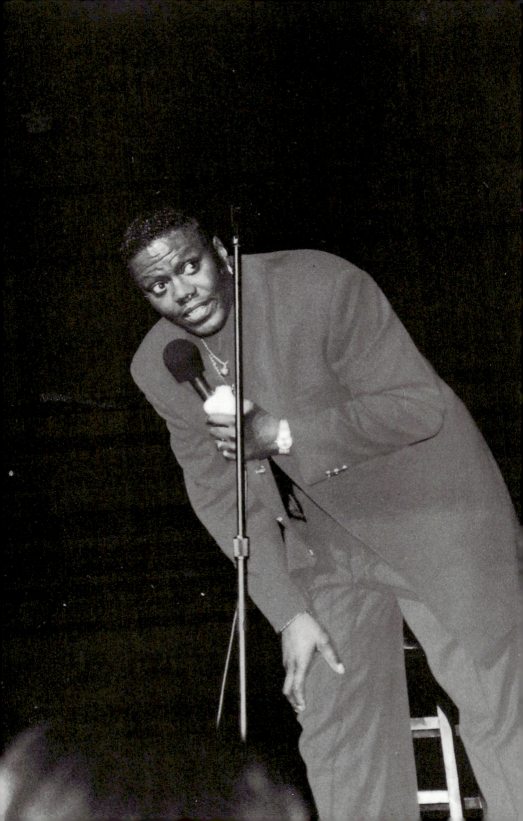

Rhonda used to come to the clubs to watch me from time to time, but she was doing late shifts at the hospital. Most of my friends had jobs, too. Morris was at Merrill Lynch and A.V. was building up his Realtor business and Big Nigger was putting in long hours at the post office. Still, they came when they could.

The one who seldom missed a show, though, was my man Billy. Of course, it was easy for him: He was always between jobs.

I loved having him there. He was fun to be with, he was smart, and he was a bit of a comedian himself. Some of the stuff I did onstage, it came from him. I ain't lyin'. The man'd be scribbling jokes on paper napkins till it was time for me to go up.

"My wife, she know how to take care of herself. Her hair, her nails—she always just right. I get home, and she look *hot*, and I want me some of that. But I'm hungry; a man needs fuel. I ask her what's for dinner and she don't even get up from in front of the TV; says for me to look in the fridge. I look. I find one egg in there, cracked. Some old potted meat, all black and hard. I go back and tell her, 'Woman, you want to get laid—I need some food in me!' She still lookin' at the TV. She don't even turn to look at me. 'Who says I want to get laid?' she axe."

That was Billy Staples's humor. The women in his humor always kind of mean. But that's the kind of women he picked. He wasn't smart about women. He could have been something, that Billy, but he didn't believe in himself. He had no self-faith. So he'd find women who'd take care of him. That was the "pimp" side of him.

Billy was seeing a girl at the time; I'll call her Shawna. They'd been together for about a year, and Billy thought she was it—a real class act. She had her own hair salon and drove a Mercedes-Benz and usually popped for dinner. Took care of him, like his women always did. But there was a big downside to Shawna,

which is that she was very jealous. *Pathologically* jealous. Billy couldn't go anywhere without her knowing where he was going or why, and how long he'd be away.

Shawna was mostly okay with me. She knew Billy and I were close. But lots of times she wouldn't let him out of the house. She had about seven locks and chains and shit on her front door, and one of them was a dead bolt. And on more than one occasion Billy called from her place to say he wasn't going to make it; Shawna had locked him in.

He didn't make it for my grandfather's funeral but showed up later, at the house, with Shawna. She was clinging to him, holding on for dear life, and when he finally tore free for a moment, he came over and said how sorry he was about missing the service, and how Shawna had locked him in again, and he gave me that little broken-faced look of his.

"Hey, Billy," I said. "You're here now, man. So don't worry about it. You done it. You came and showed my grandfather your respect and that's what counts."

That's all the words I got out, because suddenly Shawna surfaced between us like a shark. "I'm ready to go now," she said.

"Honey," Billy said. "We just got here."

"Didn't you hear me, Billy? I said I was ready to go."

Said it loud, too. Everybody watching now. No respect at all in that woman.

"Shawna—"

She wouldn't listen. She stormed out and slammed the screen door on her way, slammed it hard, and everyone turned to look at Billy, see what he was going to do. Everyone knew the girl had her claws in him deep. He was so embarrassed he hung his head.

"Billy," I said quietly, not wanting him to feel even worse. "You go ahead with your girl."

And he said, "Beanie, I'm sorry, man." And he hurried after her and got in her Mercedes-Benz and they left.

The next day I got with him again, and he was all apologetic. And I said, "Billy, I'm going to tell you something. We're brothers. That girl is nothing but trouble. You should get away from her. The sooner, the better." He didn't answer me. He looked at the wall. I remember thinking that Billy seemed like drug addicts I'd seen, all morose and missing it. Only his drug was Shawna, of course.

Sometimes he'd try to fight it. I'll give him that. One time he got a big carpentry job at a housing development and looked like he was going places. He was happy, and he liked it. But Shawna didn't like it. She was so insecure that she'd pop up on the job to make sure he wasn't fooling around with any of the secretaries. He wasn't fooling around with *anyone*. He loved Shawna. And he asked her nice to please not keep coming by the site; she was jeopardizing his job. But she kept coming by and sure enough he got fired, and he called me to come get him. I pulled up and he was waiting on the corner with all his tools. We went for a beer.

"You got to leave that girl," I said. "She gonna kill you."

Sure enough, one morning I get a call that Billy's in the hospital. He and Shawna had been at a party the night before and he ran into this old girlfriend from high school, and the girl hugged him. And Shawna went off and threw a drink in his face and started hollering like she was being murdered or something, and security came by and told them to leave.

Billy said he was going home without her. He'd had enough. And he stormed out and got on a bus. But Shawna followed with her car, and when he got off at the bus stop, she ran him over. If it hadn't been for the concrete bench at the corner, her car would have climbed right over the sidewalk and killed him for sure. As it was, he had a cracked rib and a fractured ankle and contusions all over his body. The ambulance came to get him. And the police, too. Plenty of witnesses had seen the car and got the license plate, but when the cops went to the hospital to talk to Billy he wouldn't press charges.

I was furious. I was tight. He came over to my house on crutches, and I had to practically carry him up the stairs. "Billy," I said, and I read him the riot act. "I'm going to tell you again. That girl is going to kill you."

"No, man, Beanie—you don't understand. Shawna's a good girl. She's just never had anyone in her life be good to her. Everyone always abandons her."

"Sure they abandon her! They abandon her because she's no good. The girl is crazy."

"No, Beanie. Don't say that." He wanted so bad for me to like her. "She just needs help."

"I ain't arguing with that! Girl needs lots of help. From a *professional*. Not from you."

He went back to her. Like a beaten-down junkie. Reminded me of that singing wino in the old neighborhood, fighting with his own self about the damn bottle. "Give it back, nigger!"

Whenever I called over to her place to talk to him, I was very respectful. But Shawna liked to taunt me. She knew I didn't like her. "Mr. Mac Man! Big Bernie. How's the funny man?"

"Doing good," I'd say, and eventually she tired of it and put Billy on the phone. I'd tell him I was going to a club that night, and asked could he come. But things were tense over there; lots of times she wouldn't let him, and it shamed him.

One night I did a party for this girl I'd met through work, and Billy came along—and brought Shawna with him. I did my show and had them rolling on the floor. Even Shawna was laughing.

After the show I sat with them for a beer, and when Billy went off to find a bathroom, Shawna got all earnest with me. "Bernie," she said. "Why don't you like me?"

"I'm sure I'd like you fine if I knew you," I said. "What I don't like is the way you treat Billy. Billy is my main man. I love that boy. I hate to see him hurting."

"He's my main man, too," she said. "And I love him, too."

"I don't think what you do is called loving," I said. "This ain't my business, but you asked. And I'm going to tell it like it is. I can't pretend it's okay."

Billy got back to the table, and he could see we was tense. He hated that. He loved Shawna, or *thought* he loved her, and he didn't want his best friend and his woman not getting along.

A few days later he came over to the house and sat there and hugged me hello and played with Boops while I got dressed. Like I said, Billy was funny. He could do Woody Woodpecker and stuff and get Boops laughing till there were tears in her eyes. He was her favorite uncle, good old Uncle Billy.

We went out to Popeye's for chicken later. Loved that spicy chicken and those red beans and the jalapeño peppers. And while we're chowin' down, Billy's mood got dark. He showed me the tip of his little finger and said, "A bullet this size can take your life."

I looked at him. "What're you sayin' that for, then?"

But he wouldn't answer. He got all quiet.

So I asked him again. "Where'd you come from with that, Billy?"

"Nowhere," he said. "It was just a thought."

But I knew it was more than a thought. Next day I called my friend Morris Allen, over at Merrill. Said something was up with our friend Billy. "I'm real worried about him." We got him over to the house a few days later, me and Morris and another friend of ours, Tony, and had some takeout and a few beers. But Billy wasn't in any festive mood.

"When I die," he said, "I want to make sure my son's taken care of."

He had a son with another woman, from when he was in high school. He looked over at Morris and began asking for financial advice, and Morris told him about living trusts and such, and how not to get a big tax bite (as if Billy had that problem), but I stopped all the money chatter and looked dead at Billy.

"Man, what's going on with you? You're among friends here. What's all this talk about bullets and dyin'?"

"Nothing, Bean. I'm just talkin'. I'm thinking about my son. I wish I could be a better father to him."

But that wasn't what he was thinking about. When I went off to get more beers, he followed me into the kitchen so close he was breathing down my damn neck. Gave me a scare. "Man! What are you creeping around for? Make me jump like that."

He's all serious. "Bean," he said. "If anything happens to me, I want you to get Shawna."

"What?"

"Just promise me that," he said, and I saw he had tears in his eyes.

I cornered him right then and there, in the kitchen, but he didn't tell me nothin'. He slipped back into the living room and joined the others.

Later, I dragged him to this club called Sandpipers, just the two of us, and I still couldn't get nothin' out of him. My main man wouldn't talk to me. Then these two girls came over and one of them looked at Billy and said, "Come here, you handsome devil. Dance with me." And Billy went and danced. But he wasn't even looking at this pretty girl. He was only thinking of Shawna. She'd be wondering where he was, maybe even looking for him now.

He came back from dancing and I said, "See that? Everywhere you go, women want you. But you got to pick the one that's trying to kill you. Tell me what the hell's going on, Billy?"

He still wouldn't talk to me. I was getting tight, but he didn't care.

Now it's four o'clock in the morning and he said he was hungry and we went over to Harold's Chicken, on 71st and Racine. Half the

city was there. Hustlers and pimps and gangsters and whores, gettin' their fill of chicken. And we ate and I took Billy back to Shawna's and her car was gone. And Billy put his head down like he knew he was in trouble. I tried to talk to him again, but he opened the door and ran off and left me there, more worried than ever.

I was still putting in my hours at Dock's, where they'd raised me to five hundred dollars a week, and I was getting plenty busy at the clubs.

Whenever Amateur Night came along, the emcees knew I'd be there—and they were happy to have me. But they never paid me. They all said the same thing: "It's about exposure, Bernie. You're getting known all over town. You're hot, brother."

I was hot, too. Other aspiring comics would come looking for me after my bit, to ask me about their own routines. Some of them were terrible, and I said I couldn't help them. But some of them were pretty good, and I started opening doors for them at different venues—the places where I was already known. It was like a little side business for me; I was playing manager. If I got a call about a party or a funeral and I couldn't make it, I'd tell them I had someone who could take my place. It worked out good. I had a good sense of what kind of comedy would work where, and I got very few complaints. Plus if there was a complaint, I always took care of it.

For my own self, though, there was some growing frustration. I felt I was being taken advantage of. I'd see where they might put my name on the marquee, but they still didn't mention any money. But what could I do? Comedy was a *calling*. And it was calling me loud.

People would be coming into Dock's and they'd see me back there at the fryer and do a double take. "Wait a minute," they'd say. "Ain't you that comedian?"

And of course the guys at work didn't know about that, and when they found out, they'd rag me. "If you so funny, what you doin' fryin' fish, boy? Why you even need this job?"

It didn't bother me. I stayed focused. I was moving forward on all fronts.

My only genuine worry at the time was Billy Staples. I never seemed able to get him on the phone, and when I did, he didn't sound like himself. He was blue and short with me and always busy with something else.

"Why you pulling this shit with me?" I told him once, getting angry. "This your brother Bernie you talking to."

"I gotta go, Bernie."

"Don't do this, man! You're pissing me off!"

Then I'd hear Shawna hollering in the background: "Billy! You gonna keep me waiting all day?"

"Like I said, Bean—"

"I want you to call me later."

"I will."

"Promise me you'll call."

"Promise."

But he didn't call. I was all the time trying to track that boy down, and always with less and less success.

////////////////////////////////

One night I got a call from the Cotton Club. They had a regular there, Bob McDonald—very funny guy. When they first discovered him, he was a mess—had a drug problem. So they got him cleaned up and fixed his teeth and put him in a tuxedo. And when he was on, he was very, very good.

But this one night he didn't show. And they knew about me, of course. But they didn't really think of me as the main attraction. They thought I was a good opener, a warm-up act. And the reason they thought this is because they'd never given me a chance.

So they called and asked if I had a suit. I told them sure, I had a suit. I had two suits, motherfucker. They said they needed me

that weekend. "Two nights, three shows each night—and we'll give you five hundred dollars."

I was thrilled, but you know Bernie—he keeps it inside. "Okay," I said, real calm, real smooth. "I'll be there."

I was flying when I got off the phone, but you wouldn't know it from looking at me. I was also thinking that I didn't have a suit, but I had some dark slacks and a white shirt and I could borrow a coat that almost matched.

Friday night, I hustled down to the club. The place was packed. A jazz band was playing. Time came, I got up onstage and did my thing.

"What is it about black people on TV? You know what I'm talking about? Must be a conspiracy or something. Maybe them white people who run the shows are giving them too much direction." Then I'd do my white voice, impersonating a TV executive—though of course I'd never met a TV executive: "Okay, here's the thing, Mr. Jones. We want you to come out and dance. And really shake it, like you people do. Then I want you to fight with your girlfriend, but *loud*. You know—loud and scary; your regular voice."

People eatin' it up, roaring. Then I'd go back to my regular voice and say, "You know what that's called? That's called *bringing out the nigga in you*. My grandma used to say that all the time: 'Don't bring out the nigga!' "

I'm not a guy who overprepares. I get up there and talk about people I know or people I've met, or I see someone in the front row wearing a red dress or something and I run with it. It's more instinctual with me. I don't sit home and polish the material. *Talking shit*, I call it. And as long as they're laughing, I know I'm on the right track.

And that night I was on the right track all the way. The jokes. The impressions. Singing along with the band. Audience loved me. Ate it right up. Heard 'em in the front row: "That Bernie Mac, he *funny*."

I could hardly get to sleep that night. Adrenaline, I guess. And the whole next day I was still wired.

I went back that night, Saturday, to honor the rest of my commitment. And I had all new material. You didn't want to be doing the same tired-ass routine, even if most of these people hadn't heard it. You want to keep fresh and on your toes. And that's what I did; I kept it fresh and killed all over again.

"I was a sex champion at one time, but those days are over, motherfucker. I'm *old* now. Old and tired. Best I can do now is three minutes. It's all I got. It's all I *want.*"

I walked off the stage, savoring the laughter and applause, and made my way back to the manager's office.

"You're getting hot, Mac," he said. "Hot hot hot."

"Thank you," I said.

He pulled out his big-ass checkbook and wrote me a check and handed it over with a big-ass smile. I looked at the check. I wasn't smiling no big-ass smile.

"A hundred and seventy-five dollars? You said five hundred."

"Five hundred? I'm sorry, Bernie. You must've misunderstood. It was a hundred and seventy-five."

I took the check and left. Didn't make no big deal about it, neither. Just walked out, thinking about what my grandmother had told me long ago: "Life is a heavyweight fight, Bernie. Protect yourself at all times." How right she was. I'd given the man an opportunity to fuck me, and he'd fucked me. I had no one to blame but myself.

Next day, I looked in the Yellow Pages and called the Crystal Ball Agency. I told them I needed representation. I seemed to be able to take care of other comics, but it looked like I didn't know how to take care of myself.

I sent them a demo tape. They called back two weeks later and said I was out of style. "What do you mean I'm out of style?" I said.

"I can do any style you want. I'm just getting good."

"Well, I'm sorry," the lady said. "You're not good enough."

<p style="text-align:center">***</p>

I took my next paycheck from Dock's and went to a record store and bought three hundred dollars' worth of records. Cosby and Pryor and George Carlin and Bob Newhart and Pigmeat Markham. Everything they had. And I went home and sat there listening to them over and over, until Rhonda and Boops was sick of hearin' the jokes. They didn't understand. I was trying to figure out what made comedy work. I wanted to be a comedian worse than ever. "I can't believe you spent three hundred dollars on records," Rhonda said. "That's a lot of money. What if you get sick—"

"So what if I get sick!?" I snapped. "What if I lose my job!? What if I get hit by a car on my way to the store!? Got-damn it, woman— comedy is what I want to do with my life. Can't live with all these *what-ifs.* What if the got-damn sun don't come up tomorrow?"

Hey, what can I say? I wasn't always a saint.

One night I did a private party, and there was a guy there that said he knew Arsenio Hall. He said Arsenio was coming out to do a show at one of the hotels, and maybe he could get me a crack at the stage. Guy got tickets for my whole family. Rhonda, her parents, some of my friends.

Big night comes. We had our own table. Arsenio came on before dinner and killed, and then we had dinner and it was comin' on my turn. Rhonda was a little nervous. She kept asking if I was ready, and I told her I was always ready. You know me: I don't believe in overpreparing. I had my shit *down.*

Well, I got up there. Must've been a thousand people in the audience. I ain't lying. Every last one of them was looking at me. I'd never experienced anything like it before.

"Good evening, ladies and gentlemen," I said. "My name is Reverend Doo Doo, and I preach a lot of shit."

Well, they went crazy. They were booing so hard I couldn't even get a *good* joke out. It was like being in a fight: I could still hear the echo of the opening bell, but I was already flat on my back.

People were throwing bread rolls at me. I ain't lyin'. One woman threw her drink—and the glass with it. I tried to say something else, but they drowned me out with their angry hollering.

I didn't know what to do. I looked over at my family and saw how they was dyin' inside. Jesus.

Now the audience was getting ugly. They were screaming: *You suck! Get off the motherfuckin' stage, motherfucker. Get your ugly ass out of here.*

So I got off. And that's when I got my standing ovation: Motherfuckers were so happy to be rid of me they stood up and cheered.

My family was devastated. On our way out, my mother-in-law said, "There's always another day, Bernard. We'll get another day." But I didn't believe it. I'd never been so humiliated in my life.

I remembered what my mama'd said, about failure being life's way of preparing you for success. And for the first time in my life, I questioned her wisdom. What if she'd been wrong? What if failure was just preparing me for more failure?

I was scared. I can't deny it. For the first time in my life, I was scared to death.

///////////////////////////////

Right after that terrible humiliation onstage, well—worse came. Hell, I don't even know how to tell this story. Just thinking on it rips my heart out. But I'll try.

Like I said, I'd been calling Billy all the time, and I could never get him on the phone. And the once or twice I managed to get through, he wasn't sounding like himself. I called Big Nigger. "Something's going on with Billy," I said. "Billy's not himself, he sounds scared, and it's really beginning to worry me."

I called Billy umpteen times more and still couldn't get him on the phone. So I left a message to meet me at Rhonda's house later. When I got to Rhonda's parents' house, he wasn't there. So I called him again, and nothing. I tried again the next day and the day after that, and still nothing.

Sunday, I'm watching the football game, still trying Billy, and I had to be at Dock's at 4:30. And just before I left for work, I got through—to Shawna.

"Big Mac, how you doin'?" It was her usual game. I told her I didn't have time to talk, and to please put Billy on. He came to the phone. "Hello," he said. He sounded groggy.

"Where you been, man? Don't you get my messages? What you doing? Sleeping?"

"It's the only way I find peace, Beanie."

"What the fuck is going on, Billy?" I said. I was steamed. And I guess being worried only made it worse. "I need to talk to you. Tomorrow's Monday, and there's *Monday Night Football*. Bears are playing Miami. Game comes on at eight. Rhonda's going to make some chili. You're going to be here, and you're going to give it to me straight. And if you're not here, I'm gonna come and get you."

I went to work that night and went back again Monday morning to open the store. It was snowing pretty heavy, and while I was watching it come down I called Billy to make sure we were still on. I got through to him. He sounded a little better. He said he'd be there; wasn't going to miss Rhonda's chili for nothing. That was my old Billy.

By the time Rhonda came to pick me up at work, there was a foot of snow on the ground. Morris called to say he wasn't going to make it: too much snow. Then A.V. called and said the same thing. I called Billy. I said I had the beer on ice and more chips than we could eat, and that the chili smelled good—perfect for this cold night. He said not to worry; he was on his way.

But he didn't come. And then the phone rang and it was Billy, with Shawna screaming and hollering at him in the background. "Come and get me!" he said. "Come and get me right the fuck now. I'm sick of this shit!" The phone clicked off. I went to get my boots and the phone rang again. I thought it was Billy, but it was Morris. I told him about Billy's call, and that I was going to drive over and get him. "You stay inside the house with your family," he said. "There's two feet of snow on the ground. You won't make it in that car."

I looked outside. It was for sure a blizzard. Snow was up to near the windows. So I called Billy and Shawna answered. "Big bad Bean," she said, laughing and sounding crazy. "What's up?"

"Let me speak to Billy," I said.

"You comin' to get your boy?"

"Let me speak to him, Shawna."

She started singing that Michael Jackson song—"You bad, you bad"—and Billy got on the phone.

"You comin' to get me?" he asked.

"I can't even get the car out," I said. "But I see the buses are still running. They the only ones on the road."

I could hear Shawna singing away in the background at the top of her voice. Something wasn't right with that girl. Billy turned and screamed at her to shut up.

"Billy?" I said. "Billy, come on. I got chips and popcorn and beer and chili and Miami is killing the Bears. They're kicking ass. They broke their streak."

"Okay," he said. "I'm coming."

I sat down to watch the game and wait, and the phone kept ringing. It was Morris or A.V. or Big Nigger, everyone following the game from their home, not together at my place, like we'd planned—all on account of the damn snow. And everyone was excited and worked up. "Look at these motherfuckers!" "They gettin' their asses whupped!"

An hour went by. Still no sign of Billy. I went to call him again when the phone rang, and I thought for sure it was him. "Billy?"

"Hi, Bean." It was Shawna. She was slurring a little, sounding strange.

"Where's Billy?" I said. "He on his way?"

"Your main man? Your main man Billy went for a walk."

"What do you mean a *walk*? In this weather? He was supposed to get on the bus and come over here."

"Bean, you know I love Billy, right?"

"What are you talking about?"

"No matter what happens, you'll still love me right?"

"Shawna, what's going on over there? You're not making any sense. Put Billy on."

She hung up on me. I was really worried now. I went out in the blowing snow to see if maybe I could dig the car out, but Rhonda was rapping on the window that I was wanted on the phone. I went back inside and picked up the phone. It was Shawna again, and she was crying.

"You'll love me no matter what, right, Bean?"

"What the hell's going on, Shawna? Put Billy on."

But she hung up on me again. I called A.V. Told him something was wrong and I was going over. He said I'd need a tank to get through that snow, and for me to forget it. "We'll go over first thing in the morning," he said. "Take care of this once and for all."

I called over to Shawna's again, but the answering machine was on. And when I tried again after the game, it was still on. So Rhonda and I looked in on Boops and went to bed.

At ten the next morning my phone rang. It was this woman from work who knew Billy and me was tight. Everybody liked Billy down at Dock's. "What's up?" I said.

"You heard about Billy?" she asked me.

"What about him?"

"Billy's brother Eric just called here, looking for you."

"Something happened to Billy?"

She didn't want to tell me, but she had to tell me. "I'm sorry, Beanie. Billy's dead."

Then the phone clicked and it was Eric, to tell me what I'd just heard. And Billy's mother takes the phone from him and she was in terrible pain. "Oh, Bernie," she said, crying. "She killed my boy. She shot him. She killed my little Billy."

I was crushed. Tears were pouring down my cheeks. My main man. I could have gone to get him, snow or no snow, but I didn't go. I felt awful. Boops came into the room. Nine years old, and she sees me crying and knows something is very wrong.

"What's wrong, Daddy?" she asked me.

"It's your uncle Billy, honey," I said. "He's dead."

She started sobbing, like her heart was breaking. I held her in my arms. My heart was breaking right along with hers. I couldn't accept it. I kept wondering what he must have felt like. Was he in pain? What were his last thoughts? Was he maybe thinking how I didn't come to get him? That I'd failed him? Was he already dead that second time Shawna called? Was he lying there bleeding?

The phone rang again. It was Billy's mother, still crying a river. "Beanie," she said. "When the trial comes, please don't forsake us." And then I remembered what Billy had told me. "Bean," he had said. "If anything happens to me, I want you to get Shawna."

But I didn't get Shawna. They charged her with second-degree murder and she got up there and said Billy used to beat her all the time. She was only defending herself against a violent, no-good man. They showed the jury pictures of her body, marked up with ugly bruises, and they said Billy's fists and feet had made those bruises.

Before I took the stand, they asked me if I was sure I still wanted to testify. I said yes, more than ever. I would tell how crazy that woman was, how she had my Billy hooked. And they took me

into a small room and showed me pictures of Billy. There was a little hole in his right temple, where she'd shot him at close range. He'd fallen forward and hit his head on the edge of the dresser, they told me. They said he died instantly. He didn't suffer.

"Oh, he suffered," I said.

I went and gave my testimony, but it didn't do a damn thing. Shawna walked out of there with probation, a free woman. I'd made my main man a promise I couldn't keep. And I kept thinking about the snow. And how he'd still be alive if I'd only got in the damn car and gone to get him.

I would never see his handsome face again. I would never hear him laugh again. Never.

Billy had suffered. And his family had suffered. And I was going to suffer for a long time to come.

Billy. My nigger. My main man. I miss you, Billy. The world is a lonelier place without you.

"STOP LIVING IN THE PAST, BEAN. YOU CAN'T CHANGE WHAT HAPPENED JUST LIKE YOU CAN'T CHANGE THE FUTURE BY WORRYING ABOUT IT. YOU JUST HAVE TO KEEP MOVING, SON."

12

MUST BE A GOT-DAMN STORM RAGING INSIDE YOU

Billy had a big funeral, with people getting up to remember him and pray and sing and tell stories. Normally I was the one who cheered the mourners at these events, with my comedy routines and such. But I didn't find the strength for it that day.

They sealed the coffin, and we took him to the cemetery and buried him.

It was a grim day. Raining. With ice everywhere from the big storm. Me and Morris left the cemetery and picked up a case of beer and went and sat in a park. We were the only ones there, two sad fools drinking beer in the cold rain and missing their friend Billy.

"I should've gone to pick him up," I said. "Blizzard or no blizzard, I should've driven over."

Morris kept telling me I was crazy to be thinking like that; that it wasn't my fault; that I had begged Billy umpteen times to open up to me and he never came clean about the serious trouble he was in.

Still, I couldn't help blaming myself. That's the way guilt works. I kept going back to the times I felt I wasn't there for him, and it was driving me crazy. I couldn't stop dwelling on it. It was with me during the day, and it kept me up half the night.

My only solace was in work. I lost myself in my work. They had about twenty Dock's around town, and at one point or another I must've worked in every last one of them. Pat the fish dry, throw it in the flour, flip it over, repeat. Then lay it in the fryer smooth. My fish would always come out flat, not a curl on it. Amazing how a man can disappear into his work. Not think of anything else. Keep it deep inside. Hidden.

But I was kidding myself. The thoughts of Billy were never far behind.

"You have to stop thinking about this," Rhonda told me.

She could see it was making me crazy, and it worried her. I'd always been hard to read, hard to ruffle; now I was walking around like a zombie. It was showing on my face. In my eyes. In the way I moved.

"Billy's the only one who believed in me," I said. "He's the only one who thought I was going to make it as a comedian."

"That's not true," Rhonda said.

But I wasn't listening.

On July 4, I was walking around in my usual daze when I got hit in the forehead by an M-80 firecracker. Woke me the fuck up. Blood was pouring down my face and my ears were ringing so loud I couldn't hear anything. I felt like I was underwater. My cousin came running over and started hollering at me, but I couldn't hear a word. I could just see his lips moving, and the worry on his face. He grabbed me by the arm and helped me home, and Rhonda lay me flat on the bed and put an ice pack on my head.

But my damn head wouldn't stop bleeding, so Rhonda took me to Jackson Park Hospital. When the nurse finally got around to taking my blood pressure, she looked at the gauge like it had to be wrong. She tried again. This time she looked plain worried, and it worried *me*.

"What's wrong?" I said.

"Nothing," she said, and she hurried off to get a doctor.

The doctor told me my blood pressure was 190 over 120. I didn't believe him. I said I felt fine and went home. I lay down and took a couple of aspirin for the headache and went to sleep.

The next morning I got up and had breakfast with my family, then walked Je'Niece to school and went to see my own doctor, a man I trusted. He took my blood pressure and looked at me funny. "Bernie," he asked. "Did you run over here?"

"No."

"This is very bad," he said. "Your blood pressure is 220 over 140."

"That can't be right!" I said. "That's worse than yesterday."

He put some kind of tablet under my tongue and told me to hold it there until it dissolved, then wrote out a prescription for hypertension.

"I don't understand this," I said. "I've always been healthy as a horse."

"I know," my doctor said. "I don't understand it, either. What's on your mind, Bernie? Must be a got-damn storm raging inside you."

And suddenly I knew what he was talkin' about; knew just the storm he meant. I'd been thinking about Billy. I'd been thinking about all the times I wasn't there for him, about how I'd failed him in life and failed him again at the trial. I couldn't stop thinking about him, and my obsession was making me sick.

By the time I got to the pharmacy, I had decided not to fill the prescription. Instead, I walked home and went into that quiet place inside me. It's like a church in there. Best church in the whole damn world.

And I remembered another of my mother's Mac-isms, something she'd tell me when I'd obsess over things that had already come and gone: *Stop living in the past, Bean. You can't change what happened. Just like you can't change the future by worrying about it. You just have to keep moving, son. It's all about forward movement.*

She was right. *Again.* I couldn't change the past, but I could sure enough keep moving. I had lost my way. I'd stopped dreaming. Take a man's dream away from him and he might as well curl up and die.

"You know something, Bean," she once said, "it's very hard to balance a bicycle when you're standing still. But when you're moving forward, there's nothing to it. You can fly.

"Well, life's like that, too. If you're not moving forward, you're going to struggle just to keep your balance. But if you're moving forward, if you've got direction, nothing can stand in your way."

I was still getting strength from my mother. Her words got me out of my rut, back on track. "You can't control what happens, Beanie. But you can control how you respond to it."

Before I knew it, I was back doing comedy. I'd leave Dock's at five and run home and shower and go find me a stage, *any* stage.

By 1988 I was somewhere just about every night. Tuesdays at Dating Game. Wednesdays at Chez Coco. Thursdays at The 500. Fridays at A.K.A. On weekends I'd do shows and private parties and be the half-time entertainment at local discos.

That's show biz, baby.

When I had a bad night, I wouldn't sleep well. I'd toss and turn. I'd be thinking about where I went wrong. About delivery, timing. And that's fine, because I'd learn from my mistakes.

On good nights, I'd toss and turn, too. I'd be pumped, high. But I had to let that go, too, else I'd be watching the sun come up.

Life isn't about what happened yesterday or about what's going to happen tomorrow. Life is about *right now*, and right now I needed my got-damn sleep. I had other fish to fry in the morning. Well, no—it was the same old fish. Them and the shrimp. But I didn't mind. Those fish paid the bills.

One day, during a break at work, I was flipping through a greasy newspaper and saw they were having open mike at the Cotton Club. Everybody was welcome: singers, dancers, comedians.

Last time I'd performed at the Cotton Club, standing in for Bob McDonald, the bastards had stiffed me. But that was water under the bridge. Why hold a grudge? If I didn't go, I'd only be hurtin' myself.

So the big night comes. I'm home, preparing. That's right, *preparing*. Don't think I'd forgotten being booed in front of my own family. *Get off the motherfuckin' stage, motherfucker.*

By this time I was doing the *Six P's*—the ones my mama had drummed into my head when I was a little boy: Proper Preparation Prevents Piss-Poor Performance.

So I was ready. Took the bus to the Cotton Club and stood in line with all the other hopefuls. And when it was my turn, I got up there and did my five minutes and killed.

"Been ten years since *Roots* came out, and black people *still* be givin' their kids crazy names. Zaqueeda. Jambalaya. Paradise. What happen to just plain *John*?

"Black folks can't fight. We drink, we smoke, we eat ham hocks. We eat chicken three, four times a *day*. Two black men fight, last about fifteen seconds. Then they dust themselves off and go to Popeye's to kiss and make up."

"That was pretty good, Bernie," the emcee told me.

It was better than pretty good. I knew it, and he knew it.

"Thanks," I said, and I went home.

"How'd you do?" Rhonda asked me.

"I killed."

I looked at Rhonda. The face on that woman. I could see she was worried. She knew how much I wanted this.

"I love you, baby," she said.

"I love you, too."

Two days later the man from the Cotton Club called me at work. "Bernard," he said. "What are you doing Tuesday night?"

"This Tuesday?"

"Every Tuesday."

"What did you have in mind?" I said.

"A regular gig. Gonna call it the 'Tuesday Tickler.' "

I took a moment. "I think I can handle that," I said.

Next Tuesday I worked at Dock's all day and went home and showered and hustled over to the Cotton Club. And there it was on the marquee, in big-ass letters: TUESDAY TICKLER WITH BERNIE MAC.

Shit.

"Ladies and gentlemen, my name is Bernie Mac and I'm your host for the evening."

Sweet.

I did Andy Griffith as a black man. Had 'em rolling on the floor.

I was off and running. People weren't just coming to laugh on Tuesdays, they were coming to see Bernie Mac.

Sometimes, hell—I was in The Zone; I could do no wrong. Like slow-motion basketball: Every shot, pure net.

Other times, I couldn't even find the backboard.

I remember one night this guy came backstage after the show. Never saw him before in my life.

"Bernie Mac?" he said.

"Yeah?"

"You ain't funny."

"I'm sorry you didn't enjoy the show," I said.

"You're right," he said. "I didn't enjoy it. Not a damn bit. I didn't enjoy it because you ain't funny, brother. Now Eddie Murphy, he funny. Richard Pryor, he funny. But Bernie Mac—he ain't funny at all."

"Well," I said, "thank you for taking the time to share that with me."

"You're welcome," he said. And he left.

I went and got myself a beer and thought about what the man had said. And it's a strange thing about people. We like to tear each other down. Why is that? What do we get out of it? And we're always *comparing*. I *know* Eddie Murphy's funny. But what does that have to do with me or my show?

I'm here to focus on my own damn self and give you the best damn show I can. I'm not here to compete with Eddie Murphy. I don't want to be Eddie Murphy. I'm busy being Bernie Mac.

I called over to the Comedy Cottage, a white club. Owner wouldn't even take the call. I went in person. "I'm Bernie Mac," I said. "I do the Tuesday Tickler at the Cotton Club."

"We got all we need," the owner said.

Maybe he thought I was too raw for his audience.

I went over to Catch a Rising Star for open mike. Lot of white faces in the audience. Ninety percent white. I found I was editing myself, trying to keep it clean, wanting to be liked—we're *always* wanting to be liked—and it took some of the bite out of my routine.

But they still clapped.

I'm gonna tell you the truth now: White audiences are a lot easier than black audiences. I ain't lying. Black audiences—they *tough*. They sittin' there all dressed up, slouching, arms crossed, sipping champagne from the bottle, and it's like they *want* you to fail. *We here to laugh, motherfucker, and when you come out of the gate you better got-damn make us laugh.*

If you don't make them laugh, they're gonna eat you up. "Nigger," they'll say, "you ain't funny." "Nigger, you suck." "Nigger, don't you ever go near a microphone again."

Whites give you the benefit of the doubt. They're thinkin' their nice white thoughts: *We're here to have a good time. We're here to be entertained, and by golly we will be entertained.* They're so polite: They'll applaud even if you don't make them laugh. Maybe white people feel guilty: "Hey, our bad. We brought you here as slaves."

Take the bad with the good, brother, and don't be affected by either.

Listen and learn. And keep going. You can do it.

"Bernie," my mother used to say, "you should never stop reaching for the stars."

A lot of people condition their children for failure, she told me. Kid wants to be an astronaut, mother tells him to aim lower; maybe manage men's shoes at the local department store. Father says, "Astronauts gotta be smart, boy! You too dumb to be a astronaut!" A child believes that. He goes nowhere. That same child with a different message could have been the first black man on the moon. Hey— that's a good point! When we gonna see a brother on the moon?

"You have a dream, it's your dream," my mama used to say. "Live it. Ain't no one gonna live it for you."

So that's what I was doing, Mama. Living the dream.

" 'YOU'RE AFRAID TO SHOW PEOPLE WHAT YOU'VE GOT INSIDE. AND THAT'S WHERE THE BEST STUFF IS, THE STUFF THAT'S BURIED DEEP DOWN.' "

13

GIVE MR. MAC FIVE MINUTES

One night the owner of the Comedy Cottage caught my act at Rising Star. Came round to buy me a beer. "You know, Bernie," he said. "You're really getting strong. We gotta talk." This is the same sumbitch who wouldn't take my calls; this is Mr. We Got All We Need.

"Sure," I said.

I called him. He was refurbishing the club, and he'd changed the name to The Last Laugh.

"I'm glad you called, Bernie," he said.

"What do you want to talk about?" I said.

He was reopening in a week, and he wanted to know how I'd feel about being there for opening night. I felt okay about it, I said. So I was there—and I tore the place up. I sang "Take Me Out to the Ball Game": the black version.

"What'd I tell you, Rhonda?" I asked my wife when I got home.

"About what?"

"About owning this town."

"What about it?"

"Rhonda! Pay attention, woman."

But she wasn't paying attention. She was looking at this brochure she'd picked up from one of the girls at the state mental hospital. A hotel in Las Vegas had a promotion going; they were practically giving the rooms away.

"We should go," Rhonda said.

"To Vegas?"

"Why not? God knows we could use a vacation."

"What about the tickets?"

"Don't you know that guy who knows that guy—?"

She was right. I did know a guy who knew a guy. And I called him. And he got me four cheap-ass tickets. For Rhonda, Je'Niece, myself, and Rhonda's mother, Mary.

It was pretty exciting. I'd never been on a plane before. I told them I wanted seats over the wing, because I figured we'd be safer with a wing under us. I was like a big kid, grinning from takeoff to landing. White people wouldn't understand that feeling. White people get on planes all the time. They *born* on planes.

Same thing with photographs. White people, they got pictures of themselves every minute of their lives. Here's little Libby, coming out of Mother's 'gina. Here's a picture of her first poop. Ain't it cute and green? Here's Libby and her little friends on her first birthday, on top of the got-damn Eiffel Tower.

Black people, they lucky to have one or two pictures of themselves. I ain't lying. I don't have a single good picture of my mother.

So anyway, we got to Vegas. Made it. I don't have to tell you about Vegas. They pump adrenaline into the air. We checked into our hotel and I saw that Redd Foxx was performing on the Strip. I love Redd Foxx. I called the place and they said we were in luck: They still had a few tickets.

"Rhonda," I said. "We're going!"

We left Mary and Je'Niece back in the room and hopped the shuttle to the Strip. We got there with time to spare, but there was already a big crowd out front—and they were restless. People were pushing and shoving to get in. This little old man next to us got knocked down, and I helped him to his feet and told everyone to give us some got-damn air. Next thing I know, with all the noise and confusion and everything, Rhonda and I found ourselves slipping into the place through a side door.

We went off to find our seats, but we must have made a wrong turn somewhere, because we were going along past an open door when I saw Redd Foxx inside, sitting on a chair, nodding off.

I guess we woke him up. He raised his head and opened his eyes and looked right at us. I didn't know what to do. So I did what any fan would do. "How you doing, Mr. Foxx, sir?" I said. "My name is Bernie Mac. I'm a comedian from Chicago."

"I'm sick, that's how I'm doing," he said. "Sick sick sick."

"I'm sorry to hear that," I said.

"What'd you say your name was?"

"Bernie Mac."

"From Chicago?"

"Yes, sir."

He was studyin' me, sizing me up. I was just excited to be there. I was about ready to further embarrass myself by telling him again what a big fan I was; how my whole family had always loved him; how everybody in the old neighborhood would come out in the street after his show and do Redd Foxx impersonations.

But he spoke first. "You want to do five minutes?" he said.

"Huh?"

Didn't even look at me. Turned and hollered for Slappy White, his old stage partner. Slappy walked in.

"Slappy, this is—"

"Bernie Mac," I said.

"Right. Bernie Mac from Chicago. Give Mr. Mac five minutes."

"Wow," I said. "I don't know what to say, Mr. Foxx."

"Don't say nothin'," he said. "Get out there and do what you do. But when I give you the light, say good night and get your ass offstage."

"Yes, sir."

"Slappy, take him down."

I turned to look at Slappy. He was giving me about as cold a look as you can give a man. But Redd was the boss, and he didn't have much choice.

Slappy took me and Rhonda backstage, where he told us to sit down and wait for the place to fill up. I looked out from behind the curtain. There was a lot of people there, still looking for their seats. A *lot* of people. Don't get me wrong. I'd been in front of plenty of audiences before, but this was Las Vegas. These people had paid good money to see Redd Foxx. They weren't expecting no Bernie Mac.

Rhonda held my hand and I closed my eyes and we said a little prayer. When I looked up again, I saw Redd Foxx coming toward us. He smiled at me and Rhonda. It was a friendly enough smile, but for some reason it made me more nervous than ever.

"Here we go," he said, and Slappy parted the curtain and went out onstage and waited for the applause to die down. He gave a little speech, welcoming everyone to the show, then introduced me. "We're bringing out this guy from Chicago," he said. "I don't know who he is, and frankly, I'm not even sure he's funny."

This got a big laugh. He had to wait awhile for the crowd to pipe down. Then he said it: "Ladies and gentlemen, Bernie Mac."

Well, I was already sweatin', but I got out there and the spotlight nailed me and I made my way across the stage and picked up the microphone.

"Say, what a handsome bunch of people!" I began. "And so happy looking! Bet you ain't gonna look this happy when you get up from the blackjack table." In those days, I was the Polite Guy. I was very cautious. I didn't want to alienate anyone. Then I told a joke, and I got a laugh. So I followed it up with another joke, and a bit about my grandmother, which got a bigger laugh. And even though I seemed to be doing pretty well, all I could think was, *I've got to get off this stage.*

I'd been up there more than the five minutes already, and I was waiting for the light, and it wasn't coming. So I looked over to see what I could see, and what I saw was Redd Foxx, and he was smiling and signaling; he was motioning with his hand, a circular motion: *Keep going.*

I did another ten minutes. "Black people, when they die—they want a good send-off. That's why they always have life insurance, so they can get themselves a nice casket and have a fancy catered affair and impress their friends from beyond the grave. But Blue

Cross/Blue Shield—no sir, they ain't gonna waste their money on that. That's why they can never afford no medication.

"Anything wrong, they take aspirin. 'He got a fever.' 'Give him some aspirin.' 'He got chills.' 'Give him some aspirin.' 'He stepped on a nail.' 'Crush up some aspirin and rub it all over.' 'He got shot.' 'Take the whole jar of aspirin and put it right in that hole there. With some duct tape or old newspaper or something.' "

Finally Slappy gave me the light and I got off the stage. The audience was whooping and hollering, and Redd Foxx was smiling at me. "That was some great shit," he said. "You're funny, kid."

I was sweating. Soaked. I didn't know what to say.

Slappy was looking at me, too. But he wasn't smilin'. I figure maybe he'd wanted me to bomb.

"Thank you very much, Mr. Foxx," I said finally. "That was very nice of you—letting me go out there."

"Bernie Mac, is it?"

"Yes, sir."

"Well, you know, Mr. Mac, you do have one little problem. You're funny, but you don't want to be funny. You want to be liked. Now if you open yourself up, and you get real, and you start taking comedy seriously—well, there's no telling how far you'll go."

"Sir?"

"You're afraid to show people what you've got inside," he said. "And that's where the best stuff is, the stuff that's buried way deep down."

"Deep down," I mumbled, echoing his words. I must've sounded pretty thick.

"You can't be afraid to fail, Mr. Mac. If you're afraid to fail, you won't dig down inside. And if you don't dig, you won't be giving us anything real—you'll be keeping the good stuff locked away."

With that, he marched right past me and out onto the stage. The crowd went wild, but I couldn't hear them. All I heard was the blood roaring in my ears.

For days afterward I couldn't stop thinking about what Redd Foxx had told me. I remembered how it used to be in grade school, in class, not wanting the other kids to know I got an A. I wanted them to like me. Smart kids—nobody liked them.

I remembered racing my brother, Darryl, to the front door, or jumping up when the phone rang, or hoping there was something in the mail for me.

I was doing the same got-damn thing onstage: I wanted the audience to like me. I wanted them to go home in got-damn *love* with me.

Redd Foxx was right. Comedy isn't about playing it safe. It's not about taking the middle road. Comedy is about risks, about puttin' it out there.

Some people might get offended, sure. And some people won't like what you have to say. But you have to give it to them straight, unedited and uncensored. Else what's the point? Why you even up there?

Funny thing is, Redd Foxx hadn't told me anything I didn't know. He'd just helped me see it better. He had pointed out that in comedy, as in life, we were always facing choices. And Redd Foxx—well, the man had strong opinions about the right choices.

After three days in Las Vegas, three days of good clean family fun, a little low-stakes gambling, and a lot of serious thinking about comedy, I went back to Chicago fortified. I felt ready to make it happen.

But I had a couple of stumbling blocks to get through. For starters, we came home to discover that our landlord needed us gone. I don't even remember what it was, but it's always something. *My sister's pregnant. My brother just got out of jail. My uncle's*

wife kicked him out for good this time. We had to move, and we had to move fast.

We found a place on 107th and King Drive. I'll be honest, it wasn't much, but we didn't have the time or the money to find better. It was two rooms and a full bath, with a small kitchen. There was a door off the kitchen that was bolted shut, and I asked the landlord what was back there.

"Nothing," he said. "Ain't your business." He was a rough type. He wasn't looking for a friend, just some fool to pay the rent.

The day after we moved in, we got a red note on the door about the gas not being paid. I called the landlord and told him, but he said he was on top of it and for us to just ignore it.

Then I got to Dock's and I'm frying my fish and the phone rings and I hear the manager saying, "No, there's no Bernie Mac here. You got the wrong number." He hung up and the phone rang again, but I got to it first. It was somebody over at The Last Laugh.

"I just called over there," he said. "Some guy told me you didn't work there."

"Don't worry about it," I said. "What's up?"

He asked if I could do a show Saturday, and I said I could— and that I'd call him later, after work.

The manager had been watching me from across the room, staring and listening. The minute I got off the phone, he came over and got in my face. "I got news for you, boy," he said. "Here, at Dock's, you're not Bernie Mac. You're Bernard McCullough. Ain't no Bernie Mac here."

I damn near hit him. But I didn't let it get to that. We had some strong words, though. Then I called Kevin Carter, who got me the job in the first place, and said I needed a transfer; it wasn't working out with this guy. Kevin and I was close. And he knew I was a good worker. He got me transferred the next day.

I had a drink with him to thank him. He didn't look so hot. He put away three shots of hard liquor to my one beer.

"What's going on, Kevin?" I said. "You're drinking awful quick."

Kevin said the company was in trouble. Dock's had grown so fast that they didn't have a system in place to handle the money, and the books had gone all to hell. They were talking to some management outfit to come in and help them run the place. He was worried about his future.

"I've been here since high school, my whole got-damn life," he said, signaling for another drink. "They're going to get rid of me."

"You don't know that," I said. "But if you drink like this every day, they'll get rid of you for sure."

A few days later I'm at a new Dock's, and they say my name on the radio. "This Saturday at The Last Laugh, Bernie Mac!"

These new motherfuckers I work with are looking at me, and suddenly I'm hearing that old refrain: "Why you working here, man? You *famous*. You on the radio."

"I like it here," I said. "And I need the money."

I went to The Last Laugh on Saturday, as advertised, and I killed.

"Black women somethin' else. I love me some black women. But black women, boy, they want to be your mama, your father, your pastor, and your boss, too. They want to tell you what to do all the got-damn time. You go out to eat, they want to order for you, too. 'He'll have the salad.' Salad? Salad, my ass! Don't be ordering for me, girl! I'm hungrier than a motherfucka! 'And some iced tea.' Iced tea? Don't fuck with me, woman! I want to get drunk tonight."

Following Monday, the phone rang at Dock's. Someone at A.K.A. wanted to know if I was available Saturday night.

When I got off the phone, the brothers I worked with were looking at me.

"So you a comedian, huh?"

"I do my thing."

"You think you funny, huh?"

"I think so. Yeah."

"I don't think you funny. I think Chris Rock funny."

Chris Rock had been discovered in a comedy club, and he'd made his film debut a couple of years earlier, with Eddie Murphy, in the sequel to *Beverly Hills Cop*.

"I think Chris is funny, too," I said.

"You just jealous," the other guy said. "You wish you was *half* as funny as Chris Rock."

Human nature! What is it about most people? It's like they want to bring you down. And for no reason!

"You're wrong," I said. "I'm not jealous."

I'd been cured of jealousy many years back. Was over at our apartment above the Burning Bush Baptist Church. I was maybe ten years old. One of my little cousins came over for Sunday dinner, and my mother hugged him so tight I ran off in tears. She came to my room to get me.

"What's wrong, Bean?" she asked.

"Why you hug him like that?" I said, still crying. "I'm your son, not him."

"You think I only got so many hugs in me?" she asked. "You think if I give him a hug, there'll be one less hug for you?"

"I don't know."

"Hugs aren't like pieces of pie, son. Plenty of hugs to go around."

"Made me feel bad," I said.

She wiped my tears and broke it down for me. Told me about jealousy. About envy. Told me about Cain and Abel, and how they ended up when they let those feelings get to them. "Jealousy and envy are just like anger," she said. "The most hurt you're doing is to yourself."

I wish more people in the world knew my mother's lesson. But it seems like most people can't help themselves. Even when

they're on top, they don't want anyone else making it. They want to be on top forever. They don't ask themselves where they're going to be when they're dead.

Swear to God, I can't figure it out. You don't get nothin' from wishing ill on anyone, but most people still do it. Can't help themselves.

I got back to the apartment—another got-damn red note on the door—and I showered and went off to Dingbats. I had a lousy night. Don't know why. Letting shit get to me, I guess.

"Before I discovered girls, I didn't believe in no cleanliness. I was a nasty muh'fucka. I was the type of nigga who'd turn his drawers inside out instead of putting on a new pair. Get up in the mornin', too lazy to brush my teeth—so I'd take my fingernail and scrape that muh'fucking plaque right off."

Nothing. Maybe a small smile in the third row. So I tried something else:

"Black people, we pay our bills when the fuck we *ready* to pay. And we never pay *all* the bill. The bill's eighty dollars, we'll give you thirty. Why? Because we got to smoke. We got to drink. If you don't drink or smoke, black folks think something's wrong with you."

But I couldn't make it happen with that audience. Maybe they had a lot of bills to pay. Or dirty drawers. Or *both*.

Went home after the show and tossed and turned all night. Woke up late the next morning, Sunday, still in a bad mood.

"Where's Je'Niece?" I asked Rhonda.

"She's out front, playing."

Je'Niece was already eleven years old—this was the summer of 1989—a tall, beautiful girl. We kept her on a tight leash. She was allowed to play outside, but she couldn't go beyond the corner. I ate something and went to look for my little girl. She wasn't where she was supposed to be. I went down to the corner and into the next block and back again. I went to houses of neighbors we

knew. No Je'Niece. My heart was pounding like a motherfucker.

Just then a car pulled up at the curb. A woman was behind the wheel, and she had three girls with her. One of the girls was Je'Niece. She got out, and she looked worried. She had good reason to look worried.

"Where the hell you been, girl?" I snapped, fit to be tied.

And the woman in the car called out, "Oh, Mr. McCullough, please don't be mad. It's all my fault. I took the girls to the store."

I didn't even listen to that woman. I grabbed Je'Niece and took her inside and already had my belt off by the time we were through the door. And I started whaling on that girl. She was crying, but I didn't hear her; I didn't *want* to hear her.

Next thing I know, Rhonda's there, grabbing my arm, trying to get between us. She's in my face, screaming—"That's enough, Bernard!"—and I could sure enough hear *her*. But I didn't stop. I pushed her out of the way and kept hitting Je'Niece, determined to teach her a lesson.

Then Rhonda came at me again, jumping on me, and again I pushed her away. And she came at me a third time, WHAM!—hit me hard in the chest. And I was so gone with rage by now that I hit her back; hit her so hard she spun around and bounced off the wall and fell to the ground.

Then everything went quiet for me. I don't know what it was. I must've been in shock or something. I could hear Je'Niece crying behind me and saw Rhonda on the floor there, whimpering, and I just got-damn shut down. I walked out. I wanted to get the hell out of there.

I walked and I kept walking, and I ended up on the East Side, at the home of Pat Cattenhead, an old friend of the family.

"Hey, Bean," she said. She hadn't yet noticed the sour look on my face. "What brings you around?"

"I had a fight with Rhonda," I said.

"What happened?" she asked.

"I don't want to talk about it," I said.

Pat closed the front door behind me. She asked if I was hungry, and I said I wasn't hungry, and could I spend the night. She went off to get fresh sheets.

The morning after the fight, I left Pat's house and went to work at Dock's, and at the end of my shift I went back to my own house and got my stuff. I got *everything*. I was steamed. It was over.

Rhonda was at work, and Boops was still in school—so I didn't have to deal with either of them.

I got back to Pat's and the phone was ringing and it was Rhonda, calling for me. I didn't want to talk to her. Pat said, "Bernie, don't be a fool. You've been together too long for it to end like this."

"No," I said. "Tell her I'm through."

And Pat said, "If you're so tough, tell her yourself." So I got on the phone and Rhonda right off said that Boops was asking for me. And I could hear her in back, "Is he coming home, Mama?" And Rhonda said for her to ask me herself and handed her the phone. And Boops got on the phone and said, "Daddy, I'm sorry about yesterday. Please come home. I miss you."

And if you have children, well, I guess I don't need to tell you what that did to me.

Then Rhonda got back on the phone and said, "Look, Bern—yesterday, it was crazy. We all went a little crazy. Come home and we'll work it out."

I said I didn't know if I wanted to work it out, and I hung up. I can be a stubborn sumbitch. And Pat was looking at me, and she said, "Bernie, we've been friends for a long time, and I never got into your business before. But I have to tell you: You're wrong on this one. If you don't go back to Rhonda, don't come back here."

At work the next day, I called Rhonda and told her I'd be coming by later. To *talk*. And I went. And I tried to act tough, but inside I knew I was to blame just as much as Rhonda. I was ashamed; I

had struck my wife in front of my child. I realized it was the shame that had made me run, and I apologized, and Rhonda cried, and Je'Niece cried, and I cried. And we were a family again.

In bed that night, after we got Boops to sleep, I told Rhonda that I loved her, and that I would never quit her. And she told me the same thing. And we knew we were going to be okay.

In the morning, when I left for work, there was another red note on the door about the bills being unpaid. I called the landlord and said I was tired of these red notes. And when I got back from work that night, there was a gas bill for three hundred dollars, addressed to me, Bernard McCullough. I called the landlord about that, too, saying it couldn't be right, and he said it wasn't his problem.

So I called Big Nigger and told him to come over and bring some tools. And he came over and we took the bolts off that door in the kitchen, and sure enough, it was just like I thought. The whole building was hooked to one gas line: mine. I was paying everybody's heat. I called the landlord and told him I wasn't paying the got-damn bill and that if he didn't take care of it I would report him. He said some things I won't repeat, and I used some choice words of my own, and when I hung up I told Rhonda we were moving.

"Good," she said.

I found another place on 101st and King, but the day before we were gonna move, the landlord sent some of his goons over. I was alone in the apartment, packing stuff, and they walked in—three big motherfuckers—and decided to teach me a lesson. I can throw a punch, I'll tell you, and I can take a punch. (If my brother, Darryl, taught me one thing, it's how to stand a beating.) But these three were too much for me. They busted me up good. And when they heard the police sirens, they quick tore out the back.

I went into the bedroom, for my gun. I don't know what I was thinking, but I guess I wanted to be ready for them if they came

back. When I stepped out into the hall, though, the cops was already there.

"Put that gun down," the one cop said.

I put the gun down, and they came in and cuffed me.

"You got a license for that gun?"

Is that what you call a *rhetorical* question?

"No, sir," I said. "If you'll just let me explain, there was—"

But they didn't let me explain. They took me down to the precinct and locked me up, and they gave me my one phone call. I called Big Nigger. I told him to please go over to the apartment and make sure these motherfuckers didn't come back, because I had a bad feeling about them.

"What about you?" he said.

"Don't worry about me," I said. "They can't hold me. But please call over to Dock's and tell them what happened."

"Okay, Bean," he said. "I'll take care of it."

By the time Big Nigger got to my place, the sons of bitches had tossed all our worldly possessions into the street, including every last stick of furniture. And they'd taken anything of value, which wasn't much.

Some of the neighbors knew us and liked us, so they saved what they could and kept the bigger furniture in their yards for us. It was a decent thing to do.

Rhonda arrived home to this mess and somehow kept herself from falling apart. She went and got Je'Niece from school and took her over to her mother's.

The next morning, Big Nigger and A.V. rented a pickup and got our stuff from the neighbors and put everything in storage. I got out of jail that afternoon and went over to Rhonda's family and they couldn't believe how I looked. The three goons had really done a job on my face. One of my eyes was swollen shut and my

upper lip was about the size of a fist. I looked like the got-damn Elephant Man.

"Oh, Bernard, Bernard—what we gonna do?" Rhonda asked.

"We'll figure it out," I said.

Her folks said we could stay there for a few days, till the new place over on King Drive was ready. And then I looked up and noticed what time it was.

"Damn," I said. "I got to be at the Dayton Gang at eight-thirty."

"What?" Rhonda said. "Are you crazy? You're not going on any stage lookin' like that!"

Well, you know what they say: The show must go on.

So I went over to the Dayton Gang. Emcee saw my face and about fell over backward. "What the hell happened to you?"

"Nothing," I said, grinning. "I don't know what you're talking about."

When I walked out onstage, the audience looked confused. They were laughing before I opened my mouth. They thought my face was part of my act. But then I told what happened, and I made it funny. I was up there for almost two hours, talkin' about real pain; talking about my life; talking about the things inside me.

And maybe for the first time I saw how we're all pretty much the same under the skin. That when you reach down, way deep down to the things that are most intimate and personal, that's when you connect with other people. Because they have the same feelings deep inside them. The same fears and hopes and dreams.

I was up there for two life-changing hours, telling my stories and spinning them for laughs. I was telling it like it was. Being *honest*. Yeah, that was it. For the first time in my life, I was doing *honest comedy*.

"DIDN'T MATTER THAT NO ONE HAD EVER HEARD OF ME; IT WAS SATURDAY NIGHT, AND THEY WERE THERE TO BE ENTERTAINED."

14

YOU
QUICK,
BOY,
MAN HITS YOU,
YOU HIT
BACK.

That night at the Dayton Gang, up there onstage looking like the Elephant Man, I got three standing ovations. Count 'em. *Three.*

And on my way home, as I thought about what had happened to me, how I'd been transformed, I realized that everything in life really *does* happen for a reason.

I felt like calling up my landlord and thanking him. I felt like tracking down the three goons who'd beat me up and buying them a round of drinks. These men had pushed me to a whole new level. I owed them.

I was amazed at how *solid* I felt. It was like I'd been to a whole new place—a different planet. And I couldn't get the audience's laughter out of my head. I said to myself, *If I don't do this full-time, I'm gonna die.*

When I think back on it, the 1980s were about people being funny. Every empty theater, every storefront, every coffee shop—everyone was a comedian.

This was especially true of blacks. Harlem had the Uptown Comedy Club. Washington, D.C., had the Comedy Connection. There was Terminal D in Newark. Chicago—my hometown—had the Cotton Club. And Los Angeles had the Comedy Act Theater, which was said to be the wildest in the bunch.

Everybody wanted to get in on the comedy action, even towns you never heard of, and suddenly there was a big boom—clubs were poppin' up left and right. That was a lucky break for me, because they didn't have enough talent to fill them, and suddenly I was getting called to Ohio and Iowa and all sorts of little places that weren't even on the map. They were happy to have me, too. There I was on the marquee: *Bernie Mac! Tonight! One Night Only!* Didn't matter that no one had ever heard of me; it was Saturday night, and they were there to be entertained.

And brother, I took every gig I got. They didn't pay much, but that didn't matter, either. They were giving me a chance to hone

my craft, to become a comedian. And I was going to work it for all I could.

Of course, by the end of the decade, I was still at Dock's, but I had a feeling my fish-fryin' days were numbered. A new company had been brought in to try to make sense of the bookkeeping, just like Kevin Carter'd said, and the future looked kind of grim.

Kevin himself got moved to a different Dock's, far from home. The original owners tried to help him—he'd been there his whole life—but his drinking got worse than ever. He started not showing up for work, always with some lame excuse, and pretty soon they let him go.

It went from bad to worse. He lost his house, his mother, his health. I went to see him. I got him a job through a guy I knew at the Board of Education, but he drank himself out of it. Rhonda's sister got him something at a department store, but he didn't last the week. The man had given up on himself.

It was sad. Dock's had been his whole life. His whole identity was wrapped up in Dock's. He didn't know himself outside of Dock's. It made me see how that happens to so many people in our society. They lose their jobs or they retire and they don't know who they are anymore. It cripples them. And it certainly crippled Kevin.

I kept hooking up with him, trying to help, but all he ever wanted was money for drink. He'd pretend he was listening to you, and he said all the right things—that he was going to change; that he would get help with the alcohol—but he only said it to get a few bucks to spend on drink. It was useless. I don't have to tell you how it ended.

////////////////////////////////

By this time, late in 1989, I didn't exactly own Chicago, but I was on my way. So I decided to fly out to Los Angeles to make

the rounds. The Laugh Factory. The Improv. The Comedy Store. I did okay. Hits and misses. Maybe more misses than hits, though, on account I was watching my step. I was a big fish in Chicago, but in L.A.—well, not that many people had even heard of me.

Still, I got up there; did my thing: "You see these fucked-up hairdos our women be wearing? Look like chandeliers. And when they get their hair done, brother—you ain't gettin' no pussy. That hair gotta last, man. Black women, when they get their hair done, they got it planned. If they get it done on Thursday, you ain't get-ting pussy all weekend. Not till it starts itching, anyway. Maybe by the following Wednesday. That's right: When you see them take a pencil to that high, hard hair, when you see them poking and scratching around in there, that's a *good* sign. That mean you're going to be gettin' some pokin' of your own."

One night at the Comedy Store this black guy, Robin Harris, got up onstage. He was thirty-seven—older than me—and he was good. I went to see him after his show, to congratulate him.

"Bernie Mac," he said, coming on strong. "Yeah, I heard of you—you black motherfucker. Whatcha doin' in L.A.? When'd you get out?"

He was playing with me, and I played right back. "You good," I said. "Damn good Yaphet Kotto look-alike."

He laughed. "You quick, boy," he said. "I like that. Man hits you, you hit back." He shook my hand and told me I should come down to South Central, to the Comedy Act Theatre, and check things out for myself. "You and I," he said, "we're going to be working together before long."

So I went down the next night. Lot of names there. Eddie Murphy. Damon Wayans. Arsenio Hall. Robert Townsend. They were all hanging out in their little groups and cliques, and every-one just ignored me. So I sat back and watched the show. Thing about me is, I can get through a door if it's a question of going

onstage, but when it comes to meeting people—I'm not pushy. I'm happy in my little corner. And that's where I stayed: in my corner. I never got onstage; I never tried.

End of the week, I went home, none the wiser. And the following day I got a call from Chuck Gueno, manager of the Regal Theatre. He told me Robin Harris was coming to Chicago, and that he'd called ahead to ask if I wanted to open for him.

"You're damn right I do," I said. I was kind of shocked, to be honest. Most people, they tell you they gonna do something—doesn't happen. Robin Harris had follow-through, and I respect that in a man.

On the big night, though, there was some confusion. This other comic was under the impression that *he* was opening for Robin, and I could see the guy was upset. So I told him that if it meant that much to him, to go ahead; I'd sit this one out. And the man went on and did a good job, and then Robin went on and killed. And Robin came looking for me after the show, because he'd heard how I'd stepped aside, and asked would I meet him later for drinks at the Four Seasons.

So I went. He was there with his mother and a few friends. Good people. And Robin said he was going on the road at the end of the year, and would I like to come out to Milwaukee and open for him. I said it sounded real good to me; that we should talk about it. He said there was nothing to talk about—we had a deal—and he invited me to dinner to celebrate. But it was two in the morning and I didn't want to impose—he was with family—so I thanked him and said good-bye to everyone and went home.

I woke Rhonda when I got home. I didn't care how late it was.

"What?" she said. Her eyes were thick with sleep.

"I'm going to open for Robin Harris in Milwaukee," I said. I was like a big, excited kid.

"That's nice, Bernard. Can I go to sleep now?"

"You don't understand," I said. "That man is really gifted. He's about to break out."

Rhonda wasn't even listening. She closed her eyes and drifted off. It took me a good long while to fall asleep. My mind was racing, I watched the sun come up.

Next day, three in the afternoon, I woke up and dragged my tired ass into the kitchen.

"Hey, Rhonda," I said, yawning like a lion. "Anything to eat in this house?"

I looked in the fridge. Found some eggs. Set them on the counter. Then I noticed the look on Rhonda's face.

"What's wrong, baby?" I said. "Somebody die?"

"Bernard," she said. "I have some bad news."

"Well, *what*, woman?"

"Robin Harris died in his sleep last night."

I couldn't believe it. It had been on the news. Robin Harris had had a heart attack in his sleep. I hardly even knew the man, but I felt the loss deeply. He was a gifted man, and a good man. Not too many of those around.

"You okay, Bernard?" Rhonda asked me.

"No," I said. "No, I am not okay."

I got dressed and went for a walk and found myself in a strange bar. I sat down and ordered a beer. I had a sip. It felt good going down, ice-cold. Then I noticed a guy across the way looking at me funny. I looked back at him hard. I was angry and I was frustrated and I thought I could use a good fight. But the sumbitch looked away. I was going to have to find another outlet for my rage.

I got to Dock's Monday, still angry, still in a fog. Phone rang as I was walking through the door. It was for me, a guy from the Cotton Club. I thought he was calling about Robin Harris, but he

wasn't. He was calling to say I'd been entered in the 1990 Miller Lite Comedy Search. It didn't make me feel any better about Robin Harris, but it got me out of my funk.

It also showed me that life goes on, with you and without you.

/////////////////////////////////

The way the Miller Lite thing worked, see, is that they narrowed it down to a hundred comedians from the Chicago area. Then they took a bunch of small groups and had us perform at about every club in town. We were performing in front of live audiences, of course, along with panels of judges, and the judges had to settle on the top ten.

And, yeah—I made the cut. I guess I was starting the decade right.

The final showdown took place at the Regal Theatre, in front of thirty-seven hundred people. Damon Wayans was hosting.

Well, my turn came, and I went out there and dedicated my bit to Robin Harris. Not because we were so close—hell, we'd only met a couple of times—but because there was something special about Robin, some kind of light inside him. It's something you feel around certain people, not something you can explain, and with Robin I felt it strong. If he had lived, I would've wanted to get close to that man. He was a lot like Big Nigger and A.V. and Morris; he had the heart of a lion.

I only had a few minutes to do my thing, so I plunged right in. "Good evening, ladies and gentlemen. I have to tell you something. I've been preparing for this contest for some time, and the other day I went home to tell my wife that I'd made the cut—that I was in the finals. Well, as I came through the door, I saw a trail of clothes leading to my bedroom. A bra here, another bra there, two pairs of panties, some jeans over by the chair.

"I was getting closer and closer to the bedroom. I was so close I could hear some heavy moanin' and groanin'. I tell you, my heart was pounding like crazy.

"Ever so quietly, I opened the door. And there was my wife, in bed with a beautiful young woman. I looked at her with disgust. 'You nasty, no-good, double-crossing, unfaithful—move over!' "

I was *on*, brother. I brought down the house. At the end of the evening, Damon Wayans went out onstage and—you guessed it—called my name.

I got a check for three thousand dollars, the biggest payday of my life, and I shook so many hands that evening that my arm went numb.

Rhonda and I floated home in the wee hours, and when I got out of bed the next morning, I ran all the way to the bank. I put the whole three thousand dollars in my daughter's name.

I walked home from the bank, still floating, wondering, *What's gonna happen now?*

"I'M GONNA PAY YOU BACK, BERNIE— I SWEAR TO GOD! I'LL PAY YOU BACK IF I HAVE TO SELL MY ARM TO DO IT!"

15

SUCCESS HAS MANY PARENTS

Funny thing about people. They're not too comfortable with success.

For about ten seconds, I owned Chicago. It was in the newspapers. On the radio. On black TV. The same motherfuckers who wouldn't give me the time of day a week earlier were calling to congratulate me and ask me to perform at their clubs. They'd come by with a bottle of champagne and one of those big, lopsided grins. "Bernie! My nigger! Always knew you were going to make it big! Number One Fan here from the start!"

Like they say, *Success has many parents. Failure is an orphan.*

And family—don't even get me started. Suddenly you got family you never knew existed. And they got problems. *Serious* problems. But they never come at you straight, see. They look all broken-faced and sigh their big sighs and you gotta ask them what's wrong; you got to pull it the fuck out of them.

"What is it, George?"

"Bernie, it don't make no sense, brother. I'm going to be living in a trailer soon."

Then there's the other kind: Once they get started, they don't stop. "They laid me off, man. I was sick a few times, and the sons of bitches laid my sorry ass off. I don't know what all I'm gonna do, Bern. Your niece—you remember your niece? Chiquita? She gotta have an operation. I ain't told nobody yet because she don't want me to tell, but it's gonna run eight thousand dollars. I know you want her to be well, Bernard. We family, right? At the end of the day, only thing we got is each other, brother. I'm gonna pay you back. I swear to God! I'll pay you back if I have to sell my arm to do it! Give you my left nut if you want it. Hell, *both* if you really need 'em. That's how much I love you, Bern. That's how much you mean to me."

After they're done hitting you up, and they see that you ain't rich—see that you're still frying fish at Dock's—they change their tune.

We put you up there, motherfucker, and we're going to bring your ass down.

What is *that* about? Why you want to wish ill on a man that never did you any harm? I don't get it. How does my small success have any bearing on you or anyone else? I don't look at Chris Rock and think, Well, I guess there's only room for six funny niggers in this cold world of ours. I'm shit out of luck.

And at work, that was the worst. It wasn't just the people coming in, doing double takes: "Hey! You that funny guy! I saw you at Dingbats last weekend!" It was the guys I worked with. We were back to that same old bullshit, only twice as strong. "You a comedian! You famous! This here's Bernie Mac, winner of the Miller Lite Comedy Search. Look at the way the brother fries that fish. Them fish go in the fryer laughing."

Got home one day and told Rhonda I'd had enough. One of my cousins worked for Wonder Bread. I called over and asked if he knew whether they had anything. He said they were looking for drivers.

I went down the next day and filled out an application. I brought some references and my entire work history and told them how I'd already driven a truck for UPS. They hired me on the spot. They gave me the worst route they had—the meanest, roughest neighborhoods—but I didn't care. I loved it. I loved sitting there in my Wonder Bread truck, driving along, alone with my thoughts. I passed an electronics store and went in and bought myself a little tape recorder. If I saw something of interest, I'd pick up my tape recorder and make a little note to myself: mean dogs; large women with tight pants; pimps and big hats; couple on the street arguing about who's paying what bills when . . . Everything was fodder. The good stuff would find its way into my comedy routines.

I'm up at Just for Laughs one night, talking about those gotdamn bills: "Creditor calls, says, 'Can I speak to Bernie Mac?' 'Uh,

Bernie ain't here right now.' 'When he comin' back?' 'He ain't: Motherfucker died this mornin'.' "

Black people can relate. All black people running from their bills.

Another time, at Dingbats, Rhonda was in the audience—and she was getting embarrassed:

"People say you get older, you get better. Well, I ain't gonna lie to you, I'm old. I can't fuck like I used to. I'm not in shape. Sex is nothing but hard got-damn work—physical labor. Pumping away like that? What the fuck you trying to prove, motherfucker? My chest hurt, my back hurt, my lips are turning white, I can't breathe, and she's going, 'Oh yeah, baby. Right there—ooh!' What the fuck is 'right there'? Bust a nut so we can go to sleep already."

People laughing like crazy. They know it's true.

"Nowadays, when my wife wants it, I think of some excuse. 'I gotta wash the car, baby.' And she turns to look at me and says, 'Bernard, you don't have a car.' "

That's the thing, see: I'm digging into my own life, and I'm spinning it every which way, and then I'm reaching out with it. I'm being true to myself and the small insights I've had. And that's what connects me to my audience: *honesty.*

You dig deep, brother, you'll find we have a lot in common. People are more alike than they know.

We were on our way home from the Cotton Club late one night, Rhonda and I, and she said, "Why you telling that stuff? People are going to think it's true."

"I'm just playing, baby. They know it ain't true."

"*Some* of it is!"

"Well, I'm not telling which part," I said, "and I hope you're not, neither."

The thing you have to understand is that onstage, I'm in character. I'm still Bernie Mac, sure, and I'm tapping into my own life,

but I'm running with it. And *running* is the right word. When I'm hot, I feel like I'm channeling a force inside me. It's as if I'm possessed. Scares Rhonda sometimes—the way my voice wavers; the way my eyes roll up into my head. I don't know where that force comes from, but it sure taps into some deep shit. It pushes me to tell it like it is, and that's what gives comedy its power: the truth, and the fact that people *recognize* it as the truth.

I might say something you've been thinking all your life, and suddenly you get it. *Amen to that, brother!* That's where the connection is.

And the best part is, I can say anything I want. About wives, girlfriends, brothers, and cousins once removed.

"I'm gonna pay you back, Bernie—I swear to God! I'll pay you back if I have to sell my arm to do it!"

People get it. They've been there. I tell jokes, too—because that's part of it, and everyone likes a good joke. But I'm more than a joke teller now. And it feels great.

Suddenly I'm getting calls from Atlanta, Pittsburgh, Mississippi. And I ain't gonna turn anyone down. Monday through Friday, I'm the Wonder Bread man. But weekends are my own.

Then Hollywood calls. The Wayans brothers have a show on Fox, *In Living Color.* Why don't I stop in for a meeting?

I take the red-eye to Los Angeles, on my own dime. I already know Damon—he was the Miller Lite emcee—and now I get to meet his brothers. Lots of energy in the room. Everybody's up. Good things are gonna happen.

After that meeting, I'm off to meet everyone else in town. Plenty of meetings; *endless* meetings. And I'm thinking it's a miracle anyone gets anything done in L.A., what with all the got-damn meetings back-to-back.

Studio executive is sitting there, wearing a Christian Science smile, telling you he's a big fan of your work—and you know the

man hasn't got a clue; maybe never even heard of you till he saw you on his list that morning. But it don't matter. You smile right back, and you try to look mighty Christian yourself.

Now they're walking you to the door, telling you how much they love you, how you're a got-damn genius, how their people are going to be in touch with your people.

But nothing ever comes of it. You never hear from them again. You have to get *bigger* to get them interested. *Much* bigger. And I'm not big.

I'm so not big I have to rush back to Chicago and get out of bed at three in the morning so I can be in my Wonder Bread truck by four-thirty.

One morning, WHAM! Tore the roof right off that truck. I was tired. I admit it. I had taken a shortcut and misjudged the underpass and suddenly I'm sitting in a convertible, loaves of bread up to my knees.

I went back to the office and 'fessed up. I swore it wouldn't happen again. They weren't happy with me, but I'd never so much as missed a day or a delivery, and we're talking fourteen-hour days on the meanest streets in town.

"It better not happen again, Bernard."

"No, sir. It won't. I'm really sorry, sir."

I took the El home. And all the way home I was asking myself, *When are you going to make up your mind, McCullough? When are you going to make the leap? Are you or are you not a comedian?*

////////////////////////

The Tuesday before Thanksgiving, I was at All Jokes Aside, a club on Wabash Avenue, and I got three standing ovations.

"White people. Bungee jumping? What is that shit? Why you want to jump off a cliff and *almost* hit the ground? You're one got-damn inch from busting your head wide open and all you got to say for yourself is, 'Whooo! Awesome, dude!'

"White people. I hear they have hurricane parties in Miami. 'We might get swept out to sea! We might die! Yippeee!'

"Not me, brother. I like simple things. I like swimming in shallow water. I like to swim where I can stand up when I get tired.

"Even skiing is too dangerous for me. The only black people that ski are the ones who went to Harvard. The rest of us ain't educated enough to like cold and pain."

I was on fire, brother. I was looking down at those laughing faces, and I could see it. They were telling me I was a comedian. Seems like everyone knew it, everyone but me.

I couldn't get to sleep that night. And just as I began to close my eyes, that got-damn alarm clock went off.

By four-thirty I was behind the wheel of my Wonder Bread truck. And in no mood. It was a big run—the Thanksgiving run, November 1991—biggest run of the year. I had thirty-two hundred dollars' worth of bread in that truck. And it was freezin' out: Radio said the wind-chill factor was making it forty below. You know what that's like? That's like a big dog taking a bite out of your ass every time you step outside.

Tired as I was, I got through it. I hopped in and out of the truck, braving the elements, delivering my loaves, and all the time I couldn't stop thinking of the night before. That laughter. Those faces. The way the crowd got to its feet and stomped and roared.

Finally, end of the day, in darkness already, I made my last delivery and pulled the truck over by a phone booth under the El. I jumped out and called the office.

"It's Bernard," I said.

"What's up?"

"I'm quitting."

"What?" My boss could hardly hear me. The wind was whistling so hard I thought it was going to pick that phone booth right up, and me with it.

"I quit!" I shouted. "I'm *done.*"

"Where the hell you at, Bernard? Where's my truck?"

I told him to come get his truck—I didn't have the energy to drive back to the office—and I hung up. I knew it was wrong, but I couldn't help myself.

I made sure the truck was locked up good and got on the El and went home. I didn't say anything to Rhonda. I had something to eat and watched a little TV, and Rhonda went back into the kitchen to make pies for Thanksgiving night. We were going to celebrate with her family.

I went to bed in a good mood. Rhonda enjoyed it. But she knew something was up. "What's going on, Bernard?"

"Nothing. I don't know what you mean. Didn't you just have a good time?"

"I had a fine time. But I know something's going on."

"Can't a man be in a good mood? There a law against that? Can't a man love his wife a little?"

"Bernard McCullough," she said. "You crazy."

The next day we got into our little Ford Escort and drove to her family's house for Thanksgiving. I was the life of the party. I was horsing around with all the in-laws and clowning with that litter of kids.

Rhonda wouldn't stop looking at me. We'd been together more than a dozen years now, and I could never put anything past that woman. Still can't.

"Bernard," she said. "You gonna tell me what's going on?"

"*Nothin'*, woman. You the one that's crazy."

We got home. Put Boops to bed. Went to our room. The apartment was cold and the windows were all frosty, and I had eaten too much. But I felt good.

"Rhonda," I said. "I have something to tell you."

"I knew it!" she said.

"You want to hear it or not?" I said.

And she smiled at me. "Yeah," she said.

"I quit my job."

She lost the smile. "What?"

"You heard me, woman. I quit my job."

"Bernie Mac—"

"I'm not a Wonder Bread man, Rhonda. I'm not a fry cook. I'm not a janitor. This time my mind's made up. It's not open to discussion. We're not negotiating here. I'm a comedian. And like I told you before, if I can't be a comedian, I'm gonna *die.*"

For the longest time Rhonda didn't say a word. Then I saw the tears in her eyes. She was crying, but she was smiling, too. She came close and hugged me.

"Do I have your blessing, Rhonda?" I asked.

"Yes," she said. "You have my blessing. I'm with you all the way."

We held on to each other.

And that was it. I was done with regular jobs.

Bernie Mac was a comedian.

"GOT-DAMN RIGHT, MUH'FUCKA. I GOT A LEVEL OF CRAZY IN ME YOU AIN'T BEGUN TO SEE."

NO-HOLDS-BARRED CRAZY

A few weeks later, at a club in Atlanta, I met this fellow Kevin Sumner. He was a short, stocky guy, smart as a whip, and he was working for Russell Simmons, over at Def Jam Records, home of hip-hop. Sumner told me he wanted to do an urban version of *Saturday Night Live*, and that he wanted to put it on film. He'd been talking to some of the guys—Bill Bellamy, Chris Tucker, Martin Lawrence—and he wanted to know if I was interested.

I had heard something about this plan of his, and of course I was interested. "Where are the auditions?" I asked.

And he said, "You don't have to audition, Bern. You're in."

A few weeks later I flew to New York for the Def Comedy Jam. They told me I could do anything I wanted, go as crazy as I wanted, because that's what *they* wanted: no-holds-barred crazy.

So I gave it to them:

"White people say 'cocksucker.' Can't nobody say 'cocksucker' like white people. Be driving down the street, 'COCKSUUUCKER-RRRR!' Black folks, their cuss word be *motherfucka. Mother*fucka. Mother*fucka.* You hear a black conversation, you'll hear twenty-one *motherfuckas* and only two regular words. But you know what they're talking about: " 'When I see *that* motherfucka, he better have my *mother*fucking money, or I'ma bust him upside his *moth-*erfucking head, mother*fucka.* Shit don't make no *mother*fucking sense. Better talk to that motherfucka 'fore I fucking kill that motherfucka. There that motherfucker right motherfuckin' now!' "

I thought it was a little over the top, but they loved it.

When Def Jam aired, it killed. We were hot. Kevin Sumner called and told me they were going to do another one. Was I in?

"Got-damn right, muh'fucka. I got a level of crazy in me you ain't begun to see."

The thing about Def Jam is that it was pure black. Black for black. It put me in mind of some of the old-timers I'd seen at the

Regal, in Chicago, when I was just a kid. People like Pigmeat Markham and Moms Mabley. They went all the way back to TOBA, when comedy was segregated. In a strange way, Def Jam was history repeating itself—making segregated comedy all over again.

What's that? You never heard of TOBA? Well, sit your ass down, I'm gonna give you a short history lesson.

Back in the early 1900s they had this thing called the Theater Owners Booking Association. It was actually started by an Italian guy from Tennessee. He ran a string of dumpy theaters in and around Memphis, and he saw how blacks didn't have many places to go. So he called a few other theater guys—white guys—and told them he was going to start booking black acts for black audiences.

Next thing you know, these white-owned theaters are booking Bessie Smith, Count Basie, Sammy Davis Jr., and all the rest of them. It was by blacks, for blacks. (With the white owners in the middle, of course, making most of the money.) And it was a big success.

Of course, nothing lasts. By the late 1930s vaudeville had pretty much died out, and for a time there black comedy went all to hell. You heard some on the radio, saw some on the screen: You had your Stepin Fetchit, mumbly and shifty-eyed: "I'm so lazy that even when I walk in my sleep I hitchhike." And Butterfly McQueen: "Gee, Miss Scarlett, I don't know nothin' 'bout birthin' no babies." And Mantan Moreland, the chauffeur in the Charlie Chan detective series: "Feets, don't fail me now!"

But then black businessmen got smart: They started opening clubs of their own, all the way from Alabama to Detroit, some of them no more than roadside shacks. By blacks, for blacks. And things went along like that for a good long while, nobody crossing the color line, until Dick Gregory came along in the early 1960s and shook things the hell up.

That Dick Gregory. Kids today, they don't know nothing about the man. Most of them don't even know who he is. But to me, hell—he's some kind of hero. I have great respect for the truth; I have respect for anyone who's not afraid to tell it like it is. And Dick Gregory was fearless.

He gets up onstage and spells it out: "This is the only country in the world where a man can grow up in the ghetto, go to the worst schools, be forced to ride on the back of the bus, then get paid five thousand dollars a week to tell about it."

That's comedy: Hit you with the truth and make you laugh.

I have a favorite story about Dick Gregory, going back to those early days, when he first began playing mixed audiences. Don't take a genius to figure out that the man got heckled. But with hecklers, see, you gotta be careful. Put them down too hard and the crowd turns on you.

One night, see, some sumbitch crossed the line. And you know, Gregory'd been expecting it. Still, when it comes, it's got power. "Nigger," the sumbitch called him. Just one word: "Nigger." Said it loud; loud enough for everyone to hear.

Well, the way they tell it, the audience just got-damn froze. And Gregory said nothing for a good half minute. Let the silence hang there; everyone looking at him, wondering how the hell he was gonna handle it. Finally, he takes a deep breath and smiles a little and says: "You know, my contract reads that every time I hear that word, I get fifty dollars. And since I'm only making ten dollars a night, I'd like everyone in the room to please stand up and yell *nigger*."

Man brought the got-damn house down. Shut that heckler right up. And—like they say—he got on with the show.

There was another guy making waves at around the same time: Richard Pryor. He was playing to mixed audiences, too, and

when he first started out, he sounded like Bill Cosby. He was funny, sure, but his comedy had no teeth. It was safe and easy; went down smooth, *too* smooth.

Still, I liked Pryor. He was from Peoria, practically a neighbor. His family owned a string of whorehouses, and they say his grandma was the head ho. But the family put values into that boy: made him go to church every Sunday. Some people, that would fuck them up good. But not Pryor. He made it funny.

Still, for a while there, it was easy funny—*white-bread* funny. Man lost his way. And he knew it, too. One day at the Aladdin in Las Vegas, he stopped dead in the middle of his act, looked out at the audience, and said, "What the fuck am I doing here?" Then he turned and walked off the got-damn stage.

After that, Pryor didn't hold anything back. Man got *teeth*. He was up there scaring white people. Talking about racism and oppression and niggers never catching a break. He was the voice of the little man, the lost little man who had nothing and was going nowhere fast. And *still* he made it funny. Angry motherfucker was doing the best comedy of his life.

Not that Dick Gregory wasn't angry. He was angry about plenty of the same shit. But he didn't let his anger show. For him, the stage was a pulpit. He thought comedy could change the world.

So, as I was saying, they were planning Def Jam 2, and I was in; Sumner knew where to find me. Meanwhile, I was getting around. I was on the road every week. I was all over the place. I opened for Dionne Warwick and Natalie Cole. For Gladys Knight and the Pips. For the Temptations.

Then I got another call from Damon Wayans. He was making a movie called *Mo' Money*, and he had a part for me. I flew out to L.A. to find that I'd been cast as a doorman. That was my part: doorman. Bernie opens the door, Bernie closes the door. Man, that Bernie got style! Timing's just right. Call him One-Take Bernie. He

can open and close that door like nobody's business!

Okay, I'm funnin' with you here—but it was the truth. That was my big Hollywood debut. I did it, and I didn't crank and moan.

In fact, I gave it my all. And I made good use of my time while I was out there. I tried out for other roles. I'd find myself at one audition after another, cooling my heels in the waiting room with a bunch of black guys that were beginning to look awfully familiar.

"What you here for?"

"Role of Jack. You?"

"Jack."

Only one role today. And I'm thinking, *If Jack has to open any doors, I got this motherfucker nailed.*

I looked up. Three black women were just arriving—also up for the role of Jack. And ten to one the looker in the middle was gonna get it.

I went up for a lot of parts in a lot of different movies, and I didn't get a single one. But that's all right. Like my mama used to say, *Failure is just life's way of preparing you for success.* Losing ain't so bad. It conditions you for winning.

Fact is, I wasn't much good at auditions. Some people know how to audition, some know how to perform. I was a performer. I didn't like going in there cold, getting the script an hour before I had to meet with the casting people. You walk in—boom! It's so unnatural. Everything so forced. Me, I like to take my time and read the script and sit with that character awhile, get to *know* that character. That way, when it's showtime, step back, brother—that character's *alive.*

Following year, *Mo' Money* comes out; got-damn doorman with more character than he can handle. People see me in it, say, "You ain't so hot. I could do that." I'm thinking, *Yeah, but it's not you opening and closing that door! It's me. And I worked got-damn hard to get there.* But all I say is, "You know what? I bet you're right. Bet you could open and close that door good as me."

People just can't handle it. Especially the ones you've known for a while. They see you up there on the screen and it's so *foreign* to them. They're thinking, "I knew Bernie Mac when he was frying fish. He can't be no actor." Denzel Washington will go up there and do a love scene, and the women will swoon. Bernie Mac does the exact same scene, maybe even a little hotter, and they don't buy it. "Uh-uh. That man used to deliver refrigerators; he the Wonder Bread man. That man's no actor. He's the guy from Dock's. He don't fool me."

Of course, maybe Denzel's friends say the same things about him. When you know a person one way, from a life they had, it's hard to change the way you see them. And that's the truth, brother.

Then it was time for Def Jam again. Some of the same guys, some new faces. The crowd's big, and it's hot. And I was on after this next cat.

Well, this poor bastard goes out there, and the brother bombs. He bombs big. They boo him the fuck off the stage. And I felt bad for him. I ain't lyin'. I felt bad because I could relate. Years earlier, as you may recall, I'd been booed off a stage in front of my entire family. And it hurt, brother. Pain like that runs deep. But you gotta come back from it. You don't come back, nobody cares. They leave you there by the side of the got-damn road.

They were still booing. Brother was long gone, went running off with his tail between his legs, and the crowd was waiting on the next clown—which would be me.

So I came through the curtain and grabbed hold of that microphone and looked down at all those angry-ass faces, and I barked: "I AIN'T SCARED OF YOU!"

Brought the got-damn house down. I was *on* . . .

"I love sex," I'm sayin'. "And I'm blessed. If I take this thing out, whole room goes dark."

Just ran with it. Did my thing and got my laughs and went home. Nobody gonna run me off no stage, motherfucker. *Ever.*

I got a call three weeks later. "We're doing it again."

"Say what?"

"Def Jam. We're going for Number Three."

"Thanks," I said. "I'll pass."

"You crazy? Def is *hot!*"

They were mad at me. They didn't understand that I was done with it. I did two shows, got my little exposure, and moved on. It was time to move on, plus I had my reasons for moving on—though I didn't think it was my place to spell them out.

But I'll spell them out now: I didn't think that second round of Def Jam was all that good. It was too raw, and there's nothing wrong with raw—if it's raw in the right way. Good raw takes you places. Good raw can open your eyes.

But when you're out there talking about "dick" and "pussy," and there's no more to it than that—well, brother, you're in trouble. That may be funny to someone in the audience, but it ain't funny to me.

They told me Russell wasn't going to like it, my not signing up for Def Jam 3. They told me they'd been good to me; that they'd put me up there; that they gave me *heat.* And I'm thinking that it's the same old shit. People think they own you. *We put you up there, mother-fucker, and we're going to bring your ass down if we want to.*

No matter. I was going to try to do my own thing, my own way. And I wasn't worried about the future. I'd made up my mind: I was a comedian. All of this was gravy. I'd been a janitor and a bus driver and I'd built houses from the ground up and I'd chased rats and shoveled scrap iron and fried fish and delivered bread, and I'd done it all honestly. I wasn't about to get dishonest with my comedy. I wasn't going to do comedy I didn't believe in. Comedy was *it* for me, brother. Nothing as important as comedy.

You gotta stay strong inside. Stay centered. Be true to yourself.

"I OWED HER SO MUCH. EVERYTHING THAT WAS HAPPENING IN MY LIFE WAS HAPPENING ON ACCOUNT OF HER, ON ACCOUNT OF HER FAITH IN ME. *BIG THINGS IN STORE FOR THAT BOY. BEANIE GONNA SURPRISE EVERYONE.* I HAD NEVER THANKED HER PROPERLY. I HAD NEVER SHOWN HER THE LOVE AND APPRECIATION SHE DESERVED."

17

I MISS MAMA

One night, back in Chicago, I was at All Jokes Aside, and I was hot. I did some bits about Los Angeles and show business; about executives with Christian Science smiles; about auditioning for the part of Jack with forty other Jack wannabes. The audience ate it up. Everybody loves Hollywood stories. By the end of the set, they were on their feet, begging for more. And I'll tell you, that feeling— that's something an entertainer can never get too much of.

I did another minute or two, then said my *Good night* and *God bless* and took a bow and got off the stage. I took a look outside. It was raining cows and bulls. I went over and asked the bartender for a six-pack of beer, then ran out and got in my car and headed home.

I was feeling good. I was feeling powerful. The rain was beating like thunder against my car. I thought maybe it was God himself out there, applauding.

I opened a bottle of beer. I know you're not supposed to drink and drive, but I needed it. And it felt good going down.

Just then a church song came on the radio. An old song I hadn't heard since I was a little boy. And I started thinking about my mother. I missed her. God, how I missed her! I wanted her in my life. I wanted her to see what I was up to. I wanted her to meet Rhonda and to know my daughter, Boops.

I owed her so much. Everything that was happening in my life was happening on account of her, on account of her faith in me. *Big things in store for that boy. Beanie gonna surprise everyone.* I had never thanked her properly. I had never shown her the love and appreciation she deserved.

A horrible feeling came over me. I felt knocked low. Emptied out.

Suddenly there was a loud sound in the car—a roar. And I realized it was *me*. I was sobbing. I had to pull over. I was going along on Lake Shore Drive and I turned off toward the empty beach and killed the engine and got out of the car in the pouring rain and stumbled to the water's edge.

I started hollering for my mother. I was crying so hard I couldn't breathe.

"Mama! Mama!"

And it wasn't even my own voice. It was little Beanie's voice coming out of me. I was calling to her like a little lost boy, with the rain beating against me and my eyes burning with tears.

I didn't get home till first light. To this day I don't even know how I found my way back. I pulled up near the corner, at 107th and King Drive, and I saw the curtains in my place, drawn back. It was Rhonda. She'd been waiting up all night. She met me at the door.

"Bernard!" she said, more upset than angry. "Where you been? I was so worried about you!"

But then she saw how I was soaked through, and how my eyes were swollen from the tears. "I miss my mother," I said. "I miss Mama. Mama, Mama."

Rhonda didn't say another word. She led me to the bedroom and took off my clothes and helped me into a hot shower and put me to bed. I lay there, drifting off, remembering how I hadn't cried at the funeral. Not real tears, anyway. I'd forced up a few because it was expected of me. But these tears were real. I was feeling that terrible loss for the first time in my life. It was beyond painful. It was the worst pain I had ever felt, a burning ache in my heart.

It was as if a part of me had been torn away.

////////////////////////////////

For a few weeks I felt all hollowed out, like I had nothing left inside me. But I didn't feel like talking about it, and Rhonda didn't press, and slowly my strength began coming back.

"Rhonda," I said one day. "I'm gonna put a show together."

"What kind of show?"

"My own show. With music, dancing. The whole thing."

"What about the comedy?"

"Don't worry," I said. "That's what'll bring them in."

In the days and weeks ahead I went from club to club, checking out the different bands. I couldn't seem to find any that really spoke to me. But one night, on my way to a club on the North Side, I heard some music that really got my attention. I went to see where it was coming from, and I walked over to the next block. And there was a street band there, with a big crowd watching, and they were doing some genuine *funk*. We're talking down-home street music, with a lot of brass.

When they took a break, I went over and introduced myself, and the guy in charge said his name was Bones. I told Bones I liked his style, and would he meet me at the Cotton Club the next day at six o'clock. Bones and his guys showed up, and they played for me, and they were even better than I'd hoped. So I arranged for them to come back the following Monday, because I wanted to see if these guys could funk in front of a live audience.

Well, they tore the place up.

The next thing I did was audition the dancers. I found a choreographer, and we narrowed it down to eight girls. *Bernie Mac and the Mac-A-Ronis*. We practiced for six weeks straight. Then I called my friend Chuck Gueno, over at the Regal, and told him to get ready for us.

We did two sold-out shows at the Regal, back-to-back, and signed on to do one a week for the next seven months. It was great. I'd come out, introduce the ten-piece band, and they'd plunge in. And then the girls would slink onto the stage and the crowd would get all lathered up. When it was my turn, I'd give them an hour and a half of nonstop comedy, and I gave them fresh stuff every week. I take my obligations to the audience very seriously. We had a lot of repeat business in that place, and I wasn't about to spit back stuff they'd already heard.

The following year, 1993, I took the show on the road. I called it the "Who Ya Wit Tour," and we hit more than twenty towns. Every

place we went sold out. They had local talent opening for us. We were *it*. We were the Big Deal. And brother, we worked hard.

One night, recently back from the tour, I was sitting down to dinner with Rhonda and Je'Niece when the phone rang. It rang *loud*. I thought for sure it was going to be bad news, but I was wrong.

It was Milt Trenier calling. He owned a nightclub in Chicago. He wanted to know if I'd like to host a regular gig at his club. "I'm thinking of calling it *The Bernie Mac Comedy and Jazz Showcase*," he said.

"Well," I said. "I like the name."

The Bernie Mac Comedy and Jazz Showcase was exactly what it sounded like—a combination of smooth jazz and comedy, with me at the center. For the next four years that's where you'd find me Tuesday nights, at Milt Trenier's club. It was a classy place, the kind of place a ball player could take his wife and kids, and I kept the comedy clean. Clean and honest.

The rest of the week, and just about *every* day of the week, I was at other clubs or on the road. I'd go anywhere that would have me. If someone had called from Anchorage, Alaska, and asked me to fly up and do a show, I would've done it; I would've made it work.

One day, late, after a show, I got home and crawled into bed with Rhonda.

"Girl," I said. "It's time."

"Time for what?"

"Time to quit, woman. We're on our way."

"Say what?"

"You heard me," I said, and I smiled a big smile.

So she quit the state mental hospital and I got myself incorporated and started MacMan Enterprises, Inc., and we began to

enjoy a few of life's luxuries: good restaurants, nice clothes, the occasional weekend trip. Everything was beginning to fall into place, and that's the way I wanted it. I'm a guy that likes order, structure. I was getting up at eight sharp every morning, having a little breakfast, then going off to work out.

After that, I'd come home and think about my comedy routines. I'd hang with myself, talk to myself. Sometimes there'd be four of us on the couch there, yammering away; kind of like those conversations I used to have with the walls when I was a little kid.

"That shit ain't funny."

"Get it right, Bean!"

"You have no idea how bad a bad woman can be!"

Rhonda would call out from the kitchen, "You talking to yourself again, Bernard?"

Damn right I was. Who else would I be talking to?

After I was done talking, I'd go to the office, see what was what, then have me a little lunch and wander over to the gun range.

I love guns. I've been around guns my whole life. You live in the 'hood, you're going to be around guns, whether or not you want to be. And while I didn't much care for guns as a kid, never really gave them a second thought, first thing I did after I got married was get me a gun. My very first gun was a Smith & Wesson snub-nose .38. A street gun. No permit. Needed it to protect my wife from that bad element.

Later, though, I went legit. When I started doing better, making money and such, I began investing in guns. Built up a veritable arsenal over the years. Learned how to break down my guns and clean them good and adjust the sights. I'm a regular James Bond, brother.

Before long, I took Rhonda to the gun club. That woman got good fast. Stand back! Don't be messing with Rhonda. She likes the pearl-handled .40 caliber. I like the .45. I have shotguns, too; over-unders, side-by-sides. I got rifles. I have a Winchester just like the Rifleman used to carry. You should see me at the range. That

thing's hanging there, by my right hand, low, and I go for it—*Boom! Boom! Boom! Boom!* That Bernie Mac; he a regular cowboy.

Then I'd go home to my other job: raising my kid.

That Je'Niece Nicole McCullough! What a beautiful girl she was turnin' out to be, but brother—hard got-damn work. Let me tell you about Je'Niece. Here it is, 1993 already, and my little girl is suddenly fifteen years old. I loved that girl to death, believe me. But the feeling wasn't always mutual.

Here's the thing, see: It takes a lot of courage to be a good parent. I'd learned that from my mama. And I was determined to be the best got-damn parent on the planet. The downside to all that hard work, though, is that it makes you very unpopular: No kid's going to see anything, *ever*, from your point of view. But so what? My mama had taught me about that, too. *Life isn't a popularity contest, Bean.*

Now I'm going to tell you the secret to being a good parent. It isn't about making your kid happy all the time. For one thing, that's impossible. For another, it isn't good for them; gives them a wrongheaded view of what life is all about. Life's got pain in it, and they better start learning to deal with it *now*.

No, sir. Being a good parent is about raising a good kid, a good citizen. And that's what I was trying to do with Je'Niece. My responsibility was not to her happiness, but to her *character.* That's what it's about: character, integrity, discipline. And you gotta let them know that that's what it's about. So you talk to them. And I talked to Je'Niece all the got-damn time. Hell, if you ask her, she'll tell you I talked too damn much. But I wanted her to know that I was there. I wanted to keep the channels of communication open.

Of course, sometimes, from where she was standing, the communication was pretty one-sided. She'd want to know why she couldn't stay at the mall till ten, and I'd tell her, "Because I said so. Because that's the rule."

Most parents don't get it. You shouldn't lecture your kid; he's not listening to you anyway. All you got to do is tell it like it is. You're in charge. Or *should* be. I know I was. And Je'Niece knew it, too. Bernie Mac is the boss. Bernie Mac is in control. This was my home and I was going to run it any damn way I saw fit, not the way some hormonal kid thought it should be run.

"When you grow up and get a place of your own," I'd tell her, "you can run it your way, but this is my house, and we play by my rules."

There were the usual issues: Homework. Tight clothes. Chores. Messy room. The whole nine yards.

And of course there was the One Big Issue: guys. I didn't want no five or six guys calling for her all the time. I didn't like that. I didn't want to think about my daughter so much as holding a guy's hand. It gave me the shivers. So, yeah—that was a big one.

We got through it, though. And sure, we had our moments— what parents don't? But if you love your children, you'll want the best for them, and the best is usually the toughest. A parent that lets his child do any old thing—stay out late, sass back, run off with friends he's never met—that's not a parent. It's easy, sure, but it doesn't do a damn thing for the child. It makes him think you don't care, and that's deadly: A child sees himself through the eyes of his parents. If he feels you don't care about him, he's not going to care about himself, either.

As a parent, you're in it for the long haul. You bring a child into this world, that's about as big a responsibility as there is. And you best not mess up. We got a generation here that's dropping the ball with their kids. That ain't right. Do the hard work when it counts. Show that kid who's in charge. Teach him some respect. Stop treating him like an equal—he ain't an equal. He's just getting started.

At the same time, work the other side—the good stuff. Make that child feel loved. Make him feel important. Make him see that

he matters. A child looks to you to see not only who he is, but what he might become. You've got to make that kid feel he can do anything he sets his mind to do. And that even if he can't, he should damn well try.

Like my mama said, you gotta reach for the stars.

At the end of the day, the most important thing a person has is his or her self-respect. And those foundations are laid in childhood. So you need to keep at it. It's not about perfection; it's about improvement. A child needs to feel worthy. A child that believes in himself has a good chance of making his way successfully in this hard world. A child that don't believe, well—you get the picture.

My mother knew that. She didn't have much to give me in the way of worldly goods, but she taught me to believe in myself—and that turned out to be the greatest gift of all.

I figured, if I could be half the parent my mother was, Je'Niece would turn out pretty good. And she turned out great. My daughter is a lovely woman, and that's not just me talking; everyone who meets her thinks so.

And no, I'm not saying I was Father of the Year. I wasn't. I came up short lots of times. I know it and she knows it and Rhonda knows it. But I worked hard. I did the best job I could. And when the best wasn't good enough, I tried harder.

Thinking on it now, on this business of parenting, there's one thing about the job that strikes me as the ultimate irony, and it's this: Being a parent is really about working yourself out of a job. That's right. You're taking this little creature, this creature you love more than you can even begin to describe, and you're preparing her to go out into the world—preparing her to leave you. That's heartbreaking, friend, but that *is* your job. So do it, and do it right.

"I DON'T WANT TO BE ANYBODY BUT BERNIE MAC. BERNIE MAC ENOUGH FOR ME, BROTHER."

SPOOKY JUICE, JUST LOOK' AT YOU NOW

18

In 1993 HBO flew me out to Los Angeles for a special, *Rosie Perez Presents Society's Ride*. It was a little like Def Jam, but it didn't catch on. And I felt bad for Rosie. I thought Rosie was *it*. People were talking about J.Lo, but J.Lo was nothing next to Rosie. That Rosie was a gem.

Before I flew home, I took advantage of being out there and tried out for other roles. I had a manager back in Chicago, and she kept sending me out on these things, and I gave it my all. And at the end of every audition I always heard the same thing: "You were great, man. They loved you." But people in Hollywood always tell you they love you. They tell you you're wonderful; that you ought to have your own show; that big things are in store for Mr. Bernie Mac. There was so much got-damn love in those rooms it was a wonder we didn't tear each other's clothes off and fuck.

One night, between auditions, I went back to the Comedy Act Theater to catch a little standup, and I couldn't believe what I was seeing. Half the acts were doing *me*. I ain't lyin'. Seemed like Def Jam had spawned a whole mess of Bernie Mac imitators, and every last one of them was bad. No, they were *beyond* bad; they were terrible. There was no heart in any of the acts. Plus it'd been done. Only these guys didn't understand that. They'd go out there and try for an easy laugh, and they might get one, too. But it was hollow. There was no honesty there. And honesty takes work.

Most people don't want to do the hard work, though. They're looking for the free ride. They want something for nothing. What do they think? That Michael Jordan was out boozing at night? Hell no! He was on that got-damn court all day, every day, trying to make himself a better player. And when he was the best there was, he went out and practiced harder.

That's the thing, see. If you want to be the best, you have to fight for it. And you have to fight for it *straight;* you have to be who you are. Why you trying to be somebody else? You looking inside yourself and not liking what you see?

Man, that was one thing I've always hated hearing: "Bernard, you remind me of Redd Foxx." Or, "You're the next Richard Pryor." Or worse, "Clean up the act a little and you could be as big as Cosby."

I don't want to be anybody but Bernie Mac. Bernie Mac *enough* for me, brother. And every day Bernie's expanding his horizons.

And I'm not just talking about work, either. When you're struggling, all you ever seem to do is work. But a little success sure enough brings its rewards.

I'm a golfer now. I love a sport where you can walk around with a cigar in your mouth. I like horses, too. *Bernie Mac, equestrian.* And I got me a boat. You should see me out there, in my rubber-soled Top-Siders, that little cap perched on my head at a jaunty angle: *Skipper Bern.* Rhonda thought I was crazy when I bought me that boat, but now she looks forward to those evenin' cruises. Life, brother. I'm standing behind the wheel of my forty-footer, the wind in my hair, my lovely woman at my side, and I'm thinking, Spooky juice, just look at you now!

I still had my regular Tuesday gig at Milt Trenier's, of course, and the rest of the week I was on the road. Work work work. Thursday to Monday, I was on eight planes a week, and I was doing this forty-three weeks a year. I went from small clubs to thousand-seat auditoriums, and it was a rare night that I didn't sell out.

No, I ain't bragging. I'm telling it like it is. I was in the trenches, and I was building an audience. Hollywood didn't give me my career. *I* gave me my career. I was out there every night, night

after night, trying to knock it out of the park. I wanted to turn every last person in the audience into a Bernie Mac fan, even if that was impossible.

And of course it *is* impossible. Not everyone's gonna be a fan. But you're not going to change human nature. You start hearing it again. This you-ain't-funny business; this you-think-you-hot? business.

Everyone's a critic. Everyone has an opinion.

Bernie too raw.

Bernie not raw enough.

Bernie gone white on us.

Bernie soft—where Bernie's politics?

Politics? I didn't know I was running for Congress, mother-fucker. You want to talk foreign policy, go ahead—get up there and talk. Me, I'm an entertainer. I was put on God's green earth to make people laugh. Sometimes, on account of this here journey I've been on, you'll find some lessons in the laughter. And that's fine with me, brother. I embrace it. But don't tell me what to say or how to say it.

And worse, everybody's hitting you up now. Friends you didn't know you had, long-lost relatives. Neighbors, local businesses, charitable organizations. "Don't you want to help the community, Mr. Mac? Don't you care about your black brothers and sisters?"

Care? Don't tell me what to do with my money. I'm not telling you what to do with yours.

But it didn't stop. It got worse. Every time I turned around, something or someone was coming at me, giving me advice on who to help and how much was needed and all the wonderful things I could do for my community.

"This shit wearing me down, Rhonda," I told my wife one day. "What do they want from me? I'm supposed to buy uniforms for these kids? Build a library? These people making me crazy."

"I can see that, honey. It ain't like you to let them get to you."

She was right. I was never one to pay much mind to other people. I have a handful of close friends, and those are the people I listen to. Them and my best friend of all: Rhonda. Plus my mama had taught me to listen to my own self.

So I got strong: *Make all the noise you want, motherfucker. I ain't listenin'.*

I got refocused. Husband, father, comedian. I played hard and I worked hard. I kept racking up those frequent flyer miles. And the phone never stopped ringin'.

"Who was that, honey?" Rhonda asked me.

"Some little club in Des Moines," I told her, sighing a big sigh. "I don't know if I can accommodate them. All this scheduling and rescheduling! I need help!"

" 'Bout time you admitted it!" she said.

"No," I said. "I'm serious. I'm going to call Geri." That would be Geri Bleavings, who worked over at the Cotton Club. We went back a number of years.

"Geri," I said, "it's Bernie Mac. I need someone to help me run my business. I'm looking for someone with style, personality, high ethics, and lots of smarts—and since I can't find no one like that, I called you."

Geri laughed and said, "When do I start?"

The Mac Man was getting streamlined.

Mac Man likes order. He likes his schedule. The Mac Man is in total control.

One day, in the middle of all this, what do you know? I got a call from Hollywood. This fellow Ted Demme was about to direct a little movie called *Who's the Man?* Ed Lover and Doctor Dre were in it, playing a couple of inept barbers, and the casting people thought I'd make a fine barber myself.

I flew out to Los Angeles and met Ted Demme, and we liked each other right off. He told me I was hired, and they sent me home with a script. My barber was called G-George. I read the script and thought about G-George until it was time to go back and face the cameras. I showed up that first day and Ted Demme asked me how I was going to play the character. I said I wasn't sure; that we'd both see it when the cameras rolled. Ted laughed and said that that was good enough for him, and I was so naïve—so new to the business—that I had no idea what a great gift he was giving me.

When the cameras rolled, Ted Demme wasn't the only one laughing. Seemed like I'd nailed G-George good. And I thought: *This making-movies shit, it ain't a bad gig.*

Next in line was *House Party 3*, followed by *Above the Rim*, with Tupac Shakur. They were small roles, but they meant a lot to me. Every moment in front of the cameras was a chance to learn something new. And that's what I was doing: I was keeping my eyes and ears open and learning.

In 1995 HBO flew me back to Los Angeles. All that talk we'd done was finally paying off. They were giving me my own comedy show, a variety show. I called it *Midnight Mac*, and I had high hopes for it.

We set it on a Chicago stage that was designed to look like a nightclub. I hired Reginald T. McCants and the Mac Men for the music, and rounded up the Mac-A-Roni Dancers. It was a half-hour show, late-night, made up of comedy sketches and musical numbers, with me as the emcee, of course.

I had this one routine where I'd bring a couple from the audience up onstage and test them to see how well they knew each other. It was called "Do You Know Me," and it always brought down the house. It showed that married people only *think* they know each other; they don't know each other for shit.

I had fun with Big Tony, too, my midget bouncer. He wasn't much more than three feet tall. One night I'm up there telling the audience that I've been studying ventriloquism, and then these two guys bring a big trunk up onstage. I keep chatting up the audience, talking about the *art* of ventriloquism, how much hard work it takes and such, and finally I pop that trunk open and reach inside and set that dummy on my lap. Only it ain't no dummy; it's Big Tony. And we get started, with me doing the talking for both of us—my lips flapping so hard I'm vying for the Worst Ventriloquist Ever award. But then Big Tony can't contain himself. He's angry. "You said I wouldn't be locked up in that trunk for more than a few minutes!" he shouts at me. And before you know it, I'm up there arguing with my own dummy . . . All part of the routine, of course.

They killed my show. One brief season and they let it die. They didn't give us a chance to find our way. I know it wasn't there yet, but we were moving in the right direction. Sure, it could've been funnier. Maybe I spent too much time clowning with the audience and acting like a game-show host. And maybe there wasn't enough of me and my routines. But hell, not everything's a hit out of the gate.

That really hurt, getting canceled. I ain't lying. That was my baby. That show went back to who I'd been in the beginning: that kid on the front porch, entertaining the neighbors; doing standup in church; the guy on the El train; the comic on the street corner, his hat laid out for handouts.

It got a Cable Ace Award, but it didn't fly. Politics killed us. They didn't have time to watch me polish my act. It was over. They let me go down in flames.

I was hurting and I was angry. I ain't lyin'. And I was looking for someone to blame. But then I remembered something my mama had told me over and over again: "If you mess something up, Bernie, remember who got you there. Don't be pointing fingers, even if finger-pointing is called for. Only one you got to blame is your own self."

She was right. I'd given Hollywood the power to take my show from me, and they'd exercised their power.

If nothing else, I was a little wiser. Hurtin', but wiser.

More movies followed. In 1995 I got a small part in *The Walking Dead*. It was set in Vietnam, in 1972. Some marines were sent in to rescue a number of POW officers. I got a chance to show off my serious side.

Next in line, *Friday*. I played a preacher who doesn't know much about the Good Book. It was a fun group. Ice Cube, Chris Tucker, Nia Long, Tiny Lister Jr. If you haven't seen the movie, rent it.

When the movies finally come out, you start getting seen, and your fans always ask you the same questions. Want to know what Ice Cube's like. Is he funny? Mean? Nia Long—is she married, or is she looking for a handsome older brother?

"I don't know nothing about Ice Cube," I'd say. "I didn't hang with Ice Cube. I'd go out, hit my mark, and go home when I was told to go home."

That was the truth. I was an actor, doing my job. If I'd been younger, maybe it would have been different. But I was forty years old, not a kid anymore. I wasn't thinking about women and drinking and partying. I was focused on my career. I had a wife and daughter at home. I had a life back in Chicago. My real friends were in Chicago.

It made me see how people who get success too fast and too early in life can get messed up real good. They don't have the smarts to handle it. So listen up: Don't be in such a got-damn hurry, brother. Slow and steady wins the race.

Life, man—it can throw some curves at you. I'm back in Chicago and the phone rings early one evening—rings *loud*—and Rhonda's sixteen-year-old niece, Toya, is on the line. Seems she

and her mother aren't getting along so good, and she's wondering if maybe she can come stay with us for a while, she and her two-year-old both.

So suddenly I'm a father all over again. And worse: I'm a got-damn grandfather.

I thought these two were a handful, but they were nothing like what was going on with some friends of ours. They had a sister who had a serious drug problem, and they ended up with her three kids.

I went over one day and I was shocked. The kids were talking back, cranking and moaning, and sassing everyone. The little one—he was messed up bad. You could see his mama'd been taking drugs when he was in the womb. Two years old, he was, and he'd be snarling at you like a junkyard dog. "Puck you!" he'd say. "Puck you, motherpucker."

I couldn't believe it! Little tyke, knee-high to a grasshopper, with that angry-ass look on his face and those sharp little cat teeth. I asked him where he learned to talk like that, and he turned to face me and put up his little fists. "Come on, motherpucker! Come *on*!"

It was sad. That kid was a mess. That kid was a walking TV commercial: STAY THE FUCK AWAY FROM DRUGS.

I was about to leave—the place was worse than a zoo—but something just came over me. I raised my voice to those three kids and got all bug-eyed and loud and crazy and put some order into that house.

"You kids better show some got-damn respect around here if you don't want to end up in three different orphanages! I ain't lyin'. Uncle Bernie don't stand for this shit!"

It worked, brother. You don't scare Bernie Mac off a stage. (Well, maybe *once*.) I can handle three snot-nosed little bastards any old time. I wasn't about to see them ruin the lives of my good-hearted friends.

And my friends—they was so grateful. Woman was crying. "Mac Man," she said, wiping the tears, "I wish you could stay. This is the first moment of peace we've had in weeks." But I couldn't stay. So I told her: "You get your ass over to Sears, the sports department. They have some baseball bats over there that are just the thing to put a kid's mind right."

Man, them tears turned to laughter. She was laughing so hard I could hear that laughter ringing in my ears all the way home. Got my brain churning. I sat my ass down and began to write. I took that experience, and my own experiences with Je'Niece and Toya and Toya's little girl, and it opened up a whole new world of comedy for me.

Next time I was up onstage, I started tellin' about these noisy, fucked-up kids, and I had people rolling in the aisles. Why? Because most of them had noisy, fucked-up kids of their own. That's why. That's what kids *is:* noisy and fucked up.

And it taught me all over again about honest comedy. The most personal is the most universal. People are more alike than they know. Maybe not everybody got fucked-up kids, but everybody for damn sure got fucked-up families!

///////////////////////////

In 1996 I landed a recurring role on *Moesha*, as Brandy's uncle Bernie. More camera time, more learnin'. *Another chance to improve myself.* It was the first TV show that focused on the life of a black teen, and every minute on that show was a pleasure.

Then Spike Lee called and put me in *Get on the Bus*. The story followed several black men on a cross-country bus trip to the Million Man March. The characters included a laid-off aircraft worker, a former gangbanger, a Hollywood actor, a cop who is of mixed racial background, a white bus driver, and me, a businessman. On the trip out we mixed it up, talking about manhood, religion, politics, race, and the march itself.

It was a serious movie, and it needed some comic relief, and I was going to be the comic relief. At the end of the day, though, the seriousness and the comic relief didn't jibe, and I ended up on the cutting-room floor. But that doesn't mean it didn't happen. It happened. I met Spike and Charles Dutton and Ossie Davis and Andre Braugher and worked on my chops as an actor. And that's what it's about, brother: The Work.

Back and forth. More planes. More frequent flyer miles than I can use up in a lifetime.

I did a little movie in Chicago, *Reasons*, about a drug dealer. But it never got released.

Next, *Don't Be a Menace* . . . with Shawn Wayans and his brother Marlon. I played a black racist police officer, and I still remember my favorite line: "I hate Whoopi Goldberg's lips, I hate the back of Forest Whitaker's neck, and most of all I hate that black ass Wesley Snipes."

I shot three movies in '97, *Booty Call*, *B.A.P.S.*, and *How to Be a Player*, and they all had one thing in common: They were small roles that were played real big in the trailers. And that's when it occurred to me. These producers were *smart*. I had a fan base that stretched from New York to Los Angeles, and they wanted to fill seats with my fans. Okay. Fine. You want to pimp me, go ahead and pimp me. I'm here to work, brother.

And that's what I did. You take what you get and you do the best you can with it. You work it. Work, work, work. I'm a man, not a kid. I'm not here for the girls or the fast cars or to pose for pictures. I'm here to make myself a better actor and a better man. So, yeah, brother, like the song says, *I wanna spread the news, that if it feel this good gettin' used, oh, you just keep on using me, until you use me up.*

Then I got a nice, serious role, on *Don King: Only in America*, and it put things into perspective for me. I didn't have to take everything that was offered. There was some good stuff out there. What I had to do was convince people I was right for it.

The next time I got a call for a movie I didn't want to do, I found the strength to say no. And there was hell to pay. "*No?* You sayin' no to me, motherfucker? Who gave you your start? Where would you be without me? I'm asking you to do this one little thing for me, and you think you're too fucking good for my movie?"

No, brother. Not too good. Everything comes to an end, and I'm ready to move on. I'm like a shark, see. I'm not interested in messin' with you. I just want to keep moving; moving is how I survive.

So, yes—it was time for a change. I'm a Chicago boy, and I had a Chicago team, but the game was being played largely in Los Angeles. So I made the rounds of the agencies and took a gamble on Steven Greener, a manager at 3 Arts Entertainment. I'd met him on *Above the Rim*—he'd been one of the producers—and I liked what he had to say. He knew the business inside out, he understood the politics, he knew it was his job to shield me from the politics and let me do my work, and he knew what my career needed: stronger roles, a chance to grow.

I signed on.

Greener then put me in touch with David Schiff, at the United Talent Agency, and Schiff introduced me to the three principal players on his team: Ruthanne Secunda, Josh Pollack, and Marty Bowen.

We were off to the races.

Only the races would have to wait.

Because a few days after the team was in place, I got a phone call from Walter Latham.

"'GIVE ME A CHANCE TO SHOW YOU AMERICA, GIVE ME A SITCOM!'"

19

THE BIGGEST SHOW BUSINESS PHENOMENON MOST WHITE PEOPLE DIDN'T EVEN KNOW ABOUT

Let me tell you about this cat Walter Latham. I met him in 1998, when he was twenty-eight years old. He was six-six, a former basketball star at East Carolina University, but his real love was comedy.

One day, back in 1992, he borrowed $4,000 from his mother and staged his very first comedy show. He was only twenty-two years old, but he knew there was a black audience out there that wanted more than hip-hop and Saturday-night TV. And he was dead right.

Before long, this smart kid was booking comedy shows all over South Carolina. Then he decided to go national.

The Kings of Comedy was Walt's idea all the way. He wanted to do a show that was bigger than any show he'd ever done before. He wanted it to be urban, black, and bare-bones: good comedy on the cheap.

The *KOC* tour went on to become the most successful comedy act in America, and the seventh most successful concert tour ever. It grossed nineteen million dollars in 1998, the first year out, pulling down an average of $450,000 per concert. By the end of its two-year run, that number had doubled, to thirty-seven million dollars.

And it was practically pure profit. Overhead didn't come any lower.

That first year, there was just the three of us: Steve Harvey, who had his own show on the WB (*The Steve Harvey Show*), Cedric Kyles, a.k.a. Cedric the Entertainer, and me, Bernie Mac. Guy Torry was the emcee, and D. L. Hughley didn't join up till 1999.

The first time I went out in front of an audience that size was truly something. Don't get me wrong, I'd done routines in front of large audiences—all of us had cut our teeth on standup—but we're talking *stadiums* here, brother. We're talking *fifteen thousand* people.

About forty-five minutes before I was due onstage, I went off with Rhonda and we held hands and bowed our heads in prayer. I always pray before a show. After that, I need about thirty minutes to get in character, so I keep to myself and let that character come forth.

Then it was time.

"Ladies and gentlemen, Bernie Mac!"

The curtain parted and I stepped out onstage, and man, it was unreal. The crowd, the noise, the giant monitors. This was *it*, man. I'd been preparing for this moment my whole life, and I was so overwhelmed that for a moment there, my legs turned to jelly. But the moment passed, and I found myself center stage, mike in hand, with the fans winding down, getting quiet, looking at me, waiting to be entertained.

Show us what you got, motherfucker. Make us laugh.

Like I told you, black audiences are *tough*. But you get that first laugh—that big roar, filling an entire stadium—and it's like a shot of pure adrenaline.

So I'm off and runnin':

"I got three new kids. At forty years of age, the *fuck* I need three new children for? Two, four, and six. These my sister's kids. State was going to take them away, and I intervened. Yeah, my sister on drugs. I said it and I ain't ashamed. Some of your family fucked up, too . . .

"I'm sitting in court, I should have sat there like my brother did. My brother ain't say a damned word. He just turned his got-damned head. When they said they was going to give the kids over to the state, he turned his head. But I had to get my self-righteous ass up: 'Naw. This ain't right. We're family. We got to stick together.' If I'd known what these bastards was like, boy, they'd be in orphanages right now.

"Man, that two-year-old—she a sumnabitch. That heifer been here before. Two-year-olds don't use words like 'inconsequential.' She's an apostle for the devil, I tell ya! One day I was combing her hair looking for some numbers.

"And the four-year-old—my sister must have been getting real high when she was conceived, because she don't say nothing; she just *look* at you. I told her the other day, 'Heffa, if a fire break out, you better learn how to whistle or something. Or you gon' be a burnt-up bitch.' I ain't got time to be going into no fire looking for somebody like this. She just stare at you.

"And the six-year-old cry like a sumbitch. But the two-year-old has control over the six-year-old's mind. I ain't lying. Whatever the two-year-old tells the six-year-old to do, he do it . . .

"Kids! The world is messed up. I'm just saying what you're afraid to say! Kids make me *sick*, motherfucker. I can't stand those sumbitches. I'm not talking about kids from the sixties, seventies, and early eighties; I'm talking about these nineties got-damned kids. Ooh, these sumbitches. I can't *stand* them. Ever since they changed the rules to stop you from hitting these fuckers, I lost interest in them. These some bad sumbitches with they small asses. They ain't got no respect for nobody."

Sound familiar? It should, for a couple of reasons. One, you know the story: I done told you about Toya and her kid, and about my friends who inherited those three little devils. And two, you're hearing the foundations of *The Bernie Mac Show*. This right here, this was the beginning of that show.

The laughter. I tell you—nothing quite as *sweet*.

I see some people down in the front row, one woman looking shocked, mouth wide open. And I say, "What you looking at me like that for, girl? You know it's the truth! Bernie Mac just say what you want to say but can't."

And this really gets them. Because that's the way it is, brother.

"When a kid gets one years old, I believe you got the right to hit 'em in the throat or stomach."

That really brings them down. Audience is roaring now. Guy in the front row just fell out of his seat.

People come by after the show for autographs. "That shit for real, brother?"

Come on, people! It's humor. I'm just trying to show you that you're not alone. World is fucked up, difficult; we all got problems. But hit a kid in the throat? I don't think so, friend. You don't beat a child. That don't teach nothin' but anger and hate.

Of course—and I know you're going to crucify me for saying this—I'm not totally against a little light smackin' now and then. If you've tried everything—if the little sumbitch is being so defiant and so disrespectful and so out of control that he might be harming himself or those around him—well, it's time to bring out the belt. Yeah, I said it: You can take your Political Correctness crap and shove it. It makes me sick. As a parent, I will smack my kid if I want to. I'm not going to smack him to hurt him, but I'm going to smack him because he needs to shift direction—and he needs to do it *now*, motherfucker. You ain't hurting your kid if you smack him right. You giving him guidance. You saving his got-damn life. And nobody going to tell me there's anything wrong with that.

But is that me up onstage? Threatenin' to clip a one-year-old in the throat? People, please. I got an evil twin inside me, just like you, but I got mine under control.

I was the least known of the three original kings, and I also happened to be the one with the least family-friendly material. You know me: I've been called the reigning champ of *motherfucka*. You done heard it already: "When I see *that* motherfucka, he better have my *mother*fucking money, or I'ma bust him upside his *mother*fucking head, mother*fucka*."

And sure. We're all different; we all have our own style; each one of us sees the world in his own uniquely comedic way. That's what makes the world go round, brother. But we also knew one thing above all others: We knew going in that the show had to be about the three of us. We all had to do well. The show worked only if we all succeeded.

And it succeeded beyond our wildest expectations. Sold out, motherfucker! Sold out all over again! Sold out three got-damn nights in a row!

Of course, if you were white, you wouldn't know it. The white media ignored us. You'd have thought there was a blackout on the *Kings*.

In 1998 thirty-four thousand people saw us at the MCI Center in Washington, D.C. But the *Washington Post* didn't review the show.

In New York City we sold out Radio City Music Hall two nights in a row. But you didn't hear a peep about it in the white press.

If I saw a white face in the audience, bright as a cotton shirt, I'd think to myself, *That's a brave motherfucker!*

We went across the country and back again. We sold out 15,000-seat arenas from Oakland to Atlanta and everywhere in between. We sold out Chicago's United Center, New York's Madison Square Garden, then went back to D.C.'s MCI Center and sold out two more shows.

As one reporter put it, we were the *Biggest Show Business Phenomenon Most White People Didn't Even Know About.* And that's the truth. If you were white, you didn't hear about us until long after we'd packed up and gone home; in fact, if Spike Lee hadn't put the show on film, you likely would've never heard of us at all.

We shot the whole film in Charlotte, North Carolina, in the space of two days: February 26 and 27, 2000. It was a tiny, all-digital production, with a budget of only three million dollars. Spike's

cameras were everywhere, onstage and off. He showed us clowning before the show, playing poker, and horsing around on a basketball court behind the auditorium.

Of course, there was a lot of showbiz in those sequences. By the time Spike Lee got to North Carolina, politics had reared its ugly head. Steve Harvey started feeling *The Kings* was his show. Don't ask me why. So mostly we didn't hang together backstage, like you saw in the film. Not me, anyway; as you know, I prefer to be on my own.

And that time on the basketball court, when I said that stuff about getting a TV show, what you missed is the question: "Bernie," Spike asked me, right there from behind the camera, "America's waiting on you. How come you got no TV show? Your buddies here have shows of their own. What about you?" So I played along. I looked right at the camera and said, "Do I have a television show?" I got to acting all hot and aggressive. "No. You know why? Because you're scared of me, that's why. Scared I'm going to say something." Then I got all weepy and whiny: "White folks, I don't mean it. I'm just playin'. If you give me a chance, I'll take the WB. I'll take UPN. I'll take USA. Give me a chance to show you . . . America, GIVE ME A SITCOM!"

I wasn't honestly even thinking about a TV show. And neither was America, I imagine. For sure nobody thought I was the next Bill Cosby. And I can't say I blame them. I think *The Original Kings of Comedy* probably scared the hell out of a lot of white people.

The Kings was pure black. Conception, marketing, performance—whole thing was geared to blacks. It was more of that Def Jam thing again: by blacks, for blacks.

When the film came out, white America didn't know what to make of it. They kept talking about us "black comics." I guess that makes Billy Crystal a "white comic," though I never thought about him in those terms. I never thought comedy was about color. And

I believe Dick Gregory said it best: "I've got to be a colored funny man, not a funny colored man."

That's what I wanted to be: a colored funny man. And it was Spike Lee's question that got me thinking: *Why didn't I have a got-damn sitcom?* I was funny. I was *beyond* funny. I called Steven Greener, back in Hollywood, and told him I wanted to do mainstream television. Greener said he'd get to work on it.

A few weeks later, I ran into Damon Wayans and told him I was looking for a TV show of my very own. "I ain't scared of them," I said, meaning white America.

And he said, "Hell, Bernie—maybe you ain't scared of them, but they scared of *you.*"

That'd be funny if it wasn't so unfunny.

This country—there's always a lot of angry talk behind closed doors. *Nigger can't get a break. We worse off than ever. This country going to shit.* But I don't buy into that shit. I try to see people as individuals. When you see people in terms of race or religion, that's when the trouble starts.

I don't understand why people work so hard at pointing out our differences; we should be celebrating the things we have in common. More blood has been spilled over religious differences than over anything else in history. If you don't believe me, brother, take a good look around you, take a look at what's going on in the world right here, right now.

And this ain't no apologist talking. I know who did what to whom. I know all about slaves. I come from a long line of slaves myself. Slavery is in my bones.

But am I a slave now?

Give it up, brother.

Every ethnic group has been oppressed. Can't keep using that. Can't keep bringing up the past. We were *all* slaves. Asians were slaves. Mexicans, Indians. Israelites were slaves. Filipinos—they

sold those people for *rice*, man. And the Egyptians, they had those muh'fuckas on posts, whipping 'em and shit, throwing salt on their backs. "That *sting*, motherfucker. Want me to row this got-damned boat, better cut that shit out!"

Yeah, there's racists out there. There's every kind of racist for every kind of group. But it ain't just a color thing. It's humanity. People are *harsh*. They thick-headed, hardwired. No amount of tinkering is going to change the way some people think. Don't tell me. I know. I've been beat the hell down as much as the next guy, and the biggest beating I've taken has been at the hands of my very own people.

Go ahead. Take me to task for saying that. But it's the truth, brother. And that's what I'm giving you: nothin' but the truth.

"AND LIKE MY GRANDMA SAID: IF YOU HAVE A HANDFUL OF GOOD, LOVING PEOPLE IN YOUR LIFE, YOU'RE A LUCKY MAN. WELL, I'M HERE TO TELL YOU: BERNIE MAC IS A LUCKY MAN."

MI CASA ES MI CASA '20 MI CASA

After the *Kings* tour, I went home to Chicago and picked up where I left off. The tour had put us on the map, but there was no rest for the wicked. I had to keep moving.

One night, not long back, I went to do a show at the Cotton Club and saw my grinning face on the marquee. AS SEEN IN THE KINGS OF COMEDY, the sign said. They even had an excerpt from *Variety*, the show business newspaper: "The concert's true showstopper is Bernie Mac. . . . Appearing on screen last, he extends his motor-mouthed, bug-eyed movie persona into a dizzying string of impeccably timed comic arpeggios worthy of regal pronouncement."

Well, thank you. I'm not going to argue with that.

I went in and walked out onstage, and the fans gave me a standing ovation. I love my fans. I love my fans in Chicago, New York, and L.A. I love my fans in Toledo, Savannah, Louisville, Detroit, and Anaheim. And I especially love my fans in all the little places in between, the ones that aren't even on the map. My fans made me, and they're making me still.

And for that, I thank every last one of you from the bottom of my heart.

At around this time, thanks to my team, there was serious talk about putting me on TV, but nobody could get a handle on how to do it. My comedy was too raw, they said. I was too strong. I scared people. I had too much *power.*

I told them I could be family-friendly, too, but I wasn't about to let them castrate me.

I went back to L.A., racking up more frequent flier miles, and met with Jeffrey S. Dyson, Christopher A. Hall, and Takashi Buford, three guys who'd been kicking around Hollywood for a good long while. They had an idea for a show called *Deadbeat Dad Detective*, about a private eye who tracks down fathers when they stop making their child support payments. It was supposed to be *Fletch* meets *Ace Ventura.*

We talked and shook hands and went off to think about it. Lot of thinking goes on in Hollywood. Endless thinking. Though of course it doesn't show.

Lot of meetings, too. Endless meetings. Lot of smiling back and forth and big promises and people all the time telling you how much they love you, but nothing happens. Still, that's the way they do business in Hollywood: *If you don't hear from us, it's not happening.*

I met with Takashi Buford again. He had a movie at Fox called *Seven Spells*. It was a casino heist, with an all-black cast. It was supposed to be *Ocean's Eleven* meets *Superfly*. Everything in Hollywood is Something Meets Something Else. *Jaws* meets *The Exorcist*. Hey, that's not bad. Maybe I can sell that one.

Again, nothing much happened—just more supporting roles. I was ready for bigger things, but I didn't crank or moan. And it's not like I wasn't working: I'd been touring forty-five weeks a year for going on thirteen years now. And the movie roles—small as they were—they kept on coming.

In '98 I played a creep called Dollar Bill in *The Players Club*. I had promised myself that I wasn't going to do those kinds of roles anymore, but I'd made a commitment to the project two years earlier. It took that long to get off the ground, and now they were back, with Ice Cube himself reminding me of my commitment. So I put on my bowler hat and my electric blue coat and did my bit the way Ice Cube asked me to do it.

Next in line, *Life*, with Eddie Murphy and Martin Lawrence, starring as a pair of convicts in a penitentiary, and my old friend Ted Demme at the helm. Ted called and told me he had a part for me, a small part, a prisoner called Jangle Leg, and he was hemming and hawing about the character. Finally he said that I had a "relationship" with one of the guys, and I almost dropped the phone.

"Are you telling me I'm gay? Is that why you're hemming and hawing, because Jangle Leg's a faggot?"

He sent me the script and I read it. I noticed I had very few lines, but there was something about the character that intrigued me. He reminded me a little of Harpo Marx—not the gay part, but the silent part. Seemed to me that every actor who plays a homosexual always plays him over the top, and I asked myself how Harpo might have done Jangle Leg. It felt like a real challenge, so I picked up the phone and called Ted.

"Teddy Bear," I said, "I'm in."

He was real happy. He thanked me over and over again and said he was looking forward to seeing me, then he asked me how I was going to play the character. "I don't know," I said. "Let me think on it."

First day of shooting, I'm on the set, and here we go. Martin Lawrence is new to the prison, and my character sees Martin and— whoo!—he thinks the boy is hot. He's going to show Martin around the prison. Teddy asked me again how I was going to play him, and again I told him I was still thinking. Then he said something to me that was about one of the nicest things any director had ever said to me, white or black. He said, "Bernie, I'm not worried. I trust you." And the reason it touched me is because it came from his heart. And it touches me to this day. Swear to God, just the memory is powerful enough to bring tears to my eyes. Because this was about *respect.* This was about a fellow human being who had enough faith in me to let me do my thing, my way. And that is a rare thing, that kind of respect—in Hollywood or anywhere else.

When the cameras finally rolled, I shuffled over to Martin's side and bowed my head low and mumbled away, and everyone was roaring before Ted even yelled "Cut!" Teddy was laughing, too. He was laughing so hard he couldn't catch his breath.

Ted Demme was a fine human being. If there was anyone in this town that I was on my way to making a connection with, it was Teddy. He came at me straight and clean, and there's precious little of that in this world. I miss Teddy. He collapsed on a basketball court early last year and died before he reached the hospital. He was thirty-eight years old.

Next up was *Ocean's Eleven*, directed by Steven Soderbergh, and what a stellar cast that was! George Clooney, Matt Damon, Brad Pitt, Andy Garcia, Julia Roberts, Casey Affleck, Scott Caan, Don Cheadle, Carl Reiner, and that wild man Elliott Gould. It was a trip to be working with people of that caliber, and to be treated as an equal.

People always ask me about the stars I've worked with—"That Julia, man, she must be superhot?"—and I always tell them the same thing: I *work* with these people. And most of the time it's a pleasure to work with them. They are solid, professional people, doing their job, just like I'm doing mine. But I'm not going to pretend I *know* them. I do my work and go home. They do their work and go home. Maybe we'll have a meal together; maybe we'll smoke cigars and watch the sun set from the deck of our hotel. But we ain't friends. We are acquaintances. I don't know George Clooney. I don't know Eddie or Martin Lawrence, neither. They have their lives, I have mine.

Maybe if I'd been in my twenties when all of this was happening, I'd be like a lot of young actors. Partying, jumping in and out of each other's beds, getting crazy. But success came to me later in life, when I was already an adult, when I already knew myself and liked myself, when I'd already staked out my world. The people who are in my life now are the people I want in my life. It's not like I don't have room for new friendships, but friendships are hard work. And like my grandma said: If you have a handful of

good, loving people in your life, you're a lucky man. Well, I'm here to tell you: Bernie Mac is a lucky man.

////////////////////////

One day, not long back in Chicago, I got a call from my manager. He said he wanted me to meet with Larry Wilmore, a long-time Hollywood writer, and he assured me that it wouldn't be a waste of time.

So I went out to Los Angeles and sat down with Mr. Wilmore. He told me he had actually started in standup comedy but soon found he was more at home in front of his computer. He'd worked on *The PJs*, an animated series about an urban housing project. It ran for two seasons on Fox and one season on the WB. Before that, he'd written for *In Living Color, Fresh Prince of Bel Air, The Jamie Foxx Show*—more shows than he could remember.

Wilmore told me that he'd seen and loved *The Original Kings of Comedy,* and he was particularly taken with one of my bits. Yeah, you guessed it: the one about inheriting those three kids.

"I think we might be able to build a show around it," he said.

It came together quickly. We decided we were going to do a series about a successful comedian in his midforties named Bernie Mac who lives in a big house in lily-white Encino, California, with his wife, Wanda, an executive at AT&T. They are childless, a career couple, until the day Bernie inherits three high-maintenance kids from his messed-up sister.

We realized that the heart of the show would be about parenting—both of us had strong opinions on the subject—and that Bernie had to be a real tough-love daddy. And not just regular tough, but *thick* tough, *hard* tough. Lay it on strong. *I'm gonna bust your head till the white meat shows.*

We felt there had to be moments in the show when it actually looked like I was going to lose control. I knew I could look

scary—people think I look scary *now*—and I sure enough had the heft for it. And another thing: I wanted to be as politically incorrect as possible. This politically correct shit was ruining the world. I wanted to get out there and be powerful. Bernie Mac don't wear no panties.

We also decided we didn't want a laugh track. We didn't need to tell the audience that the show was funny. We didn't want to cue them with fake laughs. Between the two of us, we knew the show was going to be drop-dead funny.

And we settled on doing it as a one-camera show—a single, high-definition, digital camera instead of the usual multicamera approach.

It was Larry's idea to use little pop-up notes on the screen, to drive home some of the finer points. And it was my idea to break down the fourth wall—to have me address the camera directly. We had things to say, after all. And the character of Bernie Mac was a comedian. And comedians like addressing their audiences directly.

The idea wasn't new—Tim Reid had done it in *Frank's Place*, to give you just one example—but we knew we could make it fresh. Or, as they say in Hollywood, we could take the idea and *make it our own*.

Finally, I told Larry I wanted the relationship between the TV Bernie and his TV wife to be a good, solid relationship. I was sick and tired of the way marriage was portrayed on TV. I didn't see a single TV relationship that had any real love in it, and I wanted to put that kind of love on the screen. I wanted to be honest about what my marriage was like.

Sure, Rhonda and me—we had ourselves some humbugs. She'd get mad, come at me swingin' like Joe Frazier. Not a pretty sight. Sometimes she thought she was a superhero: "I'm gonna Thor your ass!"

The thing is, see, two people meet and fall in love, and they expect to hear music for the rest of their lives. But time passes,

and people change, and their needs change. And one day they turn around and that person next to them isn't the person they married. What they don't see, however, is that maybe they're an even *better* person, better in different ways, excite you in different ways, and that you gotta take the time to know them all over again.

The love I feel for Rhonda now, it wouldn't be the same if we hadn't been through what we'd been through. Neither of us is perfect, but we stood by each other when it counted. Rhonda didn't think less of me because I was a janitor. She respected me.

Even more important, she taught me to respect *her*. Rhonda understood her own value, as a woman and as a human being, as a wife and mother. She knew that if a person doesn't respect himself or herself, they ain't gonna get respect from anybody else.

Rhonda also taught me that if we stood together we could be wicked strong. I wanted that to be part of the show, too. "I want to show marriage the way it's supposed to be, the way it *can* be if you work it right," I told Wilmore. "I'm tired of the way TV turns marriages and relationships into an ugly joke."

Wilmore was all for it. We pitched it to the Fox network, sold it, and Larry wrote the pilot. They loved it. They put us with the casting people and we hit the ground running.

We found Dee Dee Davis to play five-year-old Bryanna. She was a complete newcomer. We got Jeremy Suarez for Jordan, the pre-asthmatic middle boy in glasses, age eight. (He played Cuba Gooding's son, Tyson, in *Jerry Maguire*.) We got Camille Winbush to play the stubborn, smart-mouthed, hard-to-read teenage girl Vanessa. She'd been on *7th Heaven* for a stretch. And then we got Kellita Smith for Wanda, my loving but career-obsessed wife. Kellita and I had met on *Moesha*, and before that she'd done *The Steve Harvey Show*, *In Living Color*, and—like me—more supporting roles than she cared to list.

That pilot episode started with me lighting a cigar, loving my cigar, then looking dead at the camera and saying, "I'm not here to talk about cigars. I'm here to tell you—I'm going to kill one of them kids." So we got right to it. Who says they're going to kill a kid on national television? Bernie Mac, that's who.

Then I told the audience: "Yeah, my sister's on drugs. But a lot of families are messed up. I can't let the state take her three kids . . . " I was near tears by this time, though of course they were crocodile tears. "I'm just trying to do the right thing," I said, and my voice broke with feelin'.

This is what they call a *premise pilot.* You're laying it all out for the audience in that first episode back in Novembe 2001, giving them the whole story. This is where it begins, people. You meet my TV wife, who thinks I don't know squat about raising kids— "Bernie's a *comedian*"—and who doesn't know squat about raising kids herself. Of course, she's got a Big Job with the telephone company, and that's her priority. So when the time comes to pick the kids up at the airport, well—Bernie Mac is on his own.

Three little monsters! Right off I know my life is about to go to hell. On the drive from the airport to Encino, I tell the kids not to worry: "It's going to feel just like home!"

"Why?" the oldest girl says. "You live in the projects?"

We get to the house. "For us to live as a family," I say, "I've got to set down a few house rules. First, this is my house. Don't get me wrong, this is our *home*, but this is my house. *Mi casa es mi casa.*"

Then it gets real crazy. The oldest girl is having her period. The pre-asthmatic boy looks like he's about to die on me. The little one doesn't understand what rules *is*.

I slip into my big leather chair, my *throne*, and I look dead at the camera and say, all sorrowful: "You all keep watching, America. It gets worse." And sure enough, it does. The indignities I suffer at the hands of those three little monsters!

Before long, Social Services shows up. They want to know if I really told one of the kids that I'd bust his head till the white meat showed. And is it really possible that the kids overheard me tell Wanda to curb her spending because "we're nigga rich, not old-money rich."

At this point, the social worker can see I'm pretty upset, and he tries to reassure me: "It's not like I'm here to take away the kids."

"No, please!" I say. "Take away the kids! It's a great solution. I'm a bad man!"

It doesn't end. Parenting is hard, brother. And good parenting is war. Combat all the way.

"Now, America," I ask, wailing plaintively, "tell me again why I can't whip that girl?"

In another episode, hormonal Vanessa complains about all the rules in my house and compares it to a prison. "You think it's like a prison?" I tell her. "Well, I got news for you. It ain't. Because in prison there's *hope*."

In still another episode, I threaten to get rid of a stray dog the kids have rescued. I'm carrying the mangy mutt toward the front door, and the sumbitch growls at me. "Shut up," I tell the dog, "before I drop your ass off in Koreatown." Then I look at the camera, real sweet, and say, "Now, hold on, America! Don't go writing no letters. I'm just kidding."

There's a Christmas episode where I'm hitting the eggnog so hard I can't remember what I'm trying to say.

And advice. All the time advice. Good advice, too—if I may say so myself: "It's all about discipline, baby. And, America, you can do it, too. Yes, sir. They gonna cry, they gonna whine, they gonna beg—try to make you feel guilty. Don't go for it. You got to be strong."

Bernie Mac—he tells it like it is.

Through it all—through the great reviews and the not-so-great letters, through all those wonderful guest appearances—Halle Berry, Matt Damon, Billy Crystal, Don Rickles, Don Cheadle, India.Arie, Carl Reiner, and plenty more to come—the network never pressured us to change anything. I ain't lyin'. And that's a good thing, too, because I never let anyone handcuff me in my standup, and I wasn't about to let them do it on TV.

There are limits, sure. But that doesn't mean you can't push the envelope. And we pushed it. Pushed it hard, too—hard enough to become the highest-rated new series in the Fox lineup.

Wilmore and I, yeah—we have our moments. There are times I feel he's trying to take over the show, times he forgets the show came from *my* head and *my* heart. It's like if I were to take some-

body's music and add a riff or two and call it mine. It doesn't work that way, brother.

Other times Larry gets upset because I won't do a script the way he wrote it. But that's just the way I am. It's *my* show. I'm not going to argue about a bad script. I'm not going to ask anyone to change it. I'm just not got-damn doing it. Simple as that.

At the end of the day, though, despite the head butting—which you got to expect when you've got creative people arguing their conflicting points of view—we have ourselves a great show, and I'm proud of it and proud of everyone who's making it happen. You watch *The Bernie Mac Show* and you realize that black families ain't just about broken homes and crackheads and hos. Black families are about love, too. And love is one thing you can't have enough of.

Love, baby. I got me a big infusion of love last July, when my little girl Je'Niece got herself married. Had a big wedding, home in Chicago. Five hundred people. That girl came down the aisle and took my arm, and she was shaking like a leaf. And I patted her hand, real gentlelike, so she knew she could lean on me. And my little girl leaned on me, held on for support, and brother—it made my heart swell.

To see that gorgeous creature all grown up. About to start a new life. A woman. My only little girl. My pride and joy.

I love you, baby. You are a gift. I thank God for you every day.

"HE WILL FALL, STUMBLE, DESPAIR—BECAUSE THAT'S LIFE: THERE'S NO ESCAPING IT. BUT HE KNOWS INSIDE THAT HE'S BIGGER THAN HIS PROBLEMS. BIGGER THAN ALL OF THEM COMBINED. HE KNOWS HE'S GOING TO MAKE IT. HE KNOWS THERE'S NO PROBLEM SO BIG IT CAN'T BE BEAT.

WHY DOES HE KNOW THIS? BECAUSE YOU TAUGHT IT TO HIM."

Some months ago I read a story about a man who has three little phrases that help get him through the rough days.

Life is good. Be happy now. Let it go.

Think on those for a moment; they are deeper than you know.

My life—well, it couldn't be better. At the moment, I have several hot projects in the can. I was just in *Head of State*, a political comedy, with Chris Rock. I play Bosley in *Charlie's Angels: Full Throttle*, due this summer. I'm in *Bad Santa*, with Billy Bob Thornton and John Ritter, slated for a Christmas release. And we're already talking about a sequel to *Ocean's 11*.

I also have several projects in development. One of them is *Mr. 3000*, and—at long last—I'm the lead. I play a retired baseball player whose whole life has been defined by his 3,000 career base hits. Then it turns out he's actually three hits short, and he has to come out of retirement to make things right.

I'm also working on a remake of *Guess Who's Coming to Dinner?* where I'm flipping the colors. I play a black man—no kidding—whose daughter comes home engaged to a white guy. It's a comedy, yes—but a comedy that respects the original. If they want to get silly on me, they'll have to make the film with someone else. I've got nothing but the highest respect for Sidney Poitier, Spencer Tracy, and Katharine Hepburn, and I'm not about to make a mockery of that beautiful movie. I'm going to do the movie *I* want to do, the way I want to do it, or not at all. I don't need the flak. I know what Poitier went through after *Dinner*: He got so much grief from the black community—*You want to marry a white woman!*—that he had to take a lousy part in *Uptown Saturday Night* to find his way back into their good graces.

Politics, brother. It's everywhere. Always has been, always will be. Can't escape it. Especially in Los Angeles. It's a nice enough town, sure, but it's all about the got-damn business. It's all about who

got what deal and who's hot now and where do I fit into this mix and is my career really over. It's a star system, and stars fall. Go *crazy*, too. I don't need no seventeen ex-football players protecting me.

"This here's my posse. Where *your* posse, brother?"

"I don't got a posse."

"Yeah. I heard you was gettin' canceled."

Motherfucker. What is that shit?

"By the time you die," my grandmother used to say, "two million people will have passed through your life. And maybe three or four of them will still be by your side."

What I didn't understand, back when she told it, is that she meant this as a *good* thing. It's easy to have friends. You can have a thousand friends if you want. Or you can have three or four *real* friends.

I don't want no thousand friends. Too much got-damn work. Phone ringing all the time and doorbell going off and the cards and letters piling up in your mailbox. I want the few friends I got, because they're my real friends—starting with my wife, Rhonda, my best friend of all.

That's why I always go back to Chicago. Because Chicago is my home. In Chicago, I'm just plain old Bernie Mac. And there's maybe a few people there that like old Bernie.

I actually like old Bernie, too. That doesn't sound like much, but most people—they don't like their got-damn selves. I ain't lyin'. It's a pity, too. They should have had a mama like I had.

My mama taught me to believe in myself. She taught me to listen to my own voice above all others, to make sure that that was always the clearest voice I heard. She taught me to go down inside my own self, and to sit still, and to listen close.

All the other voices, you can listen to them, too; hear them out. There's some smart voices out there, some voices worth listening to. Might even find a little nugget of wisdom here and there. But too many voices—all they're going to do is shut you down.

"That nigger can't play ball."

"You ain't funny, motherfucker. Eddie Murphy—now *he* funny."

"Get off the got-damn stage!"

You see what I'm saying? Would I be here if I'd listened to those voices?

My mama taught me to respect myself. To hold my head high. That I had value. That I mattered.

She taught me to respect other people, too. Even the ones who were trying to bring me down. Maybe *especially* the ones who were trying to bring me down.

"They lost, Bean. Most people are lost. Most people are just struggling to find their way."

She warned me that people can be hard, and that sometimes the people closest to you can be the hardest of all. She said people were wired that way. It was their natural state; survival instinct and shit. She said people always put their interests first. Always had and always would.

"It's not about you, Bean. Not at all. They're just lookin' out for themselves. Don't take it personal and you won't get hurt feelings."

My mama was a wise woman.

"That's just the way people *is*. Don't mean nothing. You ain't gonna change them, so don't try. Only person you can change is your own self. So put your energy into that, Bean. God knows, that's a big enough job right there."

My mama taught me not to judge, and not to let myself *be* judged.

Judge not lest ye be judged.

"Good and bad, Beanie. Makes no difference. Two sides of the same coin. It's got nothing to do with you."

She was right about that, too. You don't need to hear the criticism, and you don't need to hear the praise. It's mostly just noise, anyway. And all it does is drown out your own true voice.

Listen to yourself. Be honest with yourself. Respect yourself.

And let people be what they're gonna be.

"People are in your life for a reason, Beanie. You may not know what that reason is for years to come, and you may never know, but pay attention. Funny how learning can creep up on you sometimes—and you not even aware of it."

It's true. The bad things shape you, too. Bad people, bad experiences: If they don't kill you, they make you stronger.

Life is hard. At times, it's *about* the struggle. Accept it, brother. Live with it, sister. If there's no struggle, there's no development. You don't develop, you don't change. You don't change, you don't survive.

"Suffering is a good teacher," my mama used to say. "It keeps you in its grip until you've learned your lesson."

Get angry, feel sorry for yourself, mope—what does that do? Self-pity is self–brought on, and it only stops you dead. Messes you up worse.

Get focused, brother. Figure out what you want from life and go for it.

Be like a horse with blinders: Look straight ahead. Don't look back. Don't be turning your head from side to side. Nothing there, blood. And what's there probably ain't your business; what's there ain't gonna help you get to where you want to be.

Go for it, brother. Eyes on the prize.

People going to tell you you're crazy. A damn fool. Going nowhere. They're going to say you're unrealistic. *A astronaut! You too dumb for that, boy!*

But don't you listen. They just naysayers, and they talkin' about their own fool selves. You stay away from negativity, hear?

You go for it, and go for it with passion. Want it with all your heart. Fight with the heart of a lion.

Nobody's going to do it for you, Beanie.

Be your own man. Stand on your own two feet.

Meet all the challenges, big and small.

Failure is life's way of preparing you for success.

You know why people succeed? People succeed because they outlast you. It's that simple. I ain't lyin'. They're just like you, with one big difference: They don't quit; they don't give up.

Try again, son.

All those Mac-isms:

Don't nobody owe you nothin'. You got no one to blame but yourself. No one's tying you down except your own self. Ain't nobody gonna change your life but you. Rely on others and they will soon enough let you down.

It's on account of those Mac-isms that I'm here today.

My mama taught me that life is what you make it.

She taught me to be thankful for the things I had, and to work for those I didn't. Hard work. Honest work.

She taught me that every day is about becoming a better person. About bettering myself. That I had to take responsibility for my own life and that I had to work on becoming the person I wanted to be.

Like my grandma said: *Beautiful morning, isn't it, son? Got another crack at it this morning. Another chance to improve myself.*

For those of you who have kids, remember one thing above all others: You've got to prepare that kid for the world. He's looking to you for answers.

So love that kid up good, hear? And be strong when you have to be. Rules and regulations and love. Remember to tell that kid how much he matters. Let him know that life can be anything he

damn well wants it to be. Easy, ain't it? You teach a kid to believe in himself, well—that's half the battle. A kid that believes in himself doesn't self-limit. That kid knows in his heart of hearts that he can do *anything*.

He will fall, stumble, despair—because that's life; there's no escaping it. But he knows inside that he's bigger than his problems. Bigger than all of them combined. He knows he's going to make it. He knows there's no problem so big it can't be beat.

Why does he know this?

Because you taught it to him.

You taught him the Secret of Life. Yes, you did. And the Secret of Life is this:

You fall down, you get up.

That's it. Honest. That's all there is to it.

You fall down, you get up. You keep movin'.

Thank you, Mama. I love you with all my heart.

ACKNOWLEDG-
MENTS

I would like to thank my friends, A. V. and Big Nigger: A. V., because he taught me that it's possible to love someone despite their fucked-up ways; and Big Nigger, because he knew me and loved me when I was just Bernie McCullough, and because he loves me still.

A special thanks to my team: Steven Greener, a *real* manager; the crew at United Talent Agency—David Schiff, Ruthanne Secunda, Josh Pollack, and Marty Bowen; and my attorney, Barry Hirsch.

I would also like to thank Judith Regan, Aliza Fogelson, and everyone at ReganBooks for their support and guidance, and to Pablo Fenjves for all of his hard work.

Finally, my thanks to Geri Bleavings. For ten years you've been giving it to me straight, woman. That's a rare thing in this world, but that's the way I like it.

—Bernie Mac

Photograph Captions and Credits

Photographs on pages ii–iii, vi, 154, and 269 by Priscilla Clarke, NEB Entertainment, Inc; still photographs on pages 104, 120, 132, 174, 202, 212, 221, 243, 260, 272, 282, and 293 courtesy of Regency Television; all other photographs courtesy of the author.